From the Sculptor's Hand

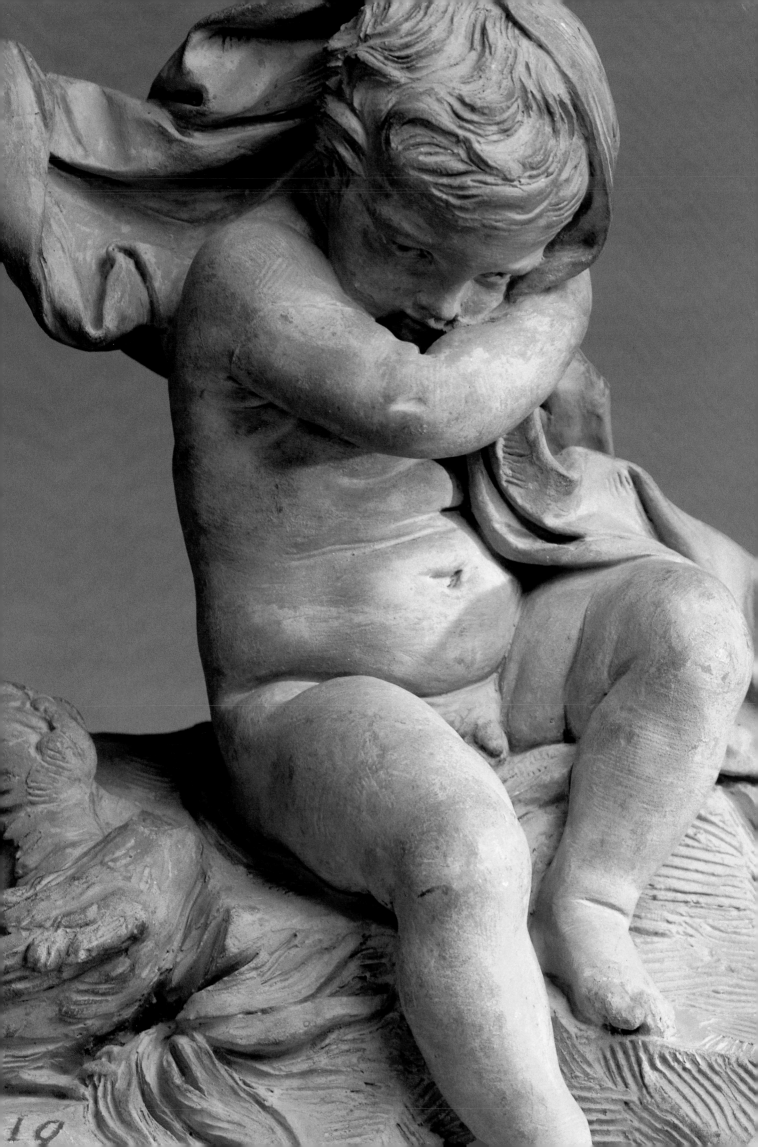

From the Sculptor's Hand

*Italian Baroque
Terracottas from the
State Hermitage
Museum*

Organized by Ian Wardropper

Essays by Sergei Androsov, Dean Walker, and Ian Wardropper
With contributions by Nina Kosareva

THE ART INSTITUTE OF CHICAGO

This book was published in conjunction with the exhibition
"Italian Baroque Terracottas from the State Hermitage Museum," organized by
The Art Institute of Chicago, the Philadelphia Museum of Art, and the
State Hermitage Museum, St. Petersburg.

The Art Institute of Chicago
February 28–May 3, 1998

Philadelphia Museum of Art
May 16–August 2, 1998

Front cover: Alessandro Algardi, *Executioner*, cat. no. 5.
Back cover: Stefano Maderno, *Laocoön*, cat. no. 3.
Frontispiece: Camillo Rusconi, *Allegory of Winter* (detail), cat. no. 32.
Contents page: Gian Lorenzo Bernini, *The Ecstasy of Saint Teresa* (detail), cat. no. 13.

Edited by Fronia Simpson, with assistance from Kate Irvin and Sue Breckenridge
Production by Amanda Freymann and Sarah E. Guernsey
Designed by Joan Sommers Design, Chicago
Typeset by Paul Baker Typography, Inc., Chicago
Color separations by Professional Graphics, Rockford, Illinois
Printed by Litho Inc., St. Paul, Minnesota
Bound by Midwest Editions, Inc., Minneapolis, Minnesota
Photography by Leonard Chejfic
Introduction and catalogue entries translated by Michael Wasserman and Dale Pesman

Photographs of works of art reproduced as comparative illustrations in this volume have been provided
in most cases through the courtesy of the owners or custodians of the work, identified in the captions.
The following photo credits apply to all images for which separate acknowledgment is due:
Art Resource, NY (p. 8, fig. 1); Alinari/Art Resource, NY (p. 12, fig. 2; p. 39, fig. 12; and comparative
photos for cat. nos. 2, 3, 5, 11–13, 15–20, 24–25, 27–28, and 35); Victoria and Albert Museum,
London/Art Resource, NY (p. 18, fig. 2; p. 32, fig. 3; and comparative photo for cat. no. 10);
Archivio Fotografico Soprintendenza Beni Artistici e Storici di Roma (p. 28, fig. 6); Kunsthistorisches
Institut in Florenz (p. 30, fig. 1); and Bibliotheca Herziana (comparative photos for cat. nos. 22 and 29).

Distributed by University of Washington Press

First Edition

Library of Congress Catalog Card Number 97-78370
ISBN 0-86559-158-X

Contents

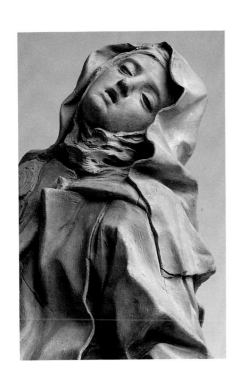

Forewords

Tsar Pavel Petrovich (Paul I) is not usually mentioned as one of the foremost collectors of art among the Russian tsars. Yet the museums of Russia are indebted to his taste for many unusual and refined collections. He had to have a fairly independent sense of the beautiful to literally "fall in love" with the collection of terracotta sculptural models and sketches in the Farsetti collection in Venice. At that time still the heir to the throne, Pavel Petrovich traveled through Europe under the pseudonym "Comte du Nord" and attempted to purchase this collection. The Venetian government did not allow it. Paul, however, was a stubborn man, and in 1800, after he had become emperor and the Venetian republic had ceased to exist, the Farsetti collection arrived in Russia.

The terracotta figurines, documents of the creative thought of the great Italian sculptors of the seventeenth and eighteenth centuries, found a home first at the Academy of Arts and later in the Hermitage. However, it was quite a while before researchers discovered in the figurines the virtues that Pavel recognized immediately. Today both scholars and the public appreciate these pictorial and sculptural sketches of the masters. In them the hand of the artist has not been supplemented by the efforts of his assistants. They bear the imprint of unedited inspiration. It is impossible to imagine or understand the Italian Baroque without these small figures, which embody so many of the characteristic traits of the art of the period. The Hermitage terracotta collection is a remarkable resource for information about this side of Italian sculpture.

The State Hermitage is delighted that its long-standing tradition of friendly collaboration with The Art Institute of Chicago is continuing with this exquisite and intelligent exhibition that presents one of the most unique of our collections.

Professor Dr. Mikhail Piotrovsky
Director
State Hermitage Museum, St. Petersburg

THE ART INSTITUTE OF CHICAGO AND THE STATE HERMITAGE MUSEUM, St. Petersburg, share a rich history of collaboration. *Italian Baroque Terracottas from the State Hermitage Museum* is the latest of several exchanges, which have brought choice French nineteenth-century paintings and rare Dutch and Flemish seventeenth-century canvases before Chicago and New York audiences. In reciprocity, for the citizens of St. Petersburg and Moscow, the Art Institute and Metropolitan Museum of Art sent Impressionist paintings and medieval objects lent from our collections. Now the Art Institute is loaning an important, new holding, superb photographic prints by Irving Penn, in exchange for an older collection, the Baroque sculptures acquired by Tsar Paul I of Russia from the collection of the Italian Filippo Farsetti around the year 1800. Felicitously, this exhibition takes place in 1998, in which we celebrate the quadricentenaries of the great Italian Baroque sculptors Gian Lorenzo Bernini and Alessandro Algardi, both of whom figure prominently in this exhibition. With warm appreciation, I thank the Director of the State Hermitage, Dr. Mikhail Piotrovsky, and his staff for their assistance in realizing this project. Equally, I am grateful to Anne d'Harnoncourt, The George D. Widener Director of the Philadelphia Museum of Art, and her staff for recognizing the merit of this exhibition and for joining with us in presenting it in the United States. Finally, it gives me great satisfaction to thank Dr. and Mrs. Sheldon Gilgore and Mr. and Mrs. Michael R. Sonnenreich. Their abiding interest in Italian art, seen here in 1994 in the exhibition of nineteenth- and twentieth-century sculpture, led to their generous sponsorship of the present project.

James N. Wood
Director and President
The Art Institute of Chicago

Acknowledgments

THE SEED FOR THIS EXHIBITION was planted a decade ago when, in the course of installing two exchange shows at the State Hermitage Museum, St. Petersburg, I had the opportunity to study the extraordinary Farsetti collection of Italian Baroque terracottas in storage. Years later I was astonished and delighted that Art Institute director James N. Wood remembered my enthusiasm for the collection and proposed the current exhibition. Hermitage Curator of Sculpture Sergei Androsov and his colleague Nina Kosareva, who first permitted me to view these works, have been unfailingly helpful through the process of selection and negotiation for the exhibition and in the preparation of the catalogue. It has been a pleasure to collaborate with my friend and colleague Dean Walker, The Henry P. McIlhenny Senior Curator of European Decorative Arts and Sculpture at the Philadelphia Museum of Art. His critical acumen guided the formation of the exhibition, and his catalogue essay is an important contribution to the history of collecting models. Suzanne F. Wells, Special Exhibitions Coordinator, and Erik Goldner, Assistant to the Curator, have been particularly helpful in mastering the logistics of touring these sculptures to Philadelphia.

Many people in The Art Institute of Chicago have supported this exhibition and catalogue with their accustomed high degree of professionalism: Teri J. Edelstein and Dorothy Schroeder, Deputy Director and Assistant Director for Exhibitions and Budgets, respectively; Mary Solt and Darrell Green of Museum Registration; Barbara Hall, Suzanne Schnepp, and Emily Dunn of Objects Conservation; Lyn DelliQuadri and Joe Cochand from Museum Graphics; Natalia Lonchyna of the Ryerson and Burnham Libraries; John Hindman of Public Affairs; many members of the Physical Plant Department; Annie Morse, Iris Wong, and Gregory Williams of the Imaging Department; and a number of staff in my department, including Nora Buriks, Marilyn Conrad, Kirsten Darnton, Bill Gross, and Mark Booth. Problems of distance and translation made the production of the catalogue challenging. The Publications Department rose to the occasion, as always, and in considerable number: Margherita Andreotti, Sue Breckenridge, Daniel Frank, Amanda Freymann, Sarah Guernsey, and Kate Irvin all had a hand in this work. From outside the institution, Michael Wasserman and Dale Pesman did the translations from the Russian, Fronia Simpson edited the manuscript, Joan Sommers produced its elegant layout, New York publisher Paul Anbinder thought up its title, and Pat Soden (Director of the University of Washington Press) took on its distribution worldwide. I am also grateful to various colleagues around the world for advice: Bruce Boucher, Ivan Gaskell, Jennifer Montagu, Tony Siegel, Mark Weil, and Phoebe Dent Weil. Architect John Vinci and his staff, particularly Ward Miller, once again created a stimulating design for one of this department's exhibitions.

Ian Wardropper
Eloise W. Martin Curator of
European Decorative Arts
and Sculpture and Ancient Art
The Art Institute of Chicago

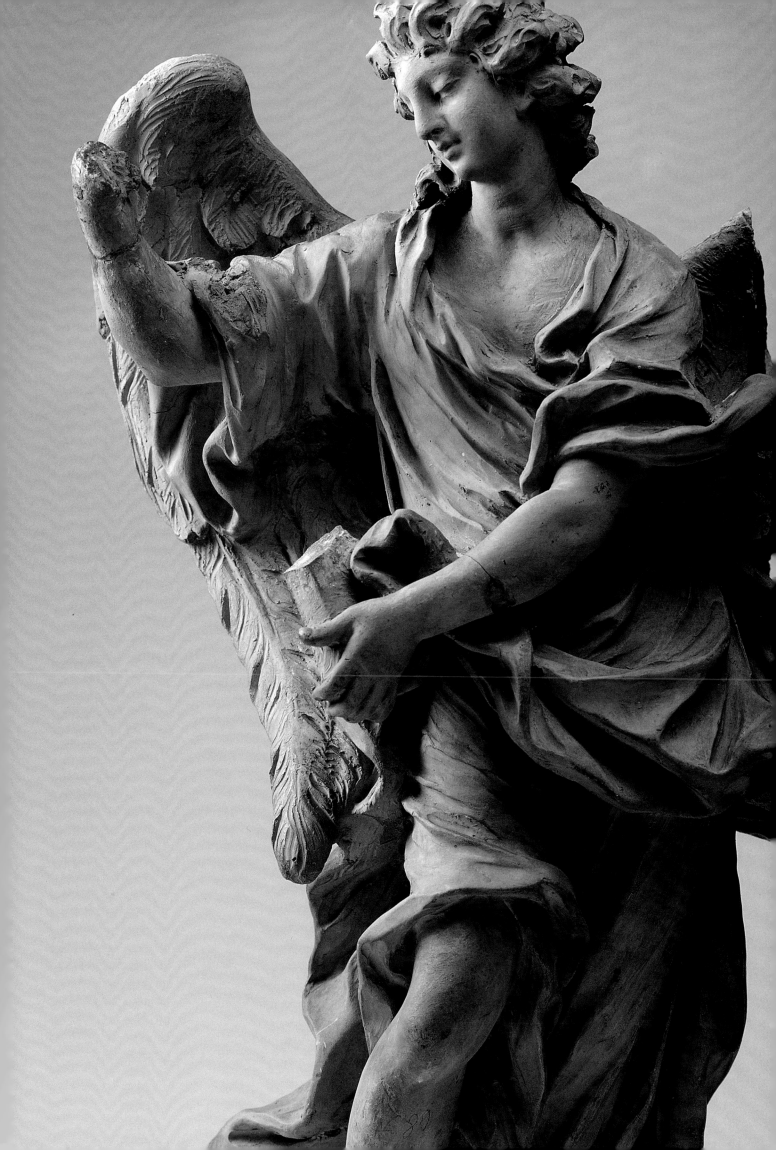

The Farsetti Collection
in Italy and Russia

SERGEI ANDROSOV

TERRACOTTA STUDIES AND MODELS perform much the same role for sculptors as drawings do for painters: they represent the artist's purest and freest style, and they can show the evolution of a composition from the roughest outline toward the final result. By the seventeenth century, successful sculptors rarely put a chisel to the final sculpture themselves; rather, most sculptors would provide their assistants with drawings and models, and the assistants would perform most of the labor on the final piece. Thus, terracotta models were often the last object in the process that sculptors touched with their own hands. This exhibition presents the viewer with a group of terracotta studies and models by seventeenth- and eighteenth-century Italian masters that have been preserved at the Hermitage State Museum in St. Petersburg. All the works originally came from a single collection, that of Abbot Filippo Farsetti, which made its way to Russia as early as 1800. Besides being of great artistic value, the terracottas bear witness to an important episode in the history of collecting in Russia.

Over the past several centuries, the increased number of specialists involved in the fabrication of a sculpture has meant that the sculptor's hand is less evident in the final work. Indeed, a bronze is usually cast in a foundry following a model supplied by the artist. Beginning in the seventeenth century, execution in marble was ever more frequently performed by an assistant stone carver; therefore, any model that captures the initial stages of a sculptor's labor is of particular interest. Giorgio Vasari, in the introduction to his collection of artists' biographies, described the basic stages in the creative process of sixteenth-century sculptors. First, they made a small model, in clay or wax, to develop and perfect their concept. These preliminary, explorative sketches and studies are called *bozzetti* (*bozzetto* in the singular). Having achieved the desired result, the sculptors or their assistants enlarged the small model to the required size, and only then would it be executed in marble or bronze.[1]

As far as we know, sculptors continued to work in much the same manner in the seventeenth and eighteenth centuries. For example, Joachim von Sandrart, the German artist and artists' biographer, described twenty-two slightly varying *bozzetti* for Gian Lorenzo Bernini's statue of Saint Longinus, all of which he saw in the master's workshop.[2] Recent research suggests that these studies were actually made of clay rather than wax.

Initially, *bozzetti* did not attract the interest of collectors. The models evidently remained in the artist's workshop; if the contents of the sculptor's studio transferred to a new owner, the models were often later destroyed as obsolete objects having no artistic value. A model for the monument to Cardinal Niccolò Forteguerri by Andrea Verrocchio (London, Victoria and Albert Museum) is one of the few such studies from the fifteenth century surviving to our time. We owe its preservation not to accident but to special circumstances: Verrocchio died before he could complete the monument, and the patrons retained his model as an aid for the subsequent craftsman.

The situation changed drastically in the mid-sixteenth century, when the aesthetics of Mannerism awakened collectors' interest in sketches and studies that reflected the artist's initial idea on paper. Even so, and most regrettably, there remain almost no models made by Michelangelo personally, evidently because he destroyed

them. Sculpted *bozzetti* and models became the focus of concerted collecting efforts only much later. A prime example of such efforts is the collection of Abbot Filippo Farsetti (1704–1774), which he amassed in the mid-eighteenth century. All factors indicate that the collector found fertile soil for creating a museum of such works.

The Farsetti family did not belong to the hereditary Venetian aristocracy. Anton Francesco Farsetti (1606–1678), born in Massa and living at first in Rome and Ferrara, purchased a palace on the Grand Canal in 1670. Bought from Marina Bragadin for 22,000 ducats, it had once belonged to the famous doge Enrico Dandolo (c. 1108–1205).³ Eighty-five years later, this palace was to house the Farsetti collection.

Filippo Farsetti, born in Venice on January 13, 1704, was Anton Francesco's great-grandson. No detailed accounts of Filippo's youth remain, but it is known that he was influenced by a Franciscan named Carlo Lodoli (1690–1761), one of the theoreticians of rationalism and functionalism in architecture. From the age of thirty, Filippo Farsetti occupied various positions in the Republic of Venice. On April 22, 1736, he was elected *podestà* and captain of Feltre, but declined the position because he planned to leave Venice for France. He settled in Paris, and apparently joined the Masonic lodge of Jean Custos there in February 1737. The same year, on April 5, Filippo Farsetti returned to his homeland. On June 28, he was elected *podestà* in Verona, but did not accept this appointment either, possibly because he was preparing to leave for Venice. On February 13, 1741, Maffeo Niccolò Farsetti, the archbishop of Ravenna, died and left a large fortune to his nephews: Filippo Farsetti and his cousins, Tommaso Giuseppe and Daniele.

From 1749 (or 1750) until 1753, Filippo Farsetti was in Rome. It was evidently during this time that he started to collect seriously, purchasing paintings and sculptures and ordering casts of famous antique statues, all of which he hoped to use to establish an art academy in Venice that would promulgate the emerging aesthetics of classicism. Farsetti commissioned the French architect Charles Louis Clérisseau to design the reconstruction of the Palazzo Farsetti into the Academy of Drawing, where students could study the most famous examples of antique art, albeit only in the form of casts. In 1752 Pope Benedict XIV (Prospero Lambertini) gave Farsetti permission to have casts made of the best-known works of antique and contemporary sculpture located in the museums and churches of Rome. Similar copies were being made at the same time for the Accademia Clementina in Bologna. For the training of painters, he purchased in Rome copies of compositions by Raphael and his school, works by Luigi Pozzi, and copies of Titian's *Bacchanalia* and Guido Reni's *Aurora* and *Archangel Gabriel*.

Along with casts of antiques, Filippo Farsetti was also purchasing small copies of famous ancient works. An entire series of such replicas was made by Stefano Maderno, an early-seventeenth-century master who must have attracted the collector's special interest. Three similar copies have been identified as works by Rusconi: the *Apollo Belvedere*, the *Farnese Hercules*, and the *Belvedere Torso* (all three now at the Galleria Giorgio Franchetti, Ca' d'Oro, Venice). This list can be supplemented by lower-quality copies mentioned in earlier inventories without artists' names, which

makes their attribution difficult (e.g., *The Sleeping Hermaphrodite*, the *Farnese Flora*, two replicas of *Marsyas*, and others preserved at the Hermitage).

It was also during this time in Rome that Filippo Farsetti began to buy *bozzetti* and models by Italian Baroque sculptors. Although we have no documents to serve as proof, he most likely purchased these preparatory studies from sculptors' students and heirs. For example, the bust *modello* of Annibale Carracci by Paolo Naldini (cat. no. 24) had formed part of the collection of the painter Carlo Maratti. The splendid *bozzetti* by Alessandro Algardi and Ercole Ferrata probably came from Ferrata's studio itself. It also seems probable that Farsetti purchased a group of works that originated in Camillo Rusconi's workshop. Finally, the rich collection of studies and models by Bernini, apparently assembled by another connoisseur, must have come from one of the master's students or heirs. The best candidate here is perhaps the sculptor Giulio Cartari, whose date of death is unknown.

Finally, judging from old inventories of the Farsetti collection, a significant number of terracottas were attributed to Michelangelo, so that it can be assumed that the collector made conscious efforts to purchase works by the great sculptor. Some of these statuettes are now also at the Hermitage. Among them are copies of Michelangelo's sculptures (such as replicas of the Vatican *Pietà*, *Evening*, and *Day*, the latter two of fairly high quality), including a signed work by Stefano Maderno (*Nicodemus with the Body of Christ*, cat. no. 1) and an allegory of Winter in the form of a herm, undoubtedly created about 1700.

One can surmise that portraits of artists constituted a special part of the collection. In addition to the bust of Annibale Carracci already mentioned, there are portraits of Bernini (for a long time considered a self-portrait, cat. no. 21), Antonio Raggi (a self-portrait?), Pierre Mignard (by Antoine Coysevox), and Gaspare Mola (by Algardi, cat. no. 7), as well as busts depicting Michelangelo, Titian, and Pietro Bembo. The Hermitage portrait of Fra Carlo Lodoli created by Jean Baptiste Boudard in 1744 (as is evident from his signature) definitely belongs to this group as well.[4] Andrea Memmo, in his book published in 1786, mentioned the bust and noted that Filippo Farsetti idolized Lodoli. Farsetti had hoped to have the bust of his mentor executed in marble, but he died before he could make the arrangements.[5]

Abbot Farsetti continued to augment his collection after he returned to Venice. Most of the bronze statuettes are of Venetian origin, many of which were made at Girolamo Campagna's workshop. Others include a marble *Jupiter and Antiope*, signed by Orazio Marinali, and a marble *Portrait of a Man* by a mid-sixteenth-century Venetian master (all these works are currently also at the Hermitage).

At the Palazzo Farsetti, the works Filippo purchased joined a collection of paintings that Anton Francesco Farsetti may have purchased along with the palace in 1670. These included works by Titian, Correggio, Andrea del Sarto, Tintoretto, Bernardo Strozzi, and Luca Giordano, as well as numerous *fiamminghi*, including Albrecht Dürer, Lucas van Leyden, Anthony van Dyck, Adriaen van Ostade, and an artist identified as Peter Paul Rembrandt.[6]

Since there was then no academy building in Venice (and indeed it was never built), collections arriving from Rome were housed at the Palazzo Farsetti. The safekeeping of this art was entrusted to Bonaventura Furlani, an ornamental sculptor from Bologna. The opening of the palace as the "Farsetti Museum" took place on June 13, 1755,[7] and, beginning in the late 1750s, foreigners traveling in Italy began to visit it.

To glorify the museum, Filippo's cousin Tommaso Giuseppe Farsetti invited a famous Latinist of the time, Natale dalle Laste, to compose a long Latin address praising the abbot.[8] In it he presented a program, evidently very near to the views of the museum's founder, on the importance for young artists to study the classical her-

itage—from the masters of antiquity to Bernini, François Duquesnoy, Pierre Legros, Nicolas Poussin, Annibale Carracci, and Guido Reni.

Doors of the Palazzo Farsetti were hospitably open to contemporary artists as well. Arriving in Venice in the late 1760s, the young sculptor Antonio Canova received his initial training at the workshop of Giuseppe Bernardi (nicknamed Torretto) and then worked under Giovanni Ferrari, but he regularly visited the Palazzo Farsetti, where he copied antiques. Canova was greatly impressed by the lessons of the ancient masters. He completed his first works on commission from Senator Giovanni Falier: two marble flower and fruit baskets (now at the Museo Correr in Venice) that were shortly thereafter purchased by Farsetti and installed on the balustrade of the staircase at the Palazzo Farsetti. In 1775, in a sculpture students' competition for the best copy, Canova presented a small-size copy of an antique *Wrestlers* from the Uffizi. It is commonly believed that a full-size cast still in existence at the Accademia in Venice served as the original in this instance, but a small terracotta replica of the same group currently preserved at the Hermitage could have been Canova's source as well.[9]

It is perhaps even more noteworthy that while in Rome, after having left Venice in October 1779, Canova kept returning to the impressions he received at the Palazzo Farsetti. Thus, after visiting the church of Santi Luca e Martina, he remarked in his diary that he had previously seen the model for the *Three Saints* group in the Farsetti collection.[10] There is no doubt that his familiarity with the Farsetti collection, particularly with antique copies, had a great effect on Canova's development as the leading master of Neoclassicism.

Abbot Filippo Farsetti had contacts with representatives of the Russian government in Italy. Marquis Pano Maruzzi (1720–1790), appointed in 1768 to the position of Russian consul in Venice, carried out a series of assignments related to purchasing works of art. In one of his undated letters, evidently written in the late 1760s, he informed the cabinet of Catherine the Great of the difficulty of acquiring ancient marble statues in Italy and mentioned one of "our cavalieri" as one of his advisors: "I consulted one of our cavalieri who is present in Rome, pensioned to study painting and sculpture, of course, the same person who had obtained permission from [Pope] Benedict XIV to make copies of the rarest sculptures in Rome, and he transported the models here to institute an academy of sculpture at his own expense."[11]

There is no doubt that the "cavaliere" whose advice Maruzzi sought was Filippo Farsetti. It was Farsetti who ordered copies of famous antique statues during the time of Pope Benedict XIV, and to him belongs the idea of founding an art academy in Venice. Finally, it appears that Abbot Farsetti was in Rome from 1766 to 1769, and it was possibly during this visit that he purchased not only more copies of antiques but also models and *bozzetti* by masters of the Baroque.[12]

Abbot Filippo Farsetti died in Venice on September 25, 1774, and his estate passed on to his cousin Daniele (1725–1787). It seems that during Daniele's lifetime little changed at the palace on the banks of the Grand Canal; it continued to be visited by artists, tourists, and other lovers of art. The first known inventory of the Farsetti collection is dated 1778, although practically the only information given about most of the works—paintings, busts, statuettes, and reliefs—is their total number. The only pieces described with more detail were casts of antiques (undoubtedly considered at the time to be the main attraction) and a small group of contemporary terracottas.[13]

About ten years later, most likely in 1788, soon after the death of Daniele Farsetti, a small book was issued in Venice with the expressive title *Museo della casa eccellentissima Farsetti in Venezia*. It contained a brief inventory of the collection, including mention of casts after antique and contemporary sculptures, models and *bozzetti* by masters of the Baroque, bronze and marble sculptures, paintings, and

5

drawings. This publication, which in many instances gives the names of artists, is very important for the attribution of sculptures in the Farsetti collection.[14]

In 1782 an event took place that determined the destiny of the Farsetti collection. In the second half of January, Venice hosted the heir to the Russian throne, Grand Prince Pavel Petrovich, and his wife, Maria Fedorovna, who were traveling in Europe incognito under the names of Count and Countess Severni ("of the North"). The Republic of Venice gave them an official reception, culminating in lavish festivities in Saint Mark's Square.

During one of these days—according to a note dated December 5, 1804, written by Count Alexander Stroganov, the president of the Academy of Fine Arts, St. Petersburg—these guests of honor visited the Palazzo Farsetti and viewed "a glorious collection of sculptural works consisting of castings and models of works of artists of antiquity." From the same note, we learn that at that time the proposal was made to transfer (or sell) the collection to St. Petersburg. However, because of the great value of the collection, the Venetian government forbade the sale "under the pretext that in accordance with his [Farsetti's] ancestors' will it must forever remain in the possession of the Farsetti family."[15]

Pavel Petrovich (later Tsar Paul I) and his wife were very interested in art. During their travels in France and Italy, they purchased not only works of contemporary art but ancient sculpture as well.[16] Thus it seems logical that they would be interested in the Farsetti collection. More than a decade later, after becoming the emperor of Russia, Paul did not forget the impressions of his stay in Venice and returned to the issue of acquiring the Farsetti collection.

At the end of the eighteenth century, the collection was owned by Anton Francesco Farsetti, Daniele's son and a passionate botanist. The great amount of money he spent on creating a botanical garden at the family villa at Santa Maria di Sala strained the family's finances, and the fall of the Republic of Venice in 1797 further aggravated the Farsettis' financial problems.

After the fall of the Republic of Venice, talks regarding Russia's acquisition of the Farsetti collection resumed. According to Stroganov, Paul I himself initiated these talks by instructing the Russian ambassador to Constantinople, Vasili Tomara, to contact Anton Francesco Farsetti. Talks with Farsetti seem not to have been very lengthy, since as early as 1799 the collection was divided into two parts and sent to Russia.

Certain sculptures from the Farsetti collection were not sent to Russia, including antique casts that subsequently found their way into the Venetian Academy of Art. In addition, some statuettes and terracotta groups by Maderno, Bernini, and Rusconi remained in Venice while their plaster copies went to Russia.[17] Currently these works are at the Galleria Giorgio Franchetti at Ca' d'Oro, Venice. The first portion of the Farsetti collection, which included 308 crates packed with "twelve plaster statues and one hundred twenty-four molds for statues, busts, and bas-reliefs," was sent via the Black Sea to Nikolaev (now in Ukraine) and arrived in St. Petersburg on March 23, 1800. According to the expert opinion of the Academy of Fine Arts, the molds turned out to be seriously damaged from frequent use, and some were, in addition, incomplete. It was concluded that they "could scarcely be utilized." Unfortunately, the list of this portion of the collection is missing.

The second part of the collection, comprising sixty-three crates with "various rarities sent from the chevalier Farsetti," arrived in St. Petersburg in October 1800. From Venice to the Prussian port of Stettin (now Szczecin, Poland), the crates were transported by land, and from Stettin to St. Petersburg, on board the ship *Minerva*. The packing list of this "second expedition" has survived both in Italian and in a contemporary Russian translation at the State Historical Archive in St. Petersburg.[18] The

Italian text is practically identical to the 1788 inventory, the only difference being that works are grouped by crates as packed. The Russian translation contains blatant errors evidently caused by unfamiliarity with the original works. It was published in 1864 by Petr Petrov, who added a few inaccuracies of his own.[19]

Finally, late in the year 1804, Anton Francesco Farsetti himself arrived in Russia "to evade his creditors."[20] He planned to collect money for the packing and transportation of his collection, which had been officially donated to the Russian court, and he counted on receiving signs of attention from the tsar. But since the transfer of the Farsetti collection, everything in Russia had changed. Paul I, the initiator of the acquisition, had been assassinated. Almost no one remembered the collection, and only with difficulty was it established that it was stored at the Academy of Fine Arts. It took Stroganov's detailed note, dated December 5, 1804, to recapitulate the events and to remind everyone about the Farsetti collection.

Farsetti estimated the expenses for packing and transporting his sculpture at the hefty sum of 18,442 rubles. Stroganov's advice to the court was to pay the money and to allocate "a decent pension" to the donor, a suggestion approved by Tsar Alexander I. The decree, dated January 31, 1805, paid Farsetti the requested amount, and assigned him a lifetime pension of "one thousand *chervonny* per year from the cabinet."

Farsetti also brought with him to Russia a set of drawings that he planned to present to the tsar (these must have been Pozzo's copies after Raphael and other painters). Stroganov examined the drawings and valued them very highly. As a result, Alexander I accepted the gift and awarded Farsetti a diamond ring.[21]

Anton Francesco Farsetti's fate from that point on is not perfectly clear. According to Italian sources, he died in Russia in 1808, but Russian documents indicate that by June 3, 1805, he was no longer in Russia and that the ring presented to him had been given to the ambassador from Naples, Duke Serra Capriola. If Farsetti was indeed hiding from his creditors, a rumor of his relocation and death in Russia would have been very convenient for him, leaving open the possibility of his living incognito anywhere in Europe while receiving a pension from the Russian tsar. This version is indirectly supported by the fact that the name of Farsetti does not appear again in Russian documents until 1817: in January of that year, a request was transmitted through the Maltese ambassador from the sister of Anton Francesco "concerning turning over to her the pension" of her late brother.[22] It is not clear from the document how the matter was resolved, but everything seems to indicate that "maiden Farsetti's" request was denied. One way or another, 1817 is clearly the latest possible date of death for Anton Francesco Farsetti.

Little was done to study the Farsetti collection during its residence of more than one hundred years at the Academy of Fine Arts. The only effort in this direction was the academy's *Index of the Sculpture Museum*, published by Georg Treu in 1871.[23] Treu was a serious scholar of antiquity, not of Baroque sculpture, and he did not disguise his negative attitude toward it. He principally tried to identify the surviving works with the ones mentioned in the Farsetti collection inventory. In Treu's opinion, names of sculptors mentioned in the roster meant only that the figurines were copies of original works by those masters. Thus, for example, *The Ecstasy of Saint Teresa* by Bernini (cat. no 13) was transformed by Treu into an unknown artist's copy of this illustrious work.

Although the Farsetti collection was transferred to the Hermitage in 1919, until recently only a small number of terracottas, representing the most interesting part of the collection, had been researched and published. Even fewer of the terracottas were included in the Hermitage's permanent installations or in temporary exhibitions.

An exhibition of sixty works from the Farsetti collection, entitled "Seventeenth- and Eighteenth-Century Italian Terracottas: Studies and Models by Baroque Masters,"

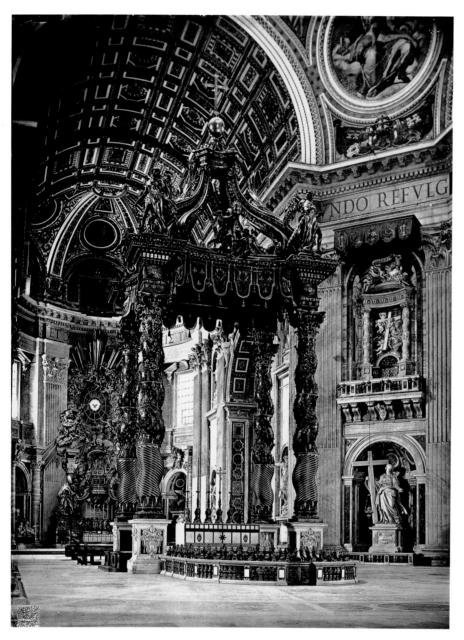

was shown at the Hermitage from 1989 to 1990. It was dedicated to the 225th anniversary of the museum, which was celebrated in 1989. The exhibition catalogue (in Russian) represented the first attempt to study most of the works.[24]

With certain changes (seven works were substituted, mainly for security reasons), the same terracottas were exhibited in Italy in 1991 and 1992. Under the title "Alle origini di Canova," the exhibition was held at the Palazzo Ruspoli in Rome, then at the Galleria Giorgio Franchetti at Ca' d'Oro in Venice.[25] Thus, works removed from Rome as long ago as the mid-seventeenth century temporarily returned to the place where most of them had been created, and then visited Venice, the city for which they were purchased by Abbot Farsetti. It is worthy of special note that at Ca' d'Oro the Hermitage terracottas stood next to statuettes and groups that also once belonged to the Farsetti collection but had been left behind in Venice.

The exhibition presented in the United States differs from its Russian and Italian predecessors mainly in its size and scope. We had no intention of representing the Farsetti collection in its entirety; therefore, some copies after antique sculptures and after Michelangelo's and Bernini's originals were excluded. A series of works of questionable attribution was also not included. In addition, there was no need to represent the entire time frame of the collection of *bozzetti* and models by Italian sculptors. Therefore, we have assembled principally works of the masters of the seventeenth through the beginning of the eighteenth centuries.

The selection emphasizes the creations of the major sculptors of the Baroque: Gian Lorenzo Bernini and Alessandro Algardi, whose four-hundredth birthdays are celebrated in 1998. The former is represented by eleven works, the latter by six. Their followers and students are represented less thoroughly, but each is reflected in works of very high quality, mostly *bozzetti* or models for monumental works.

The earliest works bear the initials of Stefano Maderno. They occupy an isolated spot in the Farsetti collection; not preparatory studies, they are finished works, meticulously crafted and fully detailed. Two groups (*Hercules with the Infant Telephus* [cat. no. 2] and *Laocoön* [cat. no. 3]) are copies of famous antique statues, while the third derives from a composition by Michelangelo (cat. no. 1). Such works were most likely made not as models to be cast in bronze, but as independent pieces. They must

have been purchased by collectors and art lovers for their antique collections and libraries, in a tradition that possibly continued until the middle of the eighteenth century. Abbot Farsetti was certainly among the admirers of Stefano Maderno: eight of eleven currently known fired-clay works by the master come from his collection. Groups by Maderno represent an introduction to the history of Baroque sculpture in Rome.

Alessandro Algardi, Bolognese by birth, belonged to the classicist movement in Roman Baroque sculpture. Among his works at the Hermitage there is not a single "study" in the true sense of the word; they were all completed in a highly finished way. The *Two Saints* group (cat. no. 4) is certainly preparatory to the *Three Holy Martyrs* group, also made of terracotta, for the church of Santi Luca e Martina in Rome. The large dimensions of the Hermitage composition suggest that this is a half-scale model. By the time Algardi made this model, he had already determined the composition of the final piece; only the rendering of the drapery was somewhat changed later. The noble, calm characteristics of Algardi's style express themselves here in free and soft modeling, fluid lines, and the harmonious balance of the composition.

The *Executioner* statuette (cat. no. 5), one of the preparatory models for the monumental *Decapitation of Saint Paul* (Bologna, San Paolo Maggiore), in contrast, is a testament to the sculptor's search for artistic form. The sharp turn of the body and exaggerated length of the left leg convey an almost Mannerist impression, despite the refined and finished treatment of details. Comparison with the monumental statue, however, shows that Algardi later arrived at a more balanced design, giving up excessive experimentation.

The *Titan* statuette (cat. no. 9) is perhaps even more characteristic of Algardi's style; it is evidently a model for casting a bronze firedog adorned with the image of Jupiter. The master skillfully conveyed the complicated pose of a seated man; all details of the figure are interpreted exactly and definitely, but thanks to the sculptor's high level of mastery, they do not slip into hardness.

Three busts in the exhibition can, with greater or lesser degrees of probability, be considered full-size models for transfer to marble. *Portrait of Lelio Frangipane* (cat. no. 6) almost perfectly corresponds to the marble bust at the church of San Marcello al Corso. The idealized, even antiquated look of this portrait may be explained by its being a posthumous depiction.

Algardi created a much more lively and spontaneous image in the portrait of Gaspare Mola (cat. no. 7), a jeweler and medalist whom he seems to have known well and to whom he must have taken a deep liking. Without trying to give his subject an elevated, heroic, or exalted character, Algardi conveyed the image of a calm and friendly person. This portrait was possibly intended for Mola's tomb. The project was not completed, and the bust was never transferred to marble.

Finally, the terracotta bust of the apostle Paul (cat. no. 8) is somewhat smaller than the corresponding marble, now in a private collection, which calls into question its purpose as a full-size model. However, it is our opinion that the soft treatment of its shape and a certain special lightness and refinement in its modeling convincingly testify in favor of Algardi's authorship.

The *bozzetti* by Gian Lorenzo Bernini presented in this exhibition are somewhat different in character. Created over the course of more than fifty years, they naturally reflect not only the evolution of the great master's creative work but changes in his individual style as well. Three extensively damaged statuettes (cat. nos. 10–12), associated with work on his early pieces *Neptune with Triton*, *Abduction of Proserpina*, and *David*, form a complete stylistic group. The treatment of shape is clear and definite,

little different from that in works by Maderno and Algardi. Bernini expressed his characteristic virtuoso technique in the emphasized plasticity and palpability of textures of both the drapery and the nude body.

The group *Tritons Holding Dolphins* (cat. no. 14), a rejected version of the composition for the Piazza Navona fountain in Rome, is resolved in a similar manner. The clarity of treatment of the Tritons' bodies recalls early works by the artist. In comparison with a similar, seriously damaged group from the Staatliche Museen in Berlin, the Hermitage group might even seem somewhat sketchy. Yet one look at the execution of the Tritons' backs is sufficient to dispel all questions of Bernini's authorship: literally, with a few strokes of his modeling tool, the sculptor conveyed the strain caused by a heavy weight supported by lifted hands. One senses the sure hand of a master in the energetic molding of figures, in their tense muscles, and in the intertwining of human and dolphin bodies. The more developed treatment of details here indicates that the sculptor was dealing with issues different from those in the Berlin group, which probably predates the Hermitage terracotta.

Three terracottas from the Farsetti collection—*The Ecstasy of Saint Teresa* (cat. no. 13), *Saint Ambrose* (cat. no. 15; see fig. 1), and *The Blessed Ludovica Albertoni* (cat. no. 20)—may be characterized as works of the mature Bernini. All three vary in details from the monumental statues, but are very meticulously crafted, particularly in the development of the draperies. *The Ecstasy of Saint Teresa* and *The Blessed Ludovica Albertoni* are executed with particular virtuosity. The first has been known for many years to art historians, who treated it with some skepticism, apparently because its published photographs were insufficiently clear. How striking it must be for them to see this work of exceptionally high quality with their own eyes! The amazingly delicate articulation of the cascading folds and a certain exceptional lightness and freshness in working with the clay show that the author could only be the cavaliere himself.

A model for the statue of *The Blessed Ludovica Albertoni* for the church of San Francesco a Ripa is the work most similar to the Saint Teresa group. In it the figure of a supine woman is amazingly dynamic and expressive, an effect achieved principally by the patterns formed by the folds of her garment: they gather together and sneak away, writhing in different directions; then they cling to the body and suddenly form their own independent curlicues and rhythms. Such detailed development of folds does not seem frivolous or artificial; the execution of the figurine is surprisingly fresh and lively.

The small equestrian figure of Constantine the Great (cat. no. 16) is an example of a great sculptor's *bozzetto*, undoubtedly belonging to the initial stage of work on the monumental marble statue erected on the Scala Regia. Everything in it bears traces of creative exploration. The hind legs of the horse are not outlined, and its body seems to emerge directly from the mass of clay. Yet its mane, clarified by quick sculpting movements, is already flying in the wind, and the folds of Constantine's garment run downward just as swiftly and precisely. The *bozzetto* gives the viewer a sense of watching a brilliant master improvise the creation of a study for a monumental statue. This model is perhaps the brightest manifestation of the quality of Bernini's *bozzetti* that Irving Lavin so fittingly termed "calculated spontaneity."[26]

Finally, three statuettes are related to Bernini's work on an ensemble of angels with attributes of the Passion, created for Rome's Ponte Sant'Angelo. Despite their varied degrees of preservation, these studies are of high quality and can be considered to have been made personally by the master. The most virtuoso execution belongs to the small figure of an angel with the Superscription, its head now missing (cat. no. 18), evidently created for the second version of the statue (erected on the bridge). Marks on the back of the statuette would have aided proportional enlargement during its transfer to marble. This second version of the marble *Angel with the Superscription* was

created by Giulio Cartari at Bernini's workshop, but under the guidance and with the participation of the great sculptor.

Finally, the last item in the group of works associated with Bernini is a portrait of the master himself (cat. no. 21). It was long considered to be a self-portrait, but it is more likely that its author was one of Bernini's pupils. The sculptor carefully modeled the thin, energetic face of the old master, depicting every wrinkle and fold of skin. The image he created is evidently very accurate, representing the acute intelligence and deep refinement of the cavaliere who was one of the most outstanding personalities in the history of sculpture.

Masters of the next generation may be divided into two groups: students of Bernini and followers of Algardi. In reality, however, this distinction is quite vague: Bernini inevitably influenced the followers of Algardi, regularly inviting them to participate in the most important sculptural works in Rome; for example, several of Algardi's followers assisted Bernini in adorning the Ponte Sant'Angelo with statues of angels.

The model for the head of the *Angel with the Sponge* belongs to Antonio Giorgetti (cat. no. 27), a master who died young, soon after the completion of the marble figure. The angel's facial type combines Bernini's softness and spirituality with Algardi's suppleness and precision.

Ercole Ferrata, a sculptor very close to Algardi, created the model and statue of *Angel with the Cross* (see cat. no. 22), a much more individualized work. The strong movement, energetic turn of the head, and tense, tangled drapery lines give this model an air of irrationality and expressiveness characteristic of this master's creative personality.

The graceful group of wrestling putti (cat. no. 23) is currently also attributed to Ferrata. While the concept of this and similar groups stems from the art of François Duquesnoy (nicknamed Fiammingo), here the composition seems to be less intricately developed than in the Flemish artist's works.

Melchiorre Caffà, undoubtedly a very promising sculptor, was only twenty-nine when he died from injuries sustained in a foundry accident. It is believed that, while working in the Ferrata studio, Caffà created *bozzetti* for many monumental compositions. The figurine representing the apostle Andrew (cat. no. 29) is probably one of these studies. A somewhat exaggerated theatricality manifests itself in the graceful turn of the head with eyes directed toward heaven; in the gesture of the hands, clasped in prayer and raised unnaturally high; and in the energetic *contrapposto* of the entire figure. These devices became almost standard in the work of early-eighteenth-century masters, but it should be noted how precocious Caffà was in developing an expressive movement of the body.

One of the studies for the monumental *Martyrdom of Saint Eustace*, a lion figurine also attributed to Caffà (cat. no. 28), is much more fresh and spontaneous than the final composition. Not restrained by the requirements of traditional iconography, the sculptor carefully portrayed the characteristics of the figure of the king of beasts: a relatively thin torso, powerful paws with sharp claws, a long tail with its brushy tip resting on the ground, and, finally, the expressive head, with its mane treated in an amazingly picturesque manner. The free-spirited modeling of this sculpture reveals the touch of a great master.

One of Algardi's collaborators, Domenico Guidi may be considered the leading master in Rome during the last years of the seventeenth century, after Bernini's death. *Charity* (cat. no. 25), created in the second half of the 1660s as a study for a monumental group in the cathedral of San Giovanni dei Fiorentini, is typical for the sculptor, who liked complex compositions and enjoyed rendering tangled draperies. But he

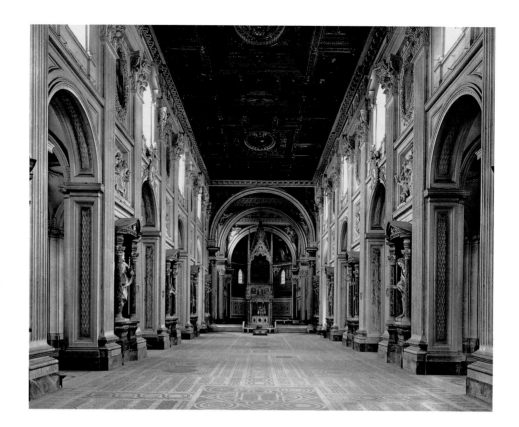

could not escape Bernini's influence; for example, his putto supporting a shield undoubtedly derives from Bernini's small figure of a boy with the attributes of Justice on Pope Urban VIII's tombstone at Saint Peter's cathedral.

Paolo Naldini has occupied a place in art history mainly by virtue of his meticulous execution of Bernini's ideas (among other projects, he worked on the second version of the statue of the *Angel with the Crown of Thorns* for the Ponte Sant'Angelo [cat. no. 19]). He is also the author of a series of portraits in marble. The model for the bust of Annibale Carracci (cat. no. 24; the marble was first placed on Carracci's grave in the Pantheon and is currently in the Protomoteca Capitolina at the Palazzo Senatorio in Rome) testifies to Naldini's extraordinary talent. It not only is a good portrait likeness, apparently based on renderings made during the subject's lifetime, but it also creates a convincing image of the creative artist.

Giuseppe Mazzuoli, Bernini's collaborator in his late period, continued the master's activities during the first quarter of the eighteenth century. His surface treatment is so lively and his compositions are built with such skill that his group *Charity Treading on Avarice* (a study for a bronze casting; see cat. no. 30) is in no way inferior to Bernini's own creations. (It is no accident that it was listed in the Farsetti collection inventories under Bernini's name.) Only a certain decorative quality and attempts at surface effects typical of Mazzuoli permit one to date the group to the beginning of the eighteenth century. It certainly forecasts the Rococo direction in Italian sculpture.

Filippo Parodi of Genoa is the only sculptor represented in this exhibition who did not work in Rome, yet his activities developed in the same direction as those of artists in the Eternal City. His *Putto with a Skull* (cat. no. 26), a preparatory study for the putto figure in the pedestal of the *Saint Francis of Assisi* statue in the Capella del Tesoro of Padua's basilica of Sant'Antonio, is distinguished by its meticulously precise treatment of sculpted form. In the completed version, the boy's resilient, strong body became much puffier and softer, typical of Parodi's marble works in general.

Finally, the last group of works is associated with the names of four leading sculptors working in Rome at the beginning of the eighteenth century. None of them was Roman by birth: Camillo Rusconi came from Milan, Angelo de' Rossi from Genoa, and both Pierre Legros and Pierre Etienne Monnot came from France. One can

nevertheless say that their styles were similar since they combined traditions of Bernini and Algardi to create the new "grand manner."

The Apostle James the Less by Angelo de' Rossi (cat. no. 35) is a model for a monumental statue for the basilica of San Giovanni in Laterano (fig. 2), part of a series of twelve apostles commissioned from the most illustrious sculptors of Rome. While the marble figure is somewhat ordinary, this terracotta from the Hermitage is infused with amazing freshness and spirituality, testifying to the master's extraordinary gift.

The statue of a saint in clerical garb with his right arm raised (cat. no. 34) is even more impressive. It is most likely a preparatory model for Pierre Legros's statue of Saint Francis Xavier for the church of Sant'Apollinare in Rome (whose composition it mirrors). Although not distinguished by its size or originality of concept, Legros's statue is very attractive, primarily due to its particularly expressive details, from the saint's face to the bronze crab on its base. We find the same atmosphere of elevated emotion in the Hermitage terracotta, extremely simple yet very graceful.

The statuette depicting Cybele (cat. no. 31) can be attributed to Legros's compatriot Pierre Etienne Monnot. It was most likely conceived as a model for a park or garden statue. With no particular attempts at originality, the sculptor created a model for a decorative sculpture that the viewer could walk around and carefully examine. Therefore, the solution is monumental, yet all shapes are carefully developed and finished.

Like the three sculptors described above, Camillo Rusconi also worked on the cycle of apostle statues for the basilica of San Giovanni in Laterano. His leading position among Roman sculptors was evidently confirmed by the commission of a total of four statues (the Apostles Andrew, John, Matthew, and James the Greater). Executed following Carlo Maratti's sketches, they have a classical character. The two Rusconi statuettes in this exhibition, however, are sculpted in a somewhat different manner. *Allegory of Winter* (cat. no. 32) is a model for a marble statuette in the series of Four Seasons (currently in the Royal Collection at Windsor). The graceful marble figurines resemble porcelain miniatures, and their decorative character comes across even more strongly in the terracotta from the Hermitage, which is half the size of the final version.

Finally, an extensively damaged statuette of a horseman (cat. no. 33) is an important testament to Russian-Italian artistic ties during the first quarter of the eighteenth century. It seems possible to identify the figurine as a sketch for an equestrian monument to Peter the Great, which Rusconi developed from 1719 to 1720 at the request of the architect Nicola Michetti, who was invited to work in Russia from 1718 to 1723. The Roman sculptor followed a tradition that was popular at the turn of the eighteenth century and dated back to Leonardo da Vinci: he presented the tsar on a prancing steed treading on a fallen enemy (most likely a Turk). Two statuettes of clay and wax entitled *Triumph of His Imperial Majesty* were sent from Rome to St. Petersburg. They apparently did not impress the Russian tsar, because he seems to have preferred a more classical type of monument with a calmly walking horse. Whatever the case, another composition of this nature was developed in St. Petersburg by the Florentine Bartolomeo Carlo Rastrelli, and a mounted bronze statue based on it was later cast. One can assume that Rusconi's two statuettes that arrived in St. Petersburg in 1719 were eventually destroyed. Thus, it was a stroke of fortune that another version of the statuette *Peter the Great on Horseback*, evidently purchased by Abbot Farsetti along with the rest of the works stored at the Rusconi workshop, went to Russia in 1800 as a part of the Farsetti collection. The terracotta under consideration not only testifies to a most interesting artistic idea, but it also establishes a continuity between the sculptural interests of two Russian tsars: Peter the Great, under whom purchases of Italian sculpture began; and Paul I, a worthy successor to his great-grandfather's art patronage, and during whose reign the Farsetti collection was acquired.

Surveying the History
of Collecting
Italian Sculptural Models

DEAN WALKER

THE TERRACOTTAS SELECTED FOR THIS EXHIBITION formed part of the collection assembled by the Venetian Abbot Filippo Vincenzo Farsetti in the mid-eighteenth century, whose history is recounted by Sergei Androsov elsewhere in this catalogue. Open to the public as a private museum during the second half of the 1700s, the collection was visited by many travelers, including the future Tsar Paul 1, who later initiated plans that led to the Russian acquisition of Farsetti's almost two hundred terracotta models. In our time, terracottas like these tend to be a specialized taste, prized primarily by museum curators and scholars. These sculptures are not represented in great numbers in American museums, and the same is true for many European institutions. To find these fragile statuettes included in depth in the Farsetti collection at an early moment in the history of museums is remarkable, an occurrence that raises questions about the appreciation, preservation, and display of sculptors' models. This essay explores the historical background of the ownership of terracottas in an attempt to discern patterns that may help explain the presence of these sculptures in various kinds of collections, including Farsetti's pioneering institutional setting.[1]

THE SIXTEENTH CENTURY

In Italian art, sculptural models surviving from before 1600 are rare, although many must have been made. Published references to such works in archival sources are also, as yet, relatively few and fragmentary. Nevertheless, the information we have reveals various circumstances under which terracotta or wax models were preserved from the 1470s onward.

Terracotta or wax models may have been saved for several reasons, but an essential factor for their survival was the sculptor's own use of and attitude toward his models. Potentially part of the artist's creative capital, they could function as points of reference throughout his career or as objects to be reproduced for sale. For many Renaissance artists, we have no basis to discuss this fundamental issue. Benedetto da Maiano is one sculptor from the late quattrocento who left evidence of his use of models: he retained preparatory works, which were mentioned in the inventory of his studio made after his death, and some of his terracotta models survive.[2] The inventory from 1498 lists pieces that relate to specific Florentine commissions like the Santa Croce pulpit, as well as objects perhaps of a more general usefulness, like a relief and statuette of the Virgin, various heads, and a section of a decorated frieze.

Especially instructive for the study of sixteenth-century models are the diametrically opposed attitudes toward them of Michelangelo and Giambologna, the sculptors who dominated the later 1500s. Michelangelo destroyed most of his preparatory models and many of his drawings. (The approved model for the colossal marble *David* was no more than a small wax.) Some artists responded to his actions by creating small-scale copies of the master's works. It has long been known, for example, that a version of *Samson and Two Philistines*—based on a model by Michelangelo—reached Venice, where it was drawn a number of times by Tintoretto.[3] The many bronze versions of this group also attest to interest in this composition.[4] One of the sculptors

employed by Michelangelo for the Medici Chapel, Niccolò Tribolo is credited with making terracotta statuettes after Michelangelo's figures, three of which are preserved in Italian museum collections.[5] Over the centuries, pieces derived from Michelangelo's works have clouded our understanding of how the sculptor himself used preparatory models. There was a time when almost any sixteenth-century model would be optimistically attributed to him.

In contrast to Michelangelo, Giambologna retained many of his preparatory studies. An inventory of his house in the Borgo Pinti mentions that in the studio sixteen stucco models were displayed individually on wall brackets, and wax models were placed on two shelves, while in the study, models sat on a shelf that ran around the walls of the room.[6] For Giambologna, highly finished small models were essential to the production of his bronze statuettes that were in demand throughout Europe. However, his surviving models include pieces in a range of styles, sizes, and purposes, a number of which would not have been useful or suitable for reproduction. The sculptor's models must have been numerous enough that he could dispense with some, and he must have been willing to part with them since a sizable number found their way into other hands by the 1580s, at the climax of his career.

In recent years we have come to realize that some models functioned within the legal processes that governed sculptural commissions. Benedetto da Maiano submitted highly finished models for the Santa Croce pulpit, four of which survive. Gary Radke has written that by no means were all models of this size or detail, and that a number of the artist's sculptural commissions were based on smaller, less-finished models or on drawings.[7] Presentation models were made less for the use of sculptors than for the patrons whose property the models were. Sometimes these models were retained for a long time, such as Andrea Verrocchio's 1477 models for the altar of the Florentine baptistry of San Giovanni, which were still to be seen in 1568 at the church's office of works.[8] Radke has also commented that the wording of contracts often indicated that changes, improvements, or elaboration from the models were expected by patrons, so that many models might well be made as the sculptor worked toward a final design. Benedetto's terracotta models for the reliefs for the Santa Croce pulpit, now in the Victoria and Albert Museum, London, have gilded highlights and details. Radke has hypothesized, reasonably, that the decoration may have been added later, when the reliefs could have been employed for devotional use, a function that would account for their preservation.[9]

Two large, full-scale models in whitewashed clay by Giambologna have come down to us from the sixteenth century.[10] *Florence Triumphant over Pisa* was shown for years in the intended location of the finished marble, the Sala dei Cinquecento in the Palazzo della Signoria in Florence, and can be seen there again today. Also preserved is the model for the three-figure group *Rape of a Sabine Woman*. Both of these sculptures initially served Giambologna's patrons to see the design on the intended final scale and try it out in the proposed location. The sculptor's assistants then used them to execute much of the actual marble carving. The history of the ownership and display of these

models is incomplete at present. After being displaced by the finished marble, the *Florence Triumphant* model was seen at one time in the courtyard of Giambologna's studio, and *Rape of a Sabine Woman* is recorded as being displayed in 1687 in the grand ducal studio in the Borgo Pinti.[11] Both were eventually transferred to the Florentine Academy. Michelangelo's powerful, large model for a reclining river god—made of wood, unbaked clay, and wool—was certainly the property of the Medici family, who commissioned the decoration of the family chapel in San Lorenzo, where the finished figure was intended to be placed.[12] Another, similiar model has been lost. The very small number of surviving large or full-scale models proves that their preservation was always exceptional.

When thinking abstractly about the activity of collecting, we might assume that large groups of objects were involved. However, sixteenth-century documents often refer to sculptural models singly or in small numbers. Sometimes these models were distinct from the sculptor's own projects, like those commissioned by painters who ordered figures or reliefs to help with their work. Such were the models that Jacopo Sansovino provided for Luca Signorelli, Andrea del Sarto, and Pietro Perugino.[13] Beyond their intended use, these works must have been recognized as desirable, since the *Deposition* relief (said by Vasari to have been made for Perugino, now in London at the Victoria and Albert Museum) was acquired by the collector Giovanni Gaddi later in the sixteenth century. Anatomical models were also collected by artists. The sculptor Ridolfo Sirigatti had an exceptionally large collection of "thousands" of models of heads, arms, legs, torsos, and other parts of sculptures.[14]

A number of documents refer to the ownership of sculptors' models by the artists' close associates, friends, and patrons. Michelangelo gave fellow artist Leone Leoni a wax statuette of Hercules and Antaeus in thanks for Leoni's modeling a medallic portrait, a noteworthy act given Michelangelo's attitude toward his models.[15] Owners of models made by Sansovino included his friend Marco Mantova Benavides and the connoisseur Bindo Altoviti.[16] However, it was not until the late sixteenth century, from the circle of Giambologna, that we have some substantial information about the fortunes of a sculptor's models, including their appeal to collectors.

Throughout his life Giambologna was allowed to function independently of grand ducal authority, although at the end of his career, his workshop and foundry were Medicean property. Nonetheless, he retained ownership of his wax models, which were essential to the production of bronze statuettes. He bequeathed these waxes to his nephew, and they were inherited, in turn, by the sculptor's longtime assistant, Pietro Tacca.[17] In 1617 Grand Duke Cosimo II de'Medici followed Tacca's recommendation to purchase the models. (Scholars think that Giambologna had probably given other models to his assistants Antonio Susini and Pietro Francavilla). The Medicean rulers' attitudes toward models, however, cannot be discussed in much detail at present. Cosimo I is known to have given Michelangelo's superb *River God* to the sculptor Bartolomeo Ammanati, who turned it over to the Florentine Academy in 1583. The same ruler had, according to his inventory of 1553, a cupboard full of "anticaglia di bronzo o di terra" (curiosities of bronze or clay) whose contents, alas, are not further described.[18] Whether the Medici collected and displayed sculptural models related to their commissions is a tantalizing topic that awaits further archival research.

That one devotee of Giambologna's models existed is beyond question. This was Bernardo Vecchietti, one of the sculptor's oldest patrons, who persuaded the Flemish-born sculptor to remain in Florence and introduced the artist to Francesco, the future grand duke of Tuscany. Vecchietti's country house, Il Riposo, contained many models by contemporary sculptors, according to the description written by Raffaello Borghini in

1584.[19] From Giambologna's hand were models in wax, clay, and bronze, of prisoners, ladies, gods, rivers, and famous men. One room on the ground floor was completely lined with these models, which were combined with statues, paintings, and drawings by other masters. Charles Avery has reproduced the *Allegory of Sight* by Jan Bruegel the Younger as giving an idea of what this room looked like (fig. 1).[20] Another room contained a cabinet with five shelves in which marble statuettes, bronzes, and clay and wax models are said to have been logically arranged without, sadly, an explanation of what that logic was.

Bernardo di Mona Mattea, a grand ducal mason who was associated with Giambologna on architectural projects, collected on a more modest scale than did Vecchietti.[21] He is known to have owned a number of the sculptor's models, although it is not clear yet whether these works were related to projects on which they collaborated or if Bernardo had sought out other pieces.

Though the interest in such models appears to have been limited, other collectors are known to have existed in Florence. In the 1568 edition of *Lives of the Artists*, Vasari mentioned in his entry on Jacopo Sansovino that the model of a wax relief by the sculptor (which had previously belonged to Perugino) was to be seen in the house of Giovanni Gaddi, "along with other things of this kind and models with various imaginative themes."[22] In addition, Benedetto Gondi, the executor of Giambologna's estate, probably added works by the Flemish-born sculptor to his already existing family collection. Although it names many more paintings and drawings than sculptures, Gondi's will lists eighteen pieces by Giambologna—bronze statuettes, models (three stuccos, two waxes, and two clay figures), and a few antiquities—two pieces by Donatello, and two stucco reliefs by Antonio Pollaiuolo.[23] In most of these collections, the wax or clay models by Giambologna were part of a group of objects in various materials, which included finished pieces. Vecchietti's cabinet, with its spectrum of small sculptures of different materials and perhaps varying degrees of finish, sounds like an arrangement intended for a connoisseur's pleasure, related to the delights of the *studiolo* (study) or *Kunstkammer* (collector's cabinet) that featured precious art objects or curiosities of nature, a taste also shown, perhaps, in the smaller groups owned by Gaddi and Gondi.[24] In terms of the number of pieces displayed at his villa, Vecchietti demonstrated his relationship to the artist as patron and even as champion.

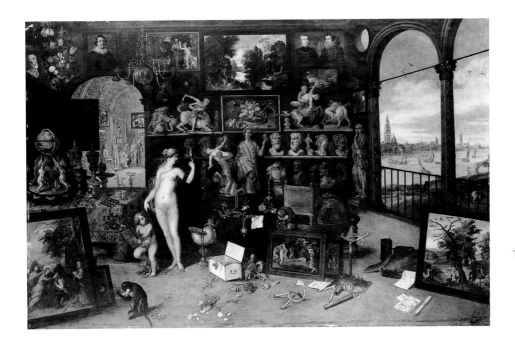

FIG. 1
Jan Bruegel the Younger,
Allegory of Sight (Venus and Cupid in a Picture Gallery),
c. 1660. Oil on copper.
Philadelphia Museum of Art,
The John G. Johnson Collection
(Johnson cat. no. 656).

Although not numerous, these references describe various ways in which models were preserved in the second half of the sixteenth century. Most often the pieces were owned in small numbers, but significant large holdings could have existed, notably in a sculptor's own studio. The owners of models were, aside from the sculptors themselves, associates of the artist, chosen students and assistants, and favored patrons and rulers— overall probably a small, local circle. Unlike the bronzes that were popular throughout Europe, Giambologna's models on which they were based were not exported outside his adopted city. The models served many uses in sculptors' studios, were included in a few private collections, or, rarely, found a home in an academy where art was encouraged through discussion and instruction. We should remember, too, the importance of owners in preserving the fragile objects. Existing Giambologna models (see fig. 2) have provenances traced to the Medici and Vecchietti. Indeed, Giambologna's models were long retained in the grand ducal collection and by the heirs of Vecchietti, to be discovered by another generation of collectors over a century and a half later.[25]

THE SEVENTEENTH CENTURY

In the seventeenth century, it was in Rome that an explosion of art patronage took place that benefited many sculptors, leading eventually to the creation of a host of monuments that still define the city for visitors. Many more sculptural models survive from the 1600s than from previous centuries, and there is more information about them. However, it is undeniable that the collecting of sculptural models remained an unusual interest throughout most of the century. Giovanni Pietro Bellori's *Nota delli musei*, a guidebook to art in Rome published in 1664, mentions the presence of only two collections with terracottas, those of Cardinal Giacomo Franzone and the sculptor Ercole Ferrata.[26]

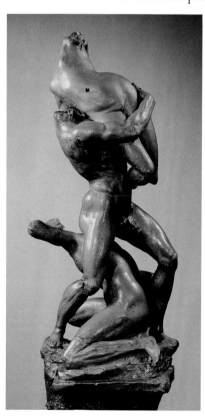

FIG. 2
Giambologna, model for *Rape of a Sabine Woman*, c. 1580. Wax. London, Victoria and Albert Museum, no. 1092-1854 [photo: © The Board of Trustees of the Victoria and Albert Museum].

Figuring prominently in both collections were models by Alessandro Algardi, who died prematurely in 1654, the Baroque sculptor about whom we are currently most completely informed through the monograph by Jennifer Montagu.[27] A number of circumstances involving Algardi's terracottas repeat those from our discussion of Giambologna's models and their admirers. Algardi preserved many of his own studies, for there were practical reasons for him to do so. Unlike Gian Lorenzo Bernini, who enjoyed an almost unbroken series of large-scale projects, Algardi had to work a decade until he received such prestigious commissions. Throughout his life Algardi made designs and small-scale models to be cast in bronze and silver. Indeed, Montagu sees in them the most direct expression of the artist's temperament and natural talent. As with Giambologna, then, some models represented for Algardi a potential source of income rather than always serving to develop ideas for large-scale works. It is also clear that, in achieving his monumental commissions, Algardi progressed through a gradual process in which a series of terracotta studies was often the means of adjusting and refining his ideas.

In his will, Algardi divided his studio among his four assistants. The beneficiaries were Ercole Ferrata and Domenico Guidi, leading Roman sculptors of the late seventeenth century; Paolo Carnieri, best known as a founder; and Girolamo Lucenti, a medalist who also worked under Bernini. No detailed inventory of Algardi's studio has been discovered, but Ferrata's portion, to

18

judge from an inventory made in 1686 after his death, included over ninety models by Algardi.[28] If this was a quarter of the studio, we have some idea of the sizable contents preserved by Algardi at the time of his death. For his heirs the terracotta or wax models could be valuable as objects from which casts could be made, and were therefore potentially commercial properties and a source of income. Algardi probably intended the pieces to be so used, and the number of existing bronze casts indicates that some models were reproduced for decades after Algardi's death.

Apart from the gifts to his assistants, Algardi made a few specific bequests of models in his will. One model for the well-known group of the *Baptism of Christ* went to his executor, Cristoforo Segni; a *Saint Michael and the Devil* was left to Abbate Pepoli in Algardi's native Bologna; and to Don Juan da Córdoba, the Spanish agent in Rome, he gave models of the firedogs with figures of Jupiter and Juno, bronze casts of which had been ordered for the king of Spain.

During Algardi's lifetime, the ownership of models by patrons was stipulated in some contracts. Virgilio Spada, who supervised his family's commission for the altar with the marble *Decapitation of Saint Paul* (see cat. no. 5) and its gilt bronze relief, retained the right to the models. He must have especially admired Algardi's work, for it was he who prevailed on Pope Alexander VII to give the large, full-scale stucco models of two reliefs, *Miracle of Saint Agnes* and *The Encounter of Saint Leo the Great and Attila*, to the Oratorio dei Filippini in 1659. Previously, the original patron, Pope Innocent X, had ceded his ownership of the *Saint Agnes* relief to the workshop of Saint Peter's.

Aside from Algardi's heirs, other artists acquired models by him in small numbers. They included the painters Ciro Ferri, Giovanni Francesco Grimaldi, Carlo Maratti, and the architect Elpidio Benedetti, who had procured an unaccepted invitation for Algardi to go to France. Prominent Romans owned models also, but so far as we know, not in great numbers. Cardinal Flavio Chigi, a collector who owned a group of terracottas, acquired a superb version of Algardi's *Baptism of Christ*. A model by Algardi also reached Cosimo III in Florence, albeit as a gift from Ferrata. One pair of terracottas became especially worthy of note: the full-size firedog models with figures of Jupiter and Juno mentioned above were either given to or bought by Cardinal Antonio Barberini by 1671, and were left by him to his brother Cardinal Francesco Barberini. The latter kept them in the Palazzo Barberini alle Quattro Fontane, where they were displayed, given a high evaluation, and written about by the Swedish architect-connoisseur Nicodemus Tessin the Younger, who was in Rome in 1688. These were impressive compositions, wax casts of which are mentioned by Giovanni Battista Passeri, and bronze casts of which were to be found in France, England, and Spain by the eighteenth century (fig. 3).[29]

The greatest admirers of Algardi's models, however, were not Romans but members of the aristocratic Franzone family of Genoa, who decorated a chapel acquired in 1677 with a *Crucifixion* by Algardi and bronze busts of saints based on the sculptor's models.[30] While living in Rome, the brother Cardinals Giacomo and Agostino acquired a number of Algardi's works, which were eventually transferred to the family palace in Genoa. Pieces they owned included marble busts, reliefs and figural groups, some bronze casts, and unique terracotta models. Jennifer Montagu has written that this enthusiasm for models was remarkable for the period and is truly surprising to find in Genoa. The high esteem of earlier generations must have diminished, however, since Federigo Alizeri described clay reliefs as lying on the floor of the family's palace in 1875.

Gian Lorenzo Bernini has rightly been called the "presiding genius" of the Roman Baroque, and he above all other sculptors has been associated with terracotta sketch models.[31] However, we are currently less well informed about the history and appreciation of his terracotta models than we are about Algardi's preparatory studies. This lack

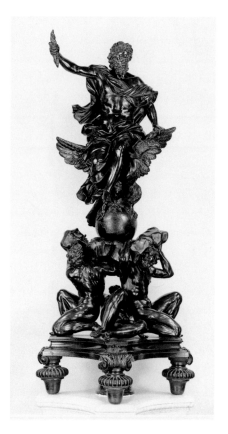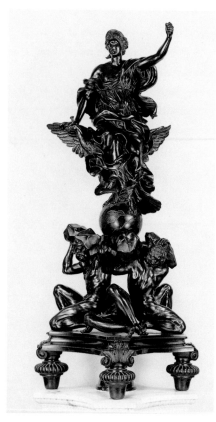

of information is greatly magnified by the length of Bernini's career, the complicated nature and unprecedented range of projects for which he was responsible, and his direction of numerous assistants. Bernini modeled clay with an unrivaled assurance, and he used multiple studies along with drawings in developing his sculptures. Most modern writers repeat Joachim von Sandrart's comment in his diary of having seen twenty-two studies for the figure of Saint Longinus, doubtless the best-known contemporary statement about Bernini's production of preparatory models. Sometimes, Bernini's students made statues directly from his small studies, by enlarging the compositions to full-scale models, and finally carved or cast the figures. For example, full-scale plaster figures were made for the over-life-size kneeling angels for the altar of the Cappella del Santissimo Sacramento at Saint Peter's, after Bernini had experimented with a number of small studies in terracotta. Two of the large plaster angels still remain at the basilica. However, we have come to know, also, that Bernini could prepare his works and participate in their execution in a variety of ways, and some of his projects have complicated histories.

Scholarship on the collecting of Bernini's clay studies is at an early stage for several reasons. No comprehensive catalogue raisonné of his works that includes collection history has yet been published. The absence of revealing archival information is also a fundamental problem. Bernini was, arguably, the most famous artist in Europe for half his life. A person like Queen Christina of Sweden, who could not afford his statues, collected a number of his drawings instead. What was the attitude of collectors toward his terracottas? The evidence for their significance and value is currently incomplete and contradictory. The terracottas may have been less appreciated in Bernini's time than in ours due to the few references to them in the contemporary writings of Filippo Baldinucci and Paul Fréart de Chantelou, a contrast to their comments about the sculptor's drawings. Nevertheless, there is the intriguing statement of Bernini's son Domenico that a family servant stole models from the studio for over twenty years to get extra money to support his family.[32] Are we to conclude that the supply of models was so great that such pieces were not missed and that this reflects Bernini's own attitude toward his models? Does this account support the idea that collectors existed who wanted to acquire the

terracottas? An interesting related hypothesis, as yet unproven, is Charles Avery's claim that Bernini made terracottas to satisfy the demands of collectors, and not only as preliminary studies.[33]

Unfortunately, we know little about the contents of Bernini's studio or how his works were treated after his death, in 1680. The most instructive evidence comes from an inventory of the family house made in 1706.[34] This document records that Bernini's assistant Giulio Cartari had been allowed to take for himself terracotta models, characterized as things of "poco relievo" (little value). According to the inventory, heads in gesso, parts of bodies, and clay models, having been moved around for twenty-five years, were broken and shattered ("rotti e spezzati"). Nevertheless, in 1706, a "quantity" of terracotta models by Bernini was recorded as still being in the palace attic.[35]

The models known today date mainly from the end of Bernini's career, and a number belong to the series of angels bearing the instruments of Christ's Passion for the Ponte Sant'Angelo (cat. nos. 17–19) and the Cappella del Santissimo Sacramento.[36] Is this due to the hazard of survival? Or were works from the end of Bernini's career, when he was most famous, those that were the most prized? That many of them belong to a particular project lends support to Sandrart's observation that Bernini made multiple studies while perfecting his ideas, and provides evidence that such models for a project may have been kept together in groups.

In the 1706 inventory, a few models appear in the description of the reception rooms of the house. In the dining room, there was a clay head of Goliath in a niche over the door. In the adjacent *anticamera* were gilded terracotta busts of Pope Urban VIII and Cardinal Borghese. Farther on, a clay model of Richelieu is mentioned, as well as a gilded terracotta model of the Triton fountain in Piazza Barberini. The three models of busts are particularly interesting evidence that in portraiture Bernini sometimes made use of full-scale models, a type of terracotta of which no example survives.[37] In general, the decor functioned autobiographically as a suite of galleries representing Bernini's patrons and the works they commissioned from him. In private spaces a few works are noted: in a bedroom were two clay reliefs of putti and a papier-mâché relief of "una Beata."[38] We may well question what became of the models retained by the family and wonder about the actual condition of those consigned to the attic. The incomplete Cleveland terracotta of the head of Proserpina (see Wardropper, fig. 11)—a fragment from one of Bernini's early commissions that preserves what is now a rare type of finished model portraying an extreme expression—remained at the residence as late as 1839.[39]

By the late 1660s, well within Bernini's lifetime, one prominent collector had assembled a group of the artist's models as part of a collection of twenty-five terracottas. This was Cardinal Flavio Chigi, who supervised some of the commissions that his uncle Pope Alexander VII had ordered from Bernini.[40] In time, Chigi installed his models in a lavish residence called the Casino alle Quattro Fontane, then on the outskirts of Rome. Famous for its garden, it also housed a personal museum devoted to Chigi's interests— natural rarities, ancient bronzes, Etruscan vases, early Christian objects, medals, waxes, Renaissance maiolica, and small paintings of landscape and genre scenes—which Olga Raggio has characterized as a variation of a German *Kunstkammer*. The complete list of his terracottas remains unpublished, but they included works by Bernini, which were related to several Chigi projects that dominated the artist's late career. However, we do not yet know the circumstances under which the cardinal acquired them. The models were rendered more precious in appearance with silvered, gilded, or bronzed surfaces, a not uncommon practice.[41] Within Chigi's museum the models represented only one side of Bernini's genius. More numerous were caricatural drawings, highly finished wash drawings for architectural projects and religious subjects, and even paintings. Inventoried in 1692, at the time of the cardinal's death, the terracottas remained in the

Casino until 1745. Then the collection was divided, and the eleven terracottas, now preserved at the Vatican Museums, were moved to the Palazzo Chigi in Piazza Colonna and kept in the library along with bound volumes of Bernini's drawings.

The fact that a group of models was obtained by a member of a family known for patronizing Bernini fits a pattern we have seen with Giambologna and Algardi. Nevertheless, we might expect to find more of Bernini's models in prominent collections. One work, a small version of the Fontana alle Quattro Fontane in Piazza Navona, belonged to Don Gasparo de Haro y Guzmán, ambassador from Spain to Rome in 1677, who considered the model one of the finest things in his collection.[42] A complete model of the fountain, in a Roman private collection, was published by A. E. Brinckmann and illustrated in his fundamental study of terracottas.[43] Were other models also prominently featured? One such piece appears in the published inventories of the Barberini family, the most important patrons of Bernini's early middle years. This was a model for an elephant supporting an obelisk, a project not completed for the family.[44] The sculpture now stands in the center of the Galleria Corsini in Florence, but to date we do not know where it was kept in Rome in the seventeenth century. Bernini was allowed to retain for himself the Triton model and bust of Pope Urban VIII—other Barberini commissions—since, according to the 1706 inventory, they remained in the sculptor's house long after his death.

Were Bernini models not more numerous because they had been destroyed? Or were the holdings of Cartari, the Bernini family, or other yet undiscovered owners larger, and kept for longer, than we now know? Ercole Ferrata, who had easily the richest and largest collection of models in late-seventeenth-century Rome and who had worked with Bernini, owned very few works possibly by him: a model in wax, a small figure in gesso, and a clay *modello*—unattributed to Bernini in the inventory—of the elephant model for the monument that Ferrata executed in the piazza of Santa Maria sopra Minerva. Because so many of Bernini's surviving models are known to have reappeared in Rome in the mid-eighteenth century, it is logical to think that they remained in the city in collections not yet identified.

The refined and particular taste of a papal nephew and cardinal contrast considerably with the studio of the active sculptor Ercole Ferrata, where—aside from models by Bernini—the largest collection of terracottas was to be seen.[45] Ferrata not only conserved his own works, over sixty of which are mentioned in the 1686 inventory, made after his death, but he also actively acquired models by other sculptors. The inventory does not always give attributions, even for pieces that can now be recognized by scholars. But among the artists' names that do appear are Michelangelo and a group of Ferrata's pupils—Francesco Aprile, Giuliano Finelli, Giovanni Battista Foggini, and Giovanni Paolo Schor. After Algardi, in terms of numbers of works represented, are those of two sculptors who died at a young age, François Duquesnoy (d. 1643) and Melchiorre Caffà (d. 1667), evidence that Ferrata was successful in acquiring portions of each studio.

Ferrata's inventory clearly describes spaces intended to serve primarily for the production of sculpture. The list reveals the crowded, functional decor, mentioning, in addition to models, sketches, casts, copies, molds, and pieces of full-scale models, bound series of prints after paintings and folios of sculptors' drawings. Sculptural models by most masters were to be found in many of the rooms that made up the studio. Groups of studies of heads were also placed in various rooms along with those of hands and other body parts, a disposition probably dictated by a practical concern for easy accessibility. Here and there, we sense a meaningful arrangement, as in the modeling room, where works attributed to or after Michelangelo were displayed along the mantelpiece in a place of honor. In another room that housed many works in relief, large

models for reliefs by Algardi and Ferrata were placed alongside the elephant model for the monument in front of Santa Maria sopra Minerva. The modeling room also had a rich selection of models for relief sculptures. The sheer number of models is clearest from another studio in which stood three bookcases with five shelves, each lined with models; still more pieces rested on the floor. Such crowded shelves are to be seen in the background of a sculptor's studio represented in a print by Abraham Bosse from 1642 (fig. 4),[46] but Ferrata's premises were bigger, with many times the number of objects visible in the engraving.

The size of Ferrata's collection was unprecedented, and his intentions about its disposition after his death especially noteworthy. From Montagu's research, we know that Ferrata instructed his executor to divide the collection between assistants in his studio at the time of his death; the Accademia di San Luca, the center of artistic discourse in Rome of which many artists were members; and the academy founded by Cardinal Federico Borromeo in the Biblioteca Ambrosiana in Milan, the city closest to Ferrata's birthplace.[47] This plan marks an important transition. The bequest contained all the studio properties of the sculptor, as well as the rich collection of models that included work by many artists. Indeed, it constituted a retrospective of Roman styles with an emphasis on pieces by Algardi and Duquesnoy, without whose works Ferrata's own art is inconceivable. In traditional fashion, just as he had been remembered by Algardi, Ferrata bequeathed certain models to some of his associates. However, his plan of naming as beneficiaries two academic institutions that instructed young sculptors shows a concern for the preservation of and accessibility to the collection beyond the immediate future and the limitations of ownership by individual artists. In the future other collectors would come to similar conclusions. The intention to institutionalize the collection is an interesting decision, given Ferrata's role as head of an informal school for much of his career. Montagu has uncovered some of his students' activities. For example, while in Ferrata's studio, the obscure Milanese sculptor Giuseppe Rusnati drew from the terracottas and is said to have made excellent copies of them as well.[48] Ferrata also set the young Camillo Rusconi to making models after the heads of sculptures by Bernini and Algardi.[49] Ferrata must have been a gifted teacher to have attracted the sculptors who came to him. As early as the 1660s, Caffà worked with him, and numerous important sculptors active in the early eighteenth century, including Rusconi and Massimiliano Soldani, were partially formed by Ferrata. The presence of so many terracottas close at hand must have played various roles in the visual education of these artists for whom the legacy of mid-seventeenth-century styles provided lifelong artistic nourishment. What occurred to thwart Ferrata's bequest we do not yet know, nor are we informed as to how the collection was finally divided.

THE EIGHTEENTH CENTURY AND AFTER

Our ignorance of the disposition of Ferrata's collection is followed by relatively sparse information about the studio contents of other sculptors of his generation and of later artists who were active in the eighteenth century. Some relevant sculptors' inventories have been published. One concerns Pierre Etienne Monnot, a French-born sculptor active in Rome with important clients in England and Germany, who died in 1733. The inventory drawn up after his death includes entries for eighty pieces, all his own work, except for two models by Pierre Legros and two heads said to be by Bernini.[50] A larger collection, which belonged to three generations of the Mazzuoli family of sculptors from Siena, is known from an inventory of 1767.[51] Of the nearly two hundred items, about twenty percent were by artists other than family members. Those works included four models by Ferrata, five each by Bernini and Duquesnoy, three or four by Algardi and another seven from his school, one each by Antonio Raggi and Legros, and two that were

Voicy la repreſentation d'un Sculpteur dans ſon Attelier

Les Choſes dont il ferme ſes ouurages ſont diuerſes. de diferente nature. et il y procede en diferentes façons. les dures Come la pierre et le bois: il les façonne
en oſtãt de la matiere auec le cizeau le maillet et aûes outilz. et les molles Comme la Cire et l'argile: il les façonne en meſtant de la matiere auec le
poulſe et l'èbauchoir: ſouuent il ſe fait vn modelle de ſa penſee come il en tient a la main et qûapres il Copie en vne aûe grandeur
fait al'eau forte par Boſſe. a Paris en l'iſle du palais. l'an 1642. auec Priuilege.

attributed to Michelangelo—an interesting collection of some size and range. Other artists must have acquired only a few pieces, like the French artists Lambert Sigisbert Adam (in Rome from 1723 to 1733) and Charles Joseph Natoire (in Rome from 1751 to 1777), both of whom owned terracottas attributed to Bernini.[52]

The largest collection of models currently known to have been in mid-eighteenth-century Rome consisted of one hundred terracottas belonging to Bartolomeo Cavaceppi. A prominent restorer and successful merchant of antiquities with an international clientele, he was rated by Goethe and others as the most prominent sculptor working in the antique manner in Rome around 1760.[53] Cavaceppi's truly prodigious collections have recently been studied at length by a team of scholars.[54] The terracottas are described in an inventory dating from 1760 to 1770, when it is thought they were catalogued with an eye to sale. Among the interesting objects composing the collection were a piece attributed to Donatello, several to Michelangelo and his students, and one to Giambologna, signs of Cavaceppi's interest in early sculptural models. The works by eighteenth-century masters were notably sparse except for those by Rusconi and Monnot (Cavaceppi's teacher), and only two of his own terracottas appear on the list. Terracottas from the seventeenth century formed the strongest part of the collection, with Duquesnoy and Bernini represented by a number of pieces. It is a tribute to Cavaceppi's knowledge and scrupulousness that the list includes qualifying comments about some terracottas as the creation of followers of an artist or as belonging to an artist's school. At the beginning of the inventory, Cavaceppi wrote that such terracottas could no longer be found and that he had apparently "exhausted the mine" in his searches.

Cavaceppi's inventory records the placement of the terracottas, which were to a degree organized by type, throughout his museumlike studio.[55] Busts appeared in an arcade with a certain number of three-dimensional models placed on a cornice there. Most of the statuettes were installed in another room. In the long room were gathered the bas-reliefs. In the room of medals was a miscellaneous grouping of Renaissance works by Michelangelo, Giambologna, and Donatello, likely assembled there as the greatest rarities. The studies represented basic sculptural types any artist would need to master, but missing is the full range of pieces we saw in the inventory of Ferrata's studio.

The degree to which Cavaceppi was a tastemaker or following a trend in assembling a collection of terracottas will require time to evaluate, and the issue of his mixed motives must remain unresolved. Given his intense commercial activities as an art dealer, Cavaceppi must have formed his collection of terracottas with some thought to possible sale. The succession of Baroque styles from the seventeenth to early eighteenth century that these works represent was not entirely divorced from Cavaceppi's approach to the restoration and copying of antiquities. Indeed, Seymour Howard has commented that Baroque elements never really left Cavaceppi's works.[56] Certainly, the study of Baroque sculpture was part of his training. From 1729 to 1733, as a young artist, he was active in the atelier of the late Baroque sculptor Monnot when the latter was completing his large commission for the Marmorbad at Kassel. At the same time, as a student at the Accademia di San Luca, he had entered the competition, or *concorso*, for the beginning class in which students were to copy famous earlier works, including seventeenth-century masterpieces. Cavaceppi himself won a prize in 1732 for his copy of Bernini's *Habakkuk and the Angel*. Over the years Cavaceppi himself wanted to open a free and informal academy in his studio for which plans were far advanced in the late 1760s. Although intending to emphasize the importance of classical art in this school, a subject directly related to the activity of the workshop, Cavaceppi could easily have estimated the Baroque terracottas in his collection as representing the values he had learned and that were still being taught at the academy.

Abbot Farsetti's interests bear comparison with those of Cavaceppi. Sadly, at present few facts are known about the Venetian's collecting. After inheriting a fortune from his uncle in 1741, Farsetti appeared in Rome between 1749 and 1753.[57] There, most of his recorded activities have to do with antiquities. He impressed his contemporaries by assembling a collection of casts of the most famous ancient statues, a feat much harder to accomplish then than it became toward the end of the century, when Cavaceppi, to name the most important figure, had already assembled a collection of molds. Farsetti's success is credited, in part, to the intervention of his powerful cousin, Cardinal Carlo Rezzonico, who in 1758 became Pope Clement XIII.

From the printed catalogue of the Museo Farsetti, which has been dated around 1788, we know that the terracotta collection was not only largely Roman in composition, but, in terms of proportion and type, it was very much like Cavaceppi's own group, but twice as large.[58] A few of the sculptures were attributed to Michelangelo, with a number to Algardi, Bernini, and Duquesnoy. Artists represented from the next generation included Ferrata, Domenico Guidi, Giuseppe Mazzuoli, and Antonio Raggi; and from the eighteenth century, Monnot and Rusconi. A few pieces by Pietro Bracci, Giovanni Battista Maini, and Angelo Piò represent artists active at mid-century. It was in the course of the 1740s that Cavaceppi emerged as a prominent dealer and restorer at the nexus of the Roman art market. It is logical, therefore, as Maria Giulia Barberini has hypothesized recently—with no documentary proof, as yet—that Cavaceppi was a source for some of the terracottas purchased by Farsetti.[59]

Farsetti's establishment of an institution for the education of young artists may remind us of Ferrata's earlier intentions. However, in Farsetti's collection the prominence of casts after antiquities reflects the taste of the advanced circle of Cardinal Albani in Rome, to which Cavaceppi belonged, and the precedent of the cast collection at the French Academy in Rome from which many young artists drew. Was Cavaceppi influenced, in turn, by the success of Farsetti's museum? In Cavaceppi's will of 1799, all of his collections were to be left to the Accademia di San Luca, a staggering bequest involving several thousand objects, including terracottas, ancient statues, medals, and old-master drawings. Immediately contested by Cavaceppi's family and undermined by

Vincenzo Pacetti, the director of the academy, the sculptor's bequest was nullified. The collections were sold, with many of the statues and the terracottas being purchased by the banker Marchese (later Duke) Giovanni Torlonia. By 1799 the Farsetti Museum had also ceased to exist, and much of the collection was shipped to Russia in that year. For a century, the latter collection retained its integrity and maintained something of its intended mission to serve art students after its installation at the Academy of Fine Arts of St. Petersburg. However, to later eyes, especially as the nineteenth century progressed, the terracottas were of little interest, even within an academic setting.

To place the Farsetti and Cavaceppi collections in proper context is difficult, given the current fragmentary state of our knowledge of eighteenth-century sculpture and our growing awareness of the wide use of terracottas throughout Europe. In the 1730s in France, for example, sculptors began exhibiting many models relating to works in progress, as well as ones for potential commissions, in the Salon exhibitions of the Royal Academy. By the 1740s French and Flemish traditions of using models for commissions had also become established practice in England.[60] In Rome, terracotta models may have been exhibited more frequently in the eighteenth century than ever before. With the establishment of competitions at the Accademia di San Luca in 1702, which were held irregularly until 1796, young sculptors had many opportunities to vie for prestigious awards decided on the basis of terracotta models. The theatrical prize ceremonies took place at the time of exhibitions when all submissions were to be seen; current works by academy members were shown as well. A number of winning submissions were retained for the academy, which began thereby to become a repository for terracottas reflecting rising sculptural talent.[61] (Other pieces had been given to the academy over the years.) Moreover, on reception, newly admitted members were supposed to donate a work to the academy. Only haphazardly obeyed, the rules stipulated that the sculptor's gift was to be a bas-relief, and the word *modelli*, used in academic discussions as well as the recorded gifts, would indicate that terracotta was an acceptable material. An additional exhibition of great interest took place in 1730, when Pope Clement XII organized a public showing of over thirty sculptors' models for the Trevi Fountain, the most important sculptural project of mid-century.[62] However, the fact that none of these models has been preserved could indicate that contemporary models were more often exhibited than collected.

The time may come when we will know which of the eighteenth-century artists kept many of their models and which acquired preparatory works by others. We might eventually expect to find patrons who followed some of the patterns we have seen, either in obtaining models relating to specific commissions or in favoring a particular artist, as Vecchietti did Giambologna or the Franzone did Algardi. Two such examples come to mind. After Monnot's death the Odeschalchi acquired the gilded, highly finished model for the tomb of their illustrious family member, Pope Innocent XI, a terracotta still to be seen in the family palace in Rome.[63] Also early in the century, about 1708, Grand Prince Ferdinando de' Medici of Florence, a connoisseur, arranged in the audience room of his private apartments the terracotta reliefs of the Four Seasons, framed behind glass, by his favorite sculptor, Massimiliano Soldani. These were the full-scale models for one of the prince's commissions executed in bronze as a gift for his brother-in-law, the Elector Palatine Johann Wilhelm.[64]

These situations throw into relief the aims that Farsetti put into practice and that Cavaceppi may have contemplated, which are unlike the traditional patronage of living artists. Cavaceppi's interests had precedents notably in Ferrata's collecting, and he had some commercial motives as well. Farsetti, by contrast, represents a new kind of academically minded Maecenas, concerned above all with the formation of artists in his

own city according to the leading principles of the day. The artists whose models were collected were far from being considered out of date. A well-known painting is useful to represent this aspect of mid-century taste. *Modern Rome* (fig. 5), as portrayed by Giovanni Paolo Pannini in 1757 for the duc de Choiseul, the French ambassador to Rome, places two sixteenth-century sculptures in the foreground: *Moses* by Michelangelo and the *Lion* by Flaminio Vacca.[65] Most of the other sculptures, depicted as freestanding pieces or represented as if in paintings, are works of Bernini, many of them over a century old. Attitudes toward the long stylistic legacies of the previous century would change by the end of the eighteenth century, but in the middle years, sculptors studied these works with care, just as they did ancient monuments. (It is meaningful that Pannini's picture has a pendant, *Ancient Rome*.)

The degree to which young sculptors at mid-century explored both worlds can only be suggested here. Joseph Nollekens, who copied antiquities for Cavaceppi, filled a sketchbook with drawings after Baroque monuments.[66] The young Antonio Canova, responding to the Farsetti collection in Venice, copied an ancient group of wrestlers, but drew from the Baroque style for his pendant sculptures of Orpheus and Eurydice. Even on a first visit to Rome in 1779, Canova wrote admiringly of a full range of ancient, Renaissance, and Baroque works.[67] Thus, models assembled by Farsetti and Cavaceppi, which we admire for what they tell us about Baroque sculpture, are also informative about the aesthetics of mid-eighteenth-century Rome. The absence of contemporary sculpture from the terracotta collections can be interpreted as a criticism, and both Cavaceppi and Farsetti saw antiquity as providing the way to the renewal of the art of their own time. From this perspective, it is natural that, with the triumph of severe Neoclassicism, earlier preparatory models, even those by the great masters of recent history, would cease to stimulate young artists.

Pieces from the sixteenth century were newly popular around the middle of the eighteenth century as desirable types of preparatory models. The research of English scholars has made clear that the early members of the Royal Academy—Joshua Reynolds, Benjamin West, Thomas Lawrence, and Joseph Nollekens—had a particular enthusiasm for Michelangelesque pieces and the *maniera* of Giambologna.[68] In Rome in the 1760s, while exploring a range of styles, as John Kenworthy-Browne has shown, Nollekens had begun to make small terracottas, called sketches or *pensieri*. Based on classical themes, they were nonetheless heavily influenced by Giambologna, and he was also

FIG. 5
Giovanni Paolo Pannini, *Imaginary Picture Gallery with Views of Modern Rome*, 1757. Oil on canvas. Boston, Museum of Fine Arts, Charles Potter Kling Fund (1975.805).

27

trying to collect Renaissance material for himself.[69] Although he was fired primarily by interest in Michelangelo before leaving England, Nollekens would surely have noted the presence of a group of sixteenth-century models in Cavaceppi's collection. Before 1772 William Lock of Norbury, another English visitor to Italy, purchased from the Medici and from Vecchietti's heirs thirty-three rare models.[70] After Lock's death in 1785, some of these models were acquired by artists, including Nollekens and the miniaturist Richard Cosway. The latter installed his Renaissance waxes over a chimney piece in a room that was described as a paragon of the taste of a *virtuoso*.[71] A reflection of this interior style is still to be seen in the London house of Sir John Soane.[72]

Ferrata's and Cavaceppi's vision that a sculptor's possessions should be preserved in institutional form—their choice was an art academy—came about only in the nineteenth century with the establishment of two templelike museums erected in honor of famous men: the Gipsoteca of Canova and the Thorvaldsen Museum in Copenhagen, which opened in 1844 and 1848, respectively. The creation of these institutions was accomplished through the approval of the artists themselves and the patriotic enthusiasm for these sculptors who had enormous international reputations. Although far from the artists' actual Roman studios, these beautiful museums have the very great benefit of preserving much of the artists' studio contents. However, given the number of large versions of their works, the preliminary working models were far from prominent.

Even models attributed to Michelangelo took time to sell in the mid-nineteenth century. The Gherardini collection (on offer, it is true, at a high price) was considered and refused by authorities governing museums in Florence and Paris.[73] The eventual buyer in 1854 was the Museum of Ornamental Art (now the Victoria and Albert Museum). There the acquisition of the models was recognized as relating to a branch of art and not manufactured wares. After this time, the collections were renamed "Art Collections," but, given the standards of the day, it is not surprising that the models were not acquired by a traditional museum of fine arts.

In Rome, the "academy of Europe" in the 1700s, models from sculptors' studios surely remained during the next century. The history of Cavaceppi's collection is not yet fully reconstructed, but the models acquired by Torlonia were preserved together in Rome until about 1900.[74] When they were sold, the three major purchasers were Ludwig Pollak, the leading antiquarian in Rome; Giovanni Piancastelli, director of the Galleria Borghese; and the omnivorous collector, the tenor Evan Gorga. (From Piancastelli came the splendid group of Bernini models now at the Harvard University Art Museums, Cambridge, Massachusetts.)

Gorga maintained his thirty different collections in a series of apartments. The space designated for the terracottas, as shown in a photograph (fig. 6), was installed in a practical and strikingly traditional way. In a list of his holdings described in 1948, Gorga referred to his terracotta collection as "a museum of terracotta from the Renaissance to

Canova," and it formed a pendant to his collection of terracottas from archaic times to the Roman Empire.[75] His aim to acquire a comprehensive survey of works in clay, worthy of an institution, was in its extended scope unlike anything else we have seen.

Institutional legatees of terracottas have not always known what to make of their collections of sculptors' models. Only a few pieces have been on continuous display at the Harvard University Art Museums and the Hermitage, to which the Farsetti collection was transferred in 1919. Undoubtedly, the small size of many terracottas, the problems of attribution, and the frequency of damages and even substantial losses to the sculptures have made terracottas difficult objects for exhibition. Easier to feature in modern museums have been impressive presentation models like Bernini's *Equestrian Statue of Louis XIV*, purchased by the Galleria Borghese in 1926 (see Wardropper, fig. 12), and later acquisitions, such as the three striking Berninis at Detroit, and the Guidi at Hamburg, reminiscent of the imposing terracotta firedogs by Algardi that found a place in Cardinal Barberini's palace in the late seventeenth century. Nevertheless, some institutions have devoted sustained energy to building collections in depth, piece by piece, along scholarly lines, notably the Berlin Museums and the Victoria and Albert Museum.

Lately, there have been encouraging indications that a new phase in the appreciation and study of terracottas has begun. Is it too much to hope that many terracottas, now unknown, will come to light and be identified? Some manifestations of this activity have been visible. Following and profiting from the studies by scholars, important museum collections of terracottas are receiving attention. The Gorga pieces with other terracottas have emerged from storage, and were reinstalled at the Palazzo Venezia in Rome and catalogued in 1991.[76] Also, as we have seen, several publications have reconstructed Cavaceppi's holdings and the history of the Torlonia collection. At the same time, Russian scholars have contributed as well by focusing new attention on the historic Farsetti collection. Following the publication of a series of articles on the terracottas, the Hermitage has presented them to audiences internationally, first with exhibitions in Rome and Venice in 1991/92.[77] And now, four hundred years after the birth of Bernini and Algardi, the current selection of terracottas travels to museums whose very existence Farsetti could not have imagined.

The Role of Terracotta Models in Italian Baroque Sculptural Practice

IAN WARDROPPER

The farsetti collection terracottas assembled in this exhibition survey some of the most significant sculptors of the Italian Baroque, particularly those established in Rome. These works also constitute a repertoire of the various roles models played in achieving the final composition of some well-known, as well as some less-recognized, monuments of the period. Focusing on the examples of Alessandro Algardi and Gian Lorenzo Bernini, this essay seeks to establish the uses sculptors made of terracotta models and to plot the shifts of attitude their makers held toward them from the late sixteenth through the early eighteenth century.

In seventeenth-century Italian workshops, the process of creating costly sculptures in bronze or marble was preceded by making models from inexpensive materials. Wax, plaster or stucco, wood, and, above all, clay were the media of choice. Several advantages promoted the use of clay over other substances. Like wax it could be modeled by hand or with tools of the trade, such as spatulas and combs; the speed with which it could be manipulated was an essential factor for sketch models, through which a sculptor quickly gave form to his concept (fig. 1). The material also lent itself to smoother finishes that could be achieved by wiping the surface with rags, and it could be covered with a slip (diluted clay) to enhance this effect. After firing, if a finer appearance was desirable to please a client, the piece could be coated with gesso, painted, or even gilded. A disadvantage—it had to be kept moist during modeling lest it dry up—was compensated by the fact that it could be hardened by baking in an oven. Wax models tend to crack and crumble over time, but terracotta—literally, baked earth—survives well and thus could be saved or sold.[1]

The increasing popularity of terracotta as the material for making models in the Baroque era coincided with changing values placed on models generally, both within and outside the workshop. Enormous projects, so characteristic of the grandeur of the times, especially in Rome, required sculptors like Bernini to employ dozens of assistants. He used models to convey his intentions to helpers who, under his close supervision, executed gigantic monuments like the Fontana alle Quattro Fontane in the Piazza Navona, Rome, or who would be given free rein to carve the many statues of the Colonnade of Saint Peter's or the Ponte Sant'Angelo. Assistants prized such models if they were lucky enough to acquire them. Bernini's pupil Giulio Cartari was allowed to select terracotta models after the master's death; and Ercole Ferrata's inventory at his death listed a few models by Bernini, a large number he inherited from Alessandro Algardi, and some by François Duquesnoy and Melchiorre Caffà that he collected.[2] Artists kept these models for several reasons: for study or teaching, just as the Abbot Farsetti intended his collection

to be used in the eighteenth century; as a record of sculptures produced in the workshop; or as a reservoir of motifs or ideas for future work.

While artists sought out such models beginning in the late Renaissance and Baroque, the pursuit of terracotta models by collectors became fashionable considerably later, especially in the eighteenth century (see essay by Dean Walker). Just as drawings—studies or preparations for paintings—became collectible, so too did models for sculptures. The same qualities—vivacity, spontaneity, and the sense that the preparatory work expresses pure artistry rather than celebrates the costliness of the material from which it was fashioned—guided the taste of these collectors. In some cases connoisseurs may have preferred a sculptor's models because the freshness of handling of the small model and the excitement of the first idea were often lost in the large, formal version that followed. Only the more durable

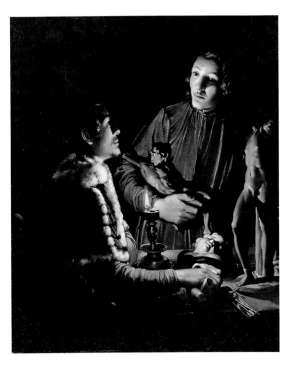

FIG. 2
Adam de Coster, *Visit to the Atelier*,
1621/22. Oil on canvas.
Copenhagen, Statens Museum for Kunst.

models, such as terracottas or plasters, however, could survive the passage from workshop modeling table to collector's pedestal (fig. 2).

Artists' treatises of the late sixteenth and seventeenth centuries record the role of the model and its evolution in workshop practices. In their writings, the sculptor-goldsmith Benvenuto Cellini and the painter-art historian Giorgio Vasari agreed on the basis of the sculptural process, seeing it as a coordinated development from small to full size and rough to more finished form.[3] First came a small sketch model—in modern times the term *bozzetto*, meaning a sculpture or oil painting that has been roughed in, is often used to describe this stage—which was usually an exercise in the overall massing of form and relationship of parts to the whole rather than a detailed plan. The sculptor then proceeded to make a *modello*, which was usually larger (between two feet high and half the size of the final work), more finished, and closer to the details he had in mind for the completed work. Finally, sometimes a full-scale model was made to ensure exact translation to the final material, usually bronze or marble, although this last stage was not consistently executed. Using various methods, the exact dimensions and features of the final model were transferred to the block of raw material as aids in carving the statue.

These theoretical principles reflected current practices. Vasari's and Cellini's famous contemporary Giambologna did indeed produce models in all these categories, some of which have survived. A number of his small sketch models exist as often in wax as in terracotta; in some cases, such as *Florence Triumphant over Pisa*, models in both media have survived, a smaller one in wax and a larger one in terracotta (figs. 3 and 4). He is also known to have made full-scale models, including a painted clay version of *Florence Triumphant over Pisa*, which survives in the Palazzo della Signoria in Florence.[4] Already by Giambologna's time, assistants saved the master's models: the

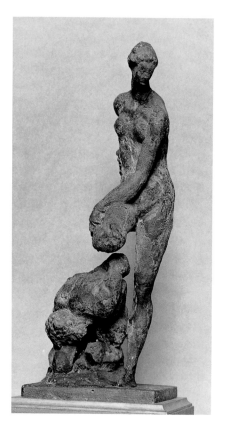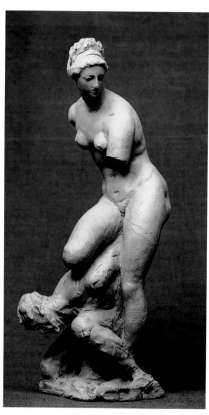

model of the nymph from his *Nymph and Satyr*, for instance, was preserved, and a half-century later, Ferdinando Tacca inherited it and incorporated it into a new composition of a bronze *Bireno and Olimpia*.[5] Giambologna's models passed into the collections of patrons, too, such as those of Bernardo Vecchietti and the Medici.

Modeling in clay was an intrinsic part of a young sculptor's training. The practice was instrumental in copying and thus learning from other sculpture, particularly antiquities. Considering the high esteem in which ancient Rome was held by sculptors and collectors in the Baroque period, it is fitting to begin examining the Farsetti collection through its didactic side. In a lecture to the French Academy in 1665, Bernini indicated his belief in the value of copying antique sculpture: "In my early youth I drew a great deal from Classical figures; and when I was in difficulties with my first statue, I turned to the Antinous as to the oracle" (fig. 5).[6] So it is not surprising to find such copies among the Farsetti examples. But Stefano Maderno's models, such as *Hercules with the Infant Telephus* (1620) and *Laocoön* (1630; cat. nos. 2 and 3), are so finely modeled and so widely spaced throughout his career that Sergei Androsov believes they were created for connoisseurs rather than for personal study.[7] Although no documents identify contemporary owners of the terracottas, only two of the series, *Hercules and Antaeus* and *Hercules and the Nemean Lion*, were turned into bronze casts. If their primary purpose was neither for the casting of bronzes nor to model large-scale marbles, then it does indeed seem likely that they were created as independent works of art. Their exceptional detail and precise reproduction of musculature reveal that aspect of antiquity that captivated Maderno and his patrons. Such terracottas were still produced in the following centuries, testifying to the long life of this genre. For example, Camillo Rusconi is recorded to have made terracotta copies of the *Apollo Belvedere* and *Farnese Hercules* for Marchese Niccolò Maria Pallavincini and for an English collector, both of which eventually formed part of Farsetti's collection.[8] It is not surprising that Farsetti kept only the finest copies of antiquity rather than student copies, but it is important to remember that such studies were most often learning exercises for young sculptors.

FIG. 5
Attributed to Wallerant Vaillant,
*Young Artists Copying a Statuette of the
So-called Antinous,* 1650/75. Oil on
canvas. Montpellier, Musée Fabre.

The use of terracotta models by Alessandro Algardi, one of the most influential sculptors of the Baroque era, is a critical example of their role in sculptural practice. Documents and extant works reveal that he produced a considerable number of models, though his attitude toward them differs from that of his rival, Bernini. When multiple models for one commission survive, they reveal a working method in which the sculptor used terracotta models first to arrive at the correct proportions of the figures, and then to refine the final statement. The large number of terracotta and plaster models for *The Encounter of Saint Leo the Great and Attila* suggests a long evolution of the composition in the artist's mind. A rapid sketch now in the Museo Nazionale in Florence (fig. 6) is thought to be an early essay, since the figures are undersized for the vast composition; a single figure of Attila in the Pesaro Museo Civico reflects the maturation of Algardi's thinking, as the principal figures grew to dominate the foreground of the relief.[9] The artist established the complex, twisting motion of the pose, but experimented with the livelier body type that ultimately became more restrained in the final marble.

The Farsetti terracottas by Algardi are all fairly close in composition to the sculptor's finished works. *Two Saints* (cat. no. 4), for instance, the only study known for the full-scale model *Three Holy Martyrs*—intended in turn to be the basis of a bronze—is similar in the overall organization of drapery. Yet in the Hermitage model there is a finer, more animated fluttering movement of the drapery, fashioned, as Jennifer Montagu has noted, in a gentle, curving manner, when compared to the broader, smoother large version.[10] The artist's challenge in this composition was to create a harmonious group, linked by continuing lines of drapery, while maintaining the individual figures emerging from beneath the thick cloth. The back view of the small model of *Two Saints* reveals that at this point Algardi had no intention of including the third saint, clearly a late addition to the final version.

In the study for the *Executioner* (cat. no. 5), Algardi choreographed the sweeping pose of one figure of a group. The sculptor channeled movement from the outstretched right leg through the upraised right arm. The figure's elevated, balletic

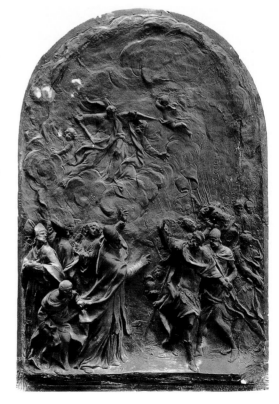

FIG. 6
Alessandro Algardi, model for
The Encounter of Saint Leo the Great and Attila,
c. 1646. Terracotta (?). Florence, Museo Nazionale
[photo: Montagu 1985a, vol. 2, plate 129].

33

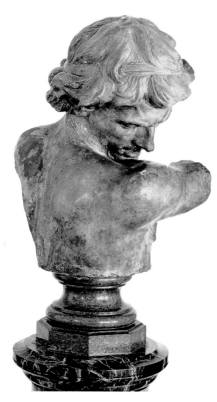

pose changed to one of a lowered center of gravity in the final work. In a sense, the relation of study to final work is like that of *Two Saints* to *Three Holy Martyrs*: the sculptor's innate grace animates his first composition, while the final work is weighted, both physically and formally. Clearly this study is not a presentation model, since Algardi did not bother to remove the clay between the executioner's legs, which he used as a reservoir from which to scoop out material to add to the figure. He was aware that the marble figure would need additional support in its lower half, however, and in the final work transformed this raw material into drapery.

As the project evolved, the sculptor had to consider the executioner's relationship to the kneeling Saint Paul and the height at which the whole group would be seen in the church of San Paolo Maggiore. Imagining the viewer's vantage may have caused Algardi to lower the arm, which potentially obscured the executioner's face. Another terracotta study (fig. 7) focuses on the downward gaze of the eyes, with the figure's chin tucked into the shoulder. The bowl of hair bound by a fillet in the Abbeg collection example is closer to the marble than is the St. Petersburg example. In the final event, Algardi seems to have lowered the shoulder even more to ensure that the executioner's cruelty would contrast with Saint Paul's calm acceptance of his martyrdom. He further emphasized the executioner's straining muscles to distinguish the young man's vital physique from Saint Paul's sagging flesh.

Algardi's designs tend to begin in a light, lyrical vein only to resolve into a weightier, more serious version. An initial drawing for *The Firedog of Jupiter* (fig. 8) supports this conclusion. The penned Jupiter, hurling thunderbolts at the rebellious Titans crushed beneath rocks, rides the eagle more agilely than does his bronze counterpart. The Hermitage study (cat. no. 9) is for a part of this pyramid of figures. While the bold strokes of the drawing reduce the Titans to physical supports of the Jupiter figure, the terracotta model allowed the sculptor to elaborate other aspects of their roles. Anatomically, the chest muscles clench and the limbs splay beneath their burden; narratively, the upturned head looks toward the furious Jupiter, while the rocks refer to the mountains of Pelion and Ossa, between which the Titans are crushed; and, decoratively, the body creates a curving form—more pronounced in the terracotta than in the drawing—which echoes the concave rhythm of a socle.

As with the *Decapitation of Saint Paul*, Algardi probably modeled each figure separately to study its composition. He also finished terracotta presentation models of the entire firedogs, which he gave to Don Juan da Córdoba; apparently these passed into the Barberini collections before disappearing. But the numerous examples of these popular sculptures have led Jennifer Montagu to wonder about the exact nature of the St. Petersburg *Titan*.[11] Precisely because the pose is so close to that of the bronze versions, she speculates that it might have been executed by a first-rate studio assistant rather than by Algardi himself. This model is not a study for the finished work in the way that *Two Saints* and *Executioner* clearly are by virtue of their notable differences from the final works. It is not a presentation model, since it is only a part of the whole and has in fact been given its own circular base. Might it be Algardi's notion for excerpting a successful motif and turning it into a sculpture in its own right? Or was this model in fact made by one of his pupils as a fine copy of an inspiring work by the

master? Questions like these engage the perplexing issue of the currency of models exchanged between masters and assistants.

Algardi's terracotta portraits constitute a final category. His busts have long been admired for their truthfulness and precision. An early historian of Algardi, Jacob Hess, was reminded of Algardi's training as a goldsmith by the clarity and deliberation with which the sculptor approached the task of making a likeness.[12] For these projects, Algardi's aim seems to have been to achieve his final statement in clay to facilitate relatively exact translation to a more durable medium. The sculptor had less need to begin with a small model in the case of a bust than he would for a complex figural pose. The Farsetti collection affords three different case studies that show how models served a master in developing a portrait: an image of someone the sculptor knew well, an imagined portrait of someone long dead, and a biblical figure quoted from one of the sculptor's own great works.

The authoritative details of the creased brow, aquiline nose, and focused gaze of the bust of Gaspare Mola (cat. no. 7) reveal that Algardi knew this contemporary goldsmith and medalist. The bust's rounded form corresponds to a type of portrait that traditionally fits into a tomb niche. Mola apparently changed his mind before his will was drawn, however, as funds were not provided to translate this terracotta into marble, the customary medium for a tomb. Comparison of this work to the bust of Lelio Frangipane (cat. no. 6), which was carved in marble, illustrates how Algardi used terracottas to declare his intentions for finished works. That bust was one of three commemorating the Frangipane family. According to the historian Giovanni Battista Passeri, Lelio died without leaving any visual likenesses.[13] Thirty years later, Algardi was free to imagine the portrait, and indeed it has more the air of idealized youth than any specific individual. The only differences between terracotta and marble can be seen in the armor's lames (overlapping sections of metal around the shoulders) and the handling of the drapery. Considering the labor involved, one would expect such a large clay object to resemble the finished image more nearly than a small study would, and Algardi's terracotta busts do relate closely to marble or bronze versions, where they exist.

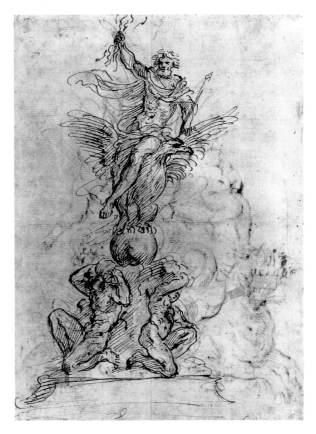

FIG. 8

Alessandro Algardi, drawing for *The Firedog of Jupiter*, c. 1650. Pen and ink over black pencil. Augsburg, Städtische Kunstsammlungen.

One last example falls into a more complex pattern of circumstances. *The Apostle Paul* (cat. no. 8) is one of a number of busts of Peter and Paul by Algardi that depend on his representations of the saints in the Leo and Attila relief. All versions share wind-swept hair, parted down the middle, rather soft expressions, and broadly handled drapery. The terracotta resembles a marble in a private collection, but it raises the question of scale. The marble bust nearly doubles the size of the Hermitage terracotta; there also exist smaller versions, approximately half the size of the St. Petersburg bust.[14] If the artist preferred to make one-to-one models in terracotta for marble busts, what role did this smaller version play? Could it be his variation to essay a popular composition in a different size—or is it an assistant's rendition? The quality is sufficiently high to be the master's, but the presence of assistants in the studio begs the question of another hand.

This thoughtful and deliberate sculptor turned to clay models—or at least saved them—at junctures of the creative process when his concepts were well formed. A fluid draftsman, Algardi may have done much of his preliminary thinking on paper rather than in clay. For large compositions like the *Encounter of Saint Leo the Great and Attila*, he clearly needed models to resolve the scale of his figures. Whether early or late in the evolution of a sculpture, most of his models tend to be carefully resolved rather than dashed off. Algardi often provided designs for metalwork and for bronzes. As a craftsman who began his career as a metalsmith, he was predisposed to fashioning models sufficiently precise that they could be the basis of work in another material or serve an assistant in exact transcription. He valued terracotta models highly enough to bequeath certain ones to important patrons and supporters, as he did with a *Baptism of Christ* for Monsignor Cristoforo Segni and *The Firedogs of Jupiter and Juno* for Don Juan da Córdoba.[15]

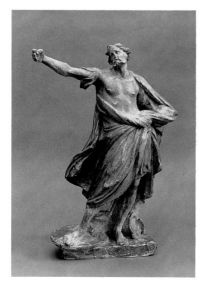

Seventeenth-century artists' treatises and contemporary accounts of Bernini's working methods describe different uses of the model in the workshop. The most striking departures seen in Bernini's approach are the liberal use of clay models, especially in the early stages of preparing for a work, an intuitive rather than systematic development through the stages of models, and the use of models for inspiration rather than as guides to carve the final work. Several well-known contemporary accounts marvel at his prodigious and seemingly cavalier preparation for a commission. Sandrart reported seeing no fewer than twenty-two small models for the colossal *Longinus* on which Bernini was at work in the early 1630s.[16] Only one of these appears to have survived (fig. 9), but the varied models for the Ponte Sant'Angelo angels support the conclusion that Bernini would dash off variations of his thoughts in three-dimensional form, trying first one avenue and then another until he found the route he wished to follow. Even more astonishing to Paul Fréart de Chantelou was Bernini's method for devising the bust of Louis XIV.[17] The artist made numerous drawings and clay models of his subject. Once he began carving the marble, however, he no longer referred to them. According to Bernini, these sketches served only "to introduce into his mind the features that he had to trace."[18] His temperament led him to immerse himself in his subject and then to improvise rather than follow a slow and deliberate progress from one stage to the next. Fréart de Chantelou did mention that Bernini made a full-scale model for the Louis XIV bust, however, so the artist's preparation for carving the marble may have been more deliberate than the story implies.

These anecdotes correspond with what is known of Bernini's restless intellect and virtuosic carving technique. Furthermore, the sculptor Orfeo Boselli, who worked for Bernini as a studio hand in the 1630s and 1640s, wrote in his treatise *Osservazioni della scoltura antica* in the 1650s that the traditional methods of making full-scale models were no longer necessary, except when needed to test the size of a sculpture in place.[19] Indeed, Bernini appears to have made less use of full-scale models for work he carved himself, and relished attacking the stone with a mental rather than a physical image to guide him. Few sculptors have had this confidence.

As the level of his activity increased dramatically by the 1630s, Bernini also relied on models to communicate his ideas to the increasing number of assistants. Drawings could not equal three-dimensional sketches for this purpose, and Bernini appears to have been both willing and able to hand assistants relatively unfinished mod-

els as the basis of his ideas. Yet using clay models for marble statues has an inherent problem: modeling requires a fundamentally different technical attitude than carving. As Irving Lavin has observed, a unique aspect of Bernini's art was his ability to preserve the ease of handling soft materials in the more difficult craft of chiseling hard ones.[20] This "calculated spontaneity" was another original aspect of Bernini's use of clay models: instead of ignoring clay's textural qualities, he found ways to be inspired by them in the final marbles. For example, the knife-thin ridges of drapery or buttery swirl of clouds in the *Angel with the Superscription* (cat. no. 17) were relatively easy to achieve in clay but exceedingly difficult in marble; Bernini's clay models seem to have inspired him to achieve those effects in the final works. Before Bernini, few sculptors thought to translate material aspects of the clay models into marble statues; rather, for most sculptors the clay served as an abstraction for the composition, not as a representation of the surface of the final work. (The situation was different for bronze casting, which was based on molds taken from the model.)

Bernini was particularly gifted in imagining scale. Like all sculptors, Bernini had to extrapolate from the small model before him on a table to the large work to be placed on a pedestal or in an architectural setting. Most sculptors need to enlarge these models closer to the desired state to grasp the effect of the final dimensions. Considering the colossal size of many of Bernini's projects, it is remarkable that he preferred to work from small models and that he had the ability to visualize the statues blown up to full scale without need for intermediary stages. We know that he did produce full-size models on occasion, although this was often to guide assistants to carve a work, such as the *Longinus*, and sometimes to judge the impact of the work in the site before committing to the final form.[21]

Bernini's methods were famous and have come to stand for the virtuosity of Baroque sculpture. He is known for his enthusiasm for the *primi pensieri*, the rapid sketch models that recorded his first thoughts for a sculpture. Ultimately his attitude toward the model was idiosyncratic. Other sculptors imitated him, but few could match or wished to follow his practices. Bernini himself used models in other ways, too. For example, he created more finished models for presenting his ideas to patrons, as was the case with the *Equestrian Statue of Louis XIV* (fig. 12), or for testing the effect of works in situ, as with the full-scale clay *Fathers of the Church* for the *Cathedra Petri* (ex-Museo Petriana, Rome). What the Farsetti collection demonstrates, in fact, is the range of types of models in seventeenth- and early-eighteenth-century Italy, from the more traditional, systematic enlargement of models instituted in the Renaissance to the highly personal style of Bernini at the height of the Baroque period.

Contemporary descriptions of Bernini's working methods, however, do not satisfactorily answer all the questions raised by a number of terracottas related to his large-scale sculpture. His practice with models was famously different from that of his predecessors. But the Farsetti models prompt reexamination of Bernini's practices in relation to such contemporaries as Algardi. Given the range of terracotta types associated with Bernini over his seventy-odd-year career, one must admit the possibility that his attitudes to models changed over time.

Those Farsetti models related to early works in Bernini's career—*Torso of Neptune* (cat. no. 10), *Torso of Pluto* (cat. no. 11), and *David* (cat. no. 12), all from the period 1620 to 1624—share the qualities of being more thoroughly finished and having their surfaces more smoothly modeled than most of the later works. It is worth recalling that the year 1624 was a watershed in Bernini's career: the commission for the *Baldacchino* led to a dramatic increase in Bernini's work load as well as in studio assistants and, in turn, quite likely, to shifts in his working methods. Could he have made more highly finished models early in his career and altered his practices over

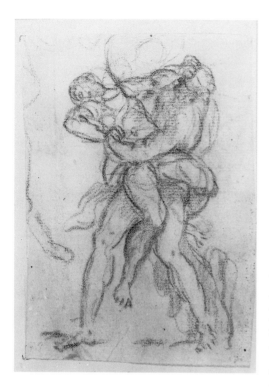

time? His own statements propose that his course in developing a composition was more systematic than others' accounts of his working methods. The contemporaneous art writer Filippo Baldinucci recorded that Bernini told students: "first comes the concept, then reflection on the arrangements of the parts, and finally, giving the perfection of grace and sensitivity to them."[22] This does not mean that the models became more and more finished over the course of each project in the traditional sense, but it does imply that Bernini considered stages of refinement desirable.

Bernini's dramatic marble *Pluto and Proserpina* is the earliest work to which preparatory studies have been connected. Considered together, a drawing and two terracotta fragments suggest a working method closer to traditional practices than those Bernini followed later in his career. A red chalk sketch in Leipzig (fig. 10) appears to reflect his first thoughts for this group: the complex intertwining of bodies and angular rhythm of limbs reveal that Bernini was meditating on examples of Mannerist sculpture.[23] Giambologna's multifigure groups, such as *Rape of a Sabine Woman*, were paradigms of the representation of struggling figures in sculpture; Bernini could hardly have ignored their precedent in his initial thoughts about a group in active conflict. It is noteworthy that the first design for *Pluto and Proserpina* was made in a drawing. In the sculptural process, drawings do not necessarily come first, yet clearly chalk and paper are the handiest materials for an artist to contrive a preliminary scheme. In the final result, the sculptor was inspired by antiquity as well: the ancient Roman statues *Hercules and the Hydra* and the *Niobids* have been proposed as sources for Pluto and Proserpina, respectively.[24] It is characteristic of Baroque sculpture to synthesize the complexity of Mannerist sources with the dramatic naturalism of ancient ones.

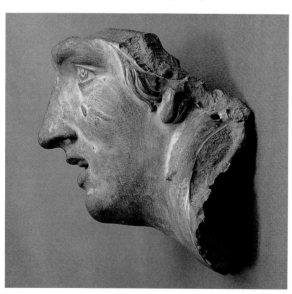

The terracotta fragments attributed to this composition—the small-scale torso of Pluto in St. Petersburg (cat. no. 11) and the larger head of Proserpina (fig. 11)—share some physical characteristics.[25] Both are more smoothly modeled than many terracottas accepted to be by Bernini's hand, and both are hollow.[26] Assuming that the two fragments were part of whole compositions, the complete St. Petersburg terracotta would have been close to two feet high, and the Cleveland head roughly twice that size. These dimensions suggest that they were originally parts of a small-scale and a half-size model, perhaps for presentation to a patron. These stages—drawn sketch, small-scale model, larger finished model—accord with practices recommended by sixteenth-century treatises and known to be followed by sculptors like Giambologna.

This sequence, however, contradicts the practices that are thought to distinguish Bernini's from earlier customs: that he did not proceed from smaller to larger models and from less to more refined stages as a means to transcribe exactly his first thoughts to his final work,

but rather used clay models principally as inspiration. Did Bernini invent his working methods at the start of his career, or did he begin more traditionally and, through the course of experience, arrive at means more congenial to his spirited temperament? The answers are not clear from documents or other sources, but in view of several more finished studies, it is worth speculating on the evolution of his working methods.

Only a year or two after Bernini completed *Pluto and Proserpina*, Cardinal Scipio Borghese commissioned another great marble statue, *David*. The Farsetti example (cat. no. 12) is meticulously prepared with slick skin and incised details of a high degree of specificity, such as the scales that decorate the breastplate at David's feet. Yet there are numerous small differences between model and marble: the terracotta lacks the eagle's-head finial on David's lyre, the tassels on the tassets (the defensive strips of metal attached to the bottom edge of the breastplate), and the tufts of hair under the arms and at the groin, while the armor collar and passages of the drapery differ from the final work. The model for David is even more finished than that for Pluto. If it is by Bernini's hand, then it must have been intended to please or persuade his patron. What evidence is there that Bernini executed such presentation models?

One indisputable example is the *bozzetto* for *The Equestrian Statue of Louis XIV* (fig. 12) that, in a letter of December 30, 1669, Bernini promised to make.[27] The monumental finished work aroused great controversy when it arrived in France, and it was subsequently recarved. Despite the alterations, it is possible to discern variations between the *bozzetto* and the marble in the horse's mane and rider's drapery. This documented presentation model is thus close but not exactly similar to the final work, as is the case with the *David* model. The two models share a level of attention to costume detail, although the

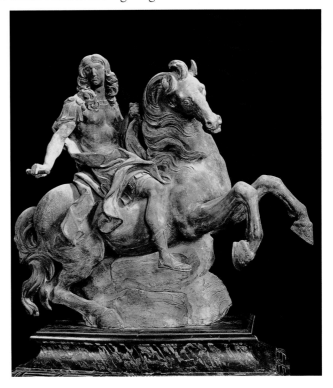

FIG. 12
Gian Lorenzo Bernini, model for
The Equestrian Statue of Louis XIV, 1669–70.
Terracotta. Rome, Galleria Borghese.

later-dated *Louis XIV* is more roughly textured than the Farsetti example. If both models are indeed by Bernini, then his styling of presentation models may have evolved from a smooth to a more vigorous working of the surface.

Another possible presentation model is that for *Habakkuk and the Angel* (fig. 13). Its painted surface long obscured any assessments of its quality, but recent cleaning revealed a delicate and precise surface, that, together with its close relationship to the final marble in the Chigi Chapel in Santa Maria del Popolo, suggests that it is a finished *modello* or presentation piece.[28] Meticulous detailing of the basket's straw and the angel's feathered wing and its relatively large size (52 cm [20½ in.] high) were probably intended to inform and impress an exacting patron. In these three cases—*David*, *The Equestrian Statue of Louis XIV*, and *Habakkuk and the Angel*—Bernini may have felt obliged by the high rank and demanding personality of cardinal, king, and pope, or he may have been compelled by intermediaries, to indicate his intentions in so thorough a manner.

These qualities of finish differ markedly from other models in the exhibition. The rump of the horse in the *bozzetto* for *Constantine the Great* (cat. no. 16), for instance, has a random, pockmarked surface when compared to the combed striations of Louis XIV's charger. Despite its fragmentary nature, the Farsetti terracotta displays

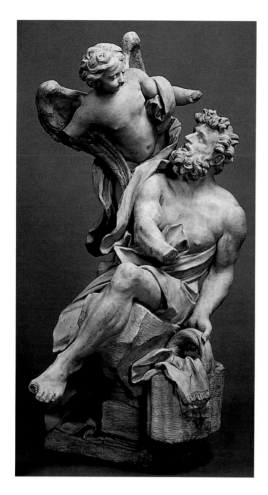

angular slices in the horse's mane and the rider's drapery, which reflect speed of execution and resemble the abbreviations of personal notation. This work expresses a compact massing and tight relation of man to horse that was of more concern to sculptor than to patron.

Even more rugged in surface treatment is *Tritons Holding Dolphins* (cat. no. 14), a model for an unused project for the Fontana del Moro. Here the musculature appears more gouged than modeled; arm muscles are only summarily delineated; details, such as fins, are barely described. The sculptor's tool flicked almost randomly across the surface or hastily pointed up an eye. The minimal level of intelligibility and high degree of abbreviation underscore the personal as opposed to public use of such a model.

Besides presenting his ideas to a patron or helping him to give form to his thoughts, Bernini's models were also a means of communication between master and assistants.[29] A set of models for sculptural decoration of the Ponte Sant'Angelo illustrates this use.[30] In 1667 the new pope, Clement IX, commissioned a series of ten angels, each carrying an instrument of the Passion, to decorate the bridge conducting visitors and pilgrims across the Tiber River to the Castel Sant'Angelo and on to Saint Peter's. Bernini controlled the overall design of the project, coordinating the gestures of the angels, which faced each other at regular intervals from both sides of the bridge. Nearly seventy years old, Bernini nonetheless reserved to himself the carving of two of these angels, those carrying the Superscription and the Crown of Thorns. These superb late works by the master so pleased the pope that they were diverted to the church of Sant'Andrea delle Fratte; Bernini was obliged to seek the help of his assistant Giulio Cartari in carving second versions for the bridge.

By good fortune several models for these works survive, as noted in catalogue numbers 17 through 19, and have been extensively studied. In the case of the models for Bernini's own use—for the *Angel with the Superscription*, which he carved himself—these various pieces range from the nearly abstract to the more fully representational. They present different compositional approaches to the syncopated rhythm of the swinging limbs and sweeping drapery. Sergei Androsov proposes that catalogue number 17 is one of the many that Bernini modeled to help him think through his intentions for this first version. Catalogue number 18, by contrast, seems to be intended for the second version of the *Angel with the Superscription*, in which drapery flows to the left rather than to the right. In working out a change for his own benefit, Bernini also intended this work to instruct the sculptor who would execute the marble. Jennifer Montagu suggested that Bernini simplified this second version both to protect it from the erosive effects of water and to enhance its perceptibility to a spectator walking on the bridge.[31]

Bernini incised a measured scale into this model to help enlarge the work (fig. 14). Another Bernini model with a similar incised scale, a kneeling angel for the Blessed Sacrament Altar (now in the Harvard University Art Museums, inv. 1937.63), indicates that these measuring marks may have been habitual for the artist late in his career. Some Bernini drawings, such as the *Triton* in The Metropolitan Museum of Art,

bear scales.[32] Squaring drawings for enlarging a composition to the scale of a painting was a common artistic practice, but integrating a scale on clay models seems to have begun with Bernini and reflects his practice of transferring a design directly from small model to marble without intermediary stages.

For the second version of the *Angel with the Crown of Thorns* (cat. no. 19), Bernini turned to one of his most trusted assistants, Paolo Naldini, whom he called the best sculptor in Rome after Antonio Raggi. As with the *Angel with the Superscription*, its visual counterpart on the bridge, Bernini simplified the flow of drapery, using the ter-racotta as a means to indicate to Naldini the alterations he wished. Although following the model closely, Naldini expressed his personal inclination toward classicism in the compact form; his own style appears in the facial expression, which is more specific than that of many of the statues on the bridge.

While the model for the *Angel with the Crown of Thorns* transmits the master's idea to an assistant, Ferrata's *Angel with the Cross* (cat. no. 22) represents a gifted assistant's translation of Bernini's ideas. A drawing thought to reflect Bernini's concept demonstrates that Ferrata followed instructions closely.[33] He reduced the size of the cross and raised the angle of the angel's face. This trusted assistant was evidently given the freedom to make such changes and to create drapery in his own manner so long as his general design followed the master's basic concept. Compared to the casual velocity with which Bernini fashioned his Ponte Sant'Angelo studies, Ferrata lavished care on his model. Antonio Giorgetti's *Head of an Angel* (cat. no. 27) confirms the pattern of assistants following the overall scheme set by the master but stamping their own character on particular details.[34] It also indicates the continuing use of large-scale models in Roman sculptural practice.

Bernini's studies for the Ponte Sant'Angelo illustrate his famous penchant for sketch models. Supremely confident, the aged artist easily manipulated clay to clarify his thoughts or pass his ideas to assistants for a large project. Earlier works such as *Constantine* or *Tritons Holding Dolphins* reflect this approach, too. Compared with Algardi's terracottas in the Farsetti collection, these works by Bernini are more spontaneously executed. But Bernini used terracotta for more than sketch models. Clearly he made more finished works for presentation; full-scale models for busts and even life-size models were part of his practice. His imaginative powers led him to an ever-freer approach to the sketch model, but in the diversity of his commissions, stretching over much of the seventeenth century, he surely made use of the many possibilities afforded by the medium.

In the wake of Algardi and Bernini, sculptors continued to find a variety of uses for terracotta. Paolo Naldini's fine bust of Annibale Carracci (cat. no. 24) shows that Algardi's practice of making precise full-scale models for portrait busts was still in use even by an artist who had practiced briefly in Bernini's workshop. Even Bernini may have used full-scale terracotta models for portraits.[35] Highly finished presentation models can be seen in the 1660s in Domenico Guidi's *Charity* (cat. no. 25), another

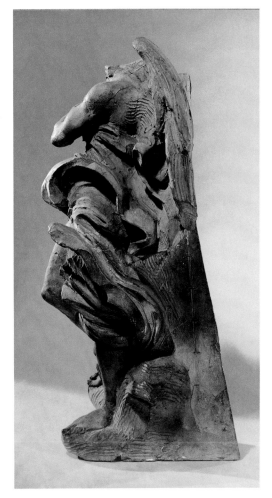

FIG. 14
Gian Lorenzo Bernini, model for the
Angel with the Superscription (side view).
Cat. no. 18.

example of a seemingly resolved model whose composition was altered in the final state. An artist like Pierre Etienne Monnot, much in sympathy with Algardi's artistic sensibility, created highly finished models (see cat. no. 31), evident in the quality of this work, as well as even more refined painted and gilded models possibly made for presentation to exalted patrons like the Landgraf Karl von Hesse-Kassel for the famous Marmorbad at Kassel.[36] Melchiorre Caffà's numerous models for the Saint Eustace relief in Sant'Agnese in Agone, Rome, illustrate the continuing use of models at different stages of conception. Using Caffà's models (see cat. no. 28), his working associate Ferrata was able to take over the Saint Eustace relief project after Caffà's death, modify the composition, and rework it within his style, while remaining true to the original concept.

Finally, studies for a work such as Angelo de' Rossi's *Apostle James the Less* (cat. no. 35), one of the apostles lining the basilica of San Giovanni in Laterano, demonstrate the continuity of clay models in this, the most important sculpture commission in eighteenth-century Rome.[37] Like the Ponte Sant'Angelo commission, one artist—in this case a painter, Carlo Maratti—was asked by the patron, Cardinal Benedetto Pamphili, to provide drawings for the statues. Some of the best sculptors of the day— Camillo Rusconi, Pierre Legros, Pierre Etienne Monnot, and others—shared this commission. The artists set up large-scale models and even chiaroscuro paintings of the figures in niches to gauge the effect of the colossal, fourteen-foot-high statues. Drawings by de' Rossi indicate considerable evolution of the figure—from a pose pointing with outstretched arm to the more compact figure seen in the Farsetti model and the final work.[38] The practice established by Bernini at the Ponte Sant'Angelo —controlling the overall design but permitting individual sculptors to develop their own variations within his parameters—still prevailed in the following century. Drawings and terracottas permit us to trace the independent thought of de' Rossi and his colleagues.

Seventeenth-century Italian sculptors fully exploited terracotta's expressive potential. While the Farsetti examples reveal that the functions prescribed in the Renaissance continued in Baroque workshops, there was an increased versatility and wider use of this simple and inexpensive medium. Bernini's exuberant manipulation of small clay models rejuvenated terracotta, but deliberate and systematic model-making continued. The appreciation of clay models outside of artists' circles began to rise, but the most desirable examples were more highly finished, such as Maderno's models of antiquity or Algardi's presentation model of the *Firedogs*. Only in the following century did connoisseurs fully appreciate the sketchier models. The works discussed here do not represent all the kinds of models that were used in seventeenth-century workshops. The process of selection—what one sculptor wished to keep from another's stock, what a collector in a later century thought worth preserving, what an exhibition, such as this one, chooses to display—may favor more finished examples. Nonetheless, these vigorous clay models reveal an artist's process of creation as he moved from personal vision to refinement, enlargement, and, lastly, transmission to assistants. His need to convince others of the worthiness of the concept is also always a factor in the making of models. These seventeenth-century terracottas dazzle modern eyes with the boldness of their handling. Of greater value still is their capacity to transport us to the sculptor's workshop, to permit us to witness the creative ferment of one of the most glorious periods of European sculpture.

Catalogue

SERGEI ANDROSOV AND NINA KOSAREVA

STEFANO MADERNO

Palestrina (?) c. 1576–1636 Rome

I
Nicodemus with the Body of Christ

HEIGHT 43 CM (16⅞ IN.). LOWER PART OF CHRIST'S RIGHT
ARM MISSING. ON THE LEFT SIDE OF THE BASE ARE
THE ARTIST'S INITIALS AND THE DATE, *1605 ST.M*
INV. NO. 560

In *Museo della casa eccelentissima Farsetti in Venezia*, the Farsetti collection cata-
logue of around 1788, this statuette was evidently identified as "Christ, Dying in
the Arms of Nicodemus, by Buonarroti." Departing from this assumption, Georg
Treu included the group with small copies of works after Michelangelo, apparent-
ly "works of the seventeenth century," and erroneously considered it a copy after
the *Rondanini Pietà*. The authorship of Stefano Maderno was established by
Zhannetta Matzulevich in the 1920s (personal communication). A similar terra-
cotta relief, also signed by Maderno and dated the same year, 1605, is now in
Berlin's Staatliche Museen. In 1933 Frida Schottmüller mentioned the Hermitage
group in reference to the Berlin work, although she mistakenly said that it
was made of marble; she also wrongly saw the Berlin relief as a model of the
Hermitage group. Ursula Schlegel published the Hermitage terracotta in 1978
and corrected the inaccuracies of Schottmüller's earlier publication, but she
did not know of the date and signature. As it happens, the authenticity of the
signature and date raises no questions, as they correspond precisely to signatures
on other works by Maderno.

The Hermitage group presents an interesting iconographic problem.
Schottmüller considered the man depicted to be Joseph of Arimathea. Schlegel,
on the contrary, identified him as Nicodemus. The Maderno group is related com-
positionally to the *Entombment* by Michelangelo (Florence, Museo dell'Opera
del Duomo), in which, according to sources, the sculptor portrayed himself as
Nicodemus. For this reason it is more correct to identify the man in the terracotta
as Nicodemus, although Maderno's image of Nicodemus can hardly be a self-
portrait, as Schlegel thought. The face of Nicodemus is not particularly individu-
alized, and the man portrayed looks older than the twenty-nine or thirty years of
age Maderno would have been at the time he worked on the group.

BIBLIOGRAPHY: *Museo della casa*, p. 22; Petrov 1864, p. 602; Treu 1871, p. 35, no. 571; Schottmüller
1933, p. 218; Schlegel 1978, p. 2; Androsov 1981, p. 90; Androsov et al. 1988, p. 58, no. 32; Leningrad 1989,
p. 31, no. 43; Androsov 1991, p. 297; Venice 1991, p. 100, no. 45; Bacchi 1996, p. 817.

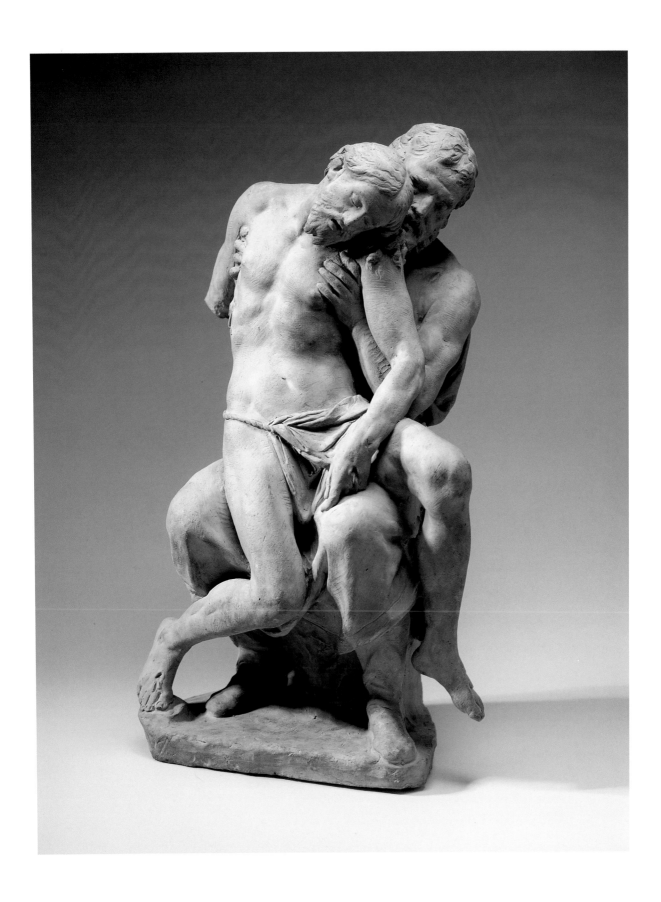

45

Hercules with the Infant Telephus

HEIGHT 51 CM (20⅛ IN.). MIDDLE OF FINGERS ON RIGHT HAND OF
HERCULES, TELEPHUS'S HANDS, AND THE TOES OF HIS LEFT FOOT
ARE BROKEN OFF. RESTORATION SEAMS AND CRACKS. ON THE STUMP,
INITIALS AND DATE, *ST.M. / EX[CUDIT] / 1620*

INV. NO. 551

A copy of an antique group preserved in the Musei Vaticani, this work was included in the catalogue of the Farsetti collection as "Hercules, Holding a Putto in One Arm and Telephus in the Other," with no attribution. Georg Treu listed the terracotta as a copy made in 1620. In the 1920s, Zhannetta Matzulevich ascertained Maderno's authorship (personal communication). The precise correspondence of the signature to that on other works by Maderno conclusively establishes the attribution.

BIBLIOGRAPHY: *Museo della casa*, p. 20; Petrov 1864, p. 603; Treu 1871, p. 34, no. 556; Leningrad 1989, p. 31, no. 44; Androsov 1991, p. 297; Venice 1991, p. 102, no. 46; Bacchi 1996, p. 817.

Hercules with the Infant Telephus.
Marble. Vatican, Musei Vaticani.

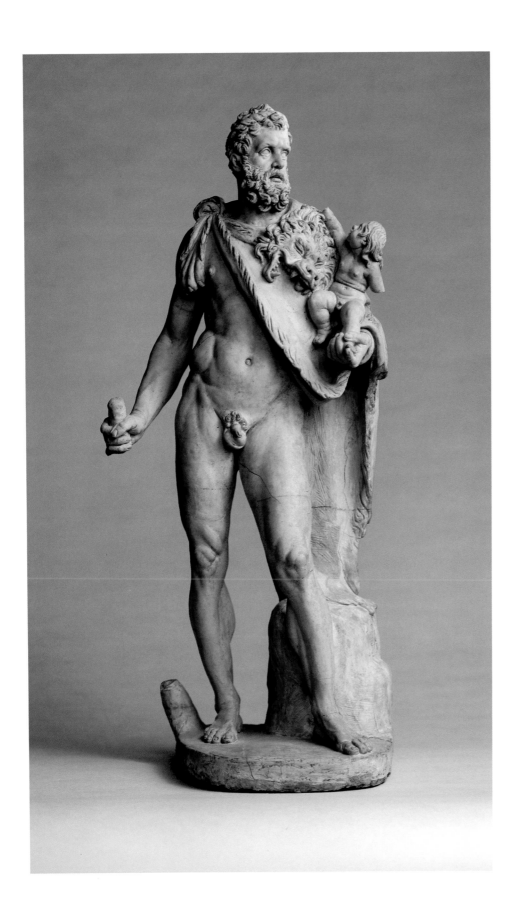

3

Laocoön

HEIGHT 71 CM (28 IN.). RIGHT ARM OF THE YOUNGER SON, FINGERS OF
THE RIGHT HAND OF THE ELDER, AND THE ENDS OF THE DRAPERIES ARE
BROKEN OFF. ON THE BACK OF THE BASE ARE THE INITIALS
OF THE ARTIST AND THE DATE, *ST.M. EX[CUDIT] / 1630*

INV. NO. 553

A copy of the well-known antique group *Laocoön*, found in Rome in 1506 and currently in the Musei Vaticani, appeared in the Farsetti collection catalogue with no indication of the artist. Georg Treu considered it to be a copy made in 1630. Zhannetta Matzulevich established Maderno's authorship in the 1920s (personal correspondence). There can be no question about this attribution, because the signature corresponds precisely to signatures on other works by Maderno.

BIBLIOGRAPHY: *Museo della casa*, p. 23; Petrov 1864, p. 604; Treu 1871, p. 34, no. 558; Leningrad 1989, p. 32, no. 45; Androsov 1991, p. 296; Venice 1991, p. 103, no. 47; Bacchi 1996, p. 817.

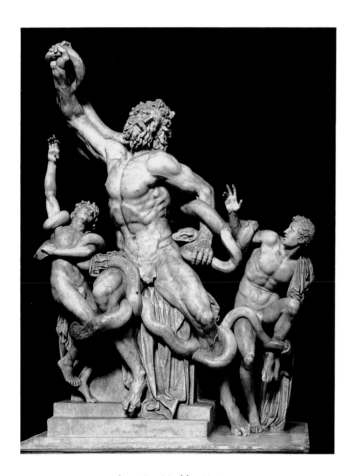

Laocoön. Marble. Vatican,
Musei Vaticani.

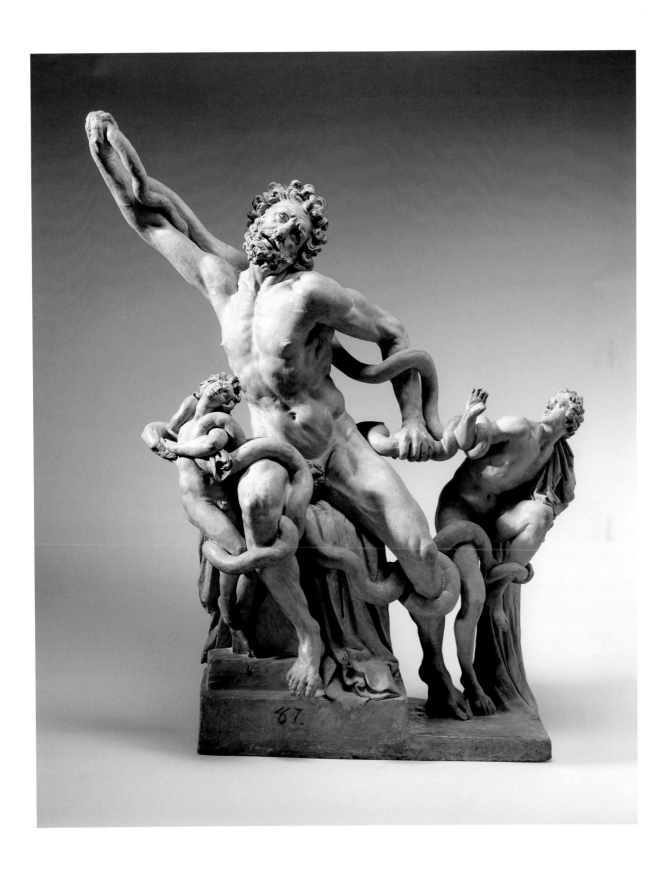

Bologna 1598–1654 Rome

4

Two Saints

HEIGHT 63 CM (24¾ IN.). HEADS OF BOTH FIGURES MISSING.

RIGHT ARM OF THE SAINT ON THE LEFT BROKEN OFF ABOVE ELBOW.

PART OF RIGHT FOOT AND PART OF BASE BROKEN.

INV. NO. 669

In the Farsetti collection catalogue of around 1788, this terracotta was described as "three saints, sculpted by Algardi." The compilers of the catalogue correctly related it to Algardi's full-scale model *Three Holy Martyrs* at the church of Santi Luca e Martina in Rome, but they erroneously interpreted the latter as a depiction of crowned saints similar to a group by Nanni di Banco in a niche of Orsanmichele, Florence. Both the subject of this terracotta group and the artist's name were subsequently forgotten. Georg Treu gave this terracotta the name *Two Saints*. It is entered in the Hermitage inventory as a seventeenth-century Italian work depicting "two men in cloaks."

Sergei Androsov determined that the group was a study for Algardi's trio of martyrs. The occasion for its commission was the discovery of relics of Saints Martina, Concordius, Epifanius, and an unknown saint on October 25, 1634. Algardi's monumental group *Three Holy Martyrs: Concordius, Epifanius, and Companion* should thus be dated to the mid-1630s. The high quality of the

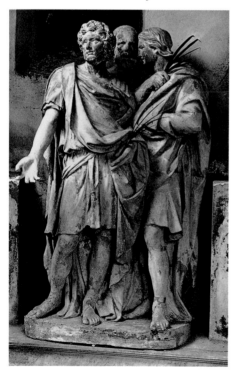

Hermitage composition leaves no doubt as to Algardi's authorship, particularly since the drapery pattern is somewhat different from that of the realized group. This conclusion is further corroborated by a purely technical observation: the Hermitage group is limited to two saints; in the final version, the head of a third saint was added after having been made separately. Thus there is no doubt that this is not a copy, but rather an artist's model reflecting a fairly advanced stage of work. The attribution of the work to Algardi has been accepted by Andrea Bacchi and by Jennifer Montagu, who justly stresses the "splendid quality" of the Hermitage group.

BIBLIOGRAPHY: *Museo della casa*, p. 24; Petrov 1864, p. 602; Treu 1871, p. 53, no. 754; Androsov 1983, p. 81; Montagu 1985a, vol. 2, p. 354, no. 48; Leningrad 1989, p. 9, no. 1; Venice 1991, p. 35, no. 1; Bacchi 1996, p. 771.

Algardi. *Three Holy Martyrs*. Terracotta. Rome, Santi Luca e Martina [photo: Montagu 1958a, vol. 2, plate 21].

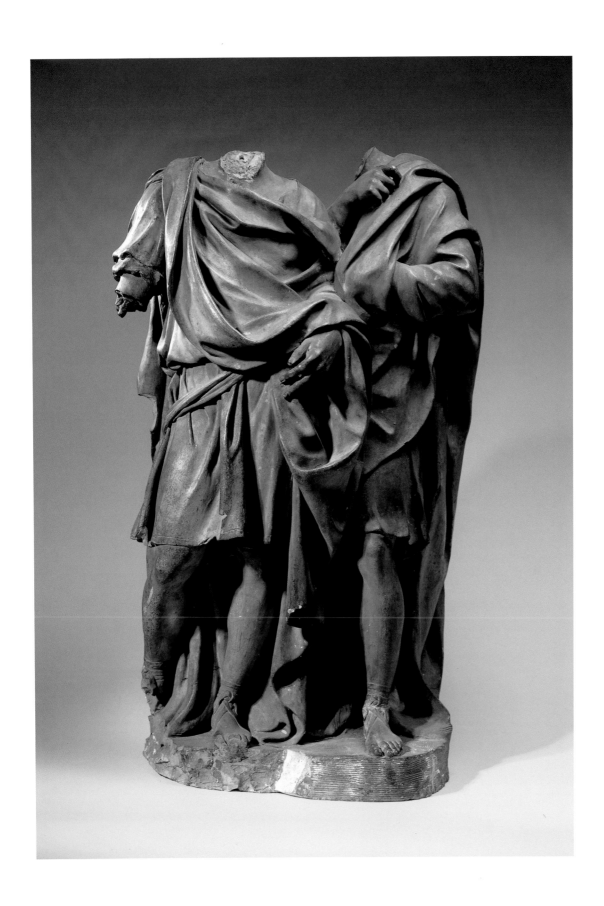

5
Executioner

HEIGHT 54 CM (21¼ IN.). RIGHT ARM ABOVE WRIST
AND LEFT ARM TO MID-FOREARM MISSING. EDGE OF
DRAPERY NEAR RIGHT SHOULDER BROKEN OFF. RESTORATION
TRACES ON RIGHT ARM, LEFT FOOT, AND LEFT ANKLE.
INV. NO. 661

In the Farsetti collection catalogue, this terracotta was identified as "Executioner by Algardi." Georg Treu called it *Running Youth* without attribution. It was entered in the Hermitage inventory under that same title as a work of an unknown seventeenth-century Italian sculptor.

Sergei Androsov identified the statuette as a *bozzetto* for the executioner's figure in the monumental marble group *Decapitation of Saint Paul* (Bologna, church of San Paolo Maggiore). Preparatory work on this group, commissioned by the Spada family, began in 1634. However, according to dates on most of the payments to Algardi, active work on the statues took place from around 1638 to 1643. At the end of 1644, Algardi had completed the statues, although the altar was erected only in 1647. The Hermitage terracotta differs from the final version in many ways: its raised right arm, its proportions, the turn of the figure, and the pattern of the draperies. In it one senses the sculptor's creative search, which permits a classification to a relatively early stage of work. Jennifer Montagu accepted the attribution, believing the Hermitage terracotta to be typical of Algardi's preliminary studies. An *Executioner* terracotta by Algardi, possibly this work, was in the Ferrata workshop in 1686 (Golzio 1935, p. 73).

A large, bust-length model for the same statue is preserved in the Abegg collection, Riggisberg (see Wardropper, fig. 7). Recently, Sotheby's auctioned a severely damaged figurine also called an Algardi study for the executioner figure.

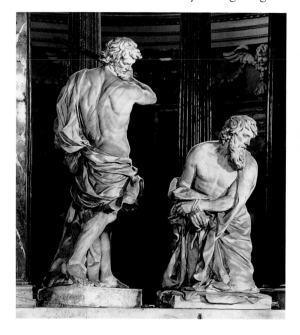

It seems fair to attribute this statuette, currently preserved at the Bayerisches Nationalmuseum in Munich, to Algardi; it appears that, as in the Hermitage statuette, the executioner's arm is raised more than it is in the marble statue (London 1988, lot 215).

BIBLIOGRAPHY: *Museo della casa*, p. 21; Petrov 1864, p. 602; Treu 1871, p. 53, no. 747 or 748; Androsov 1983, p. 82; Montagu 1985a, vol. 2, p. 372, no. 68 B.1; Montagu 1986, p. 11; Leningrad 1989, p. 9, no. 2; Venice 1991, p. 36, no. 2.

Algardi. *Decapitation of Saint Paul.*
Marble. Bologna, San Paolo Maggiore.

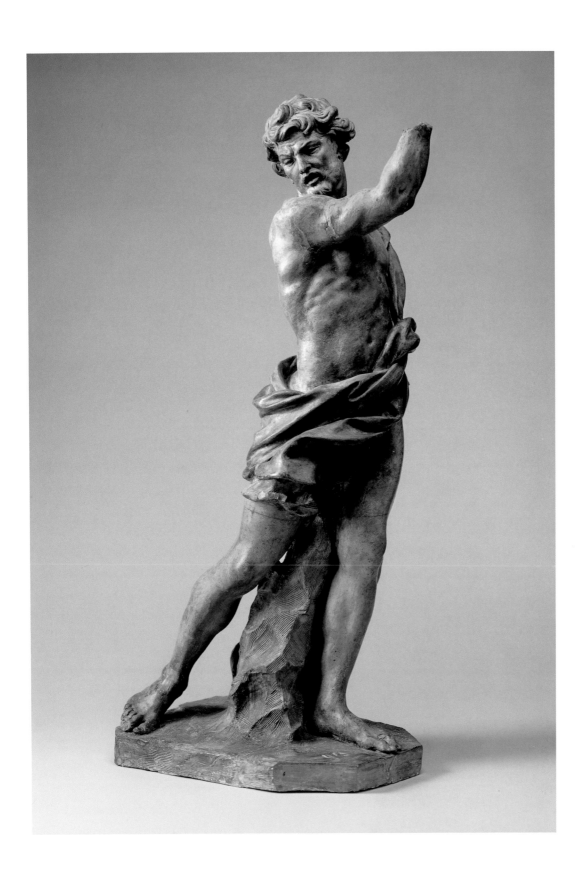

6
Portrait of Lelio Frangipane

HEIGHT 66 CM (26 IN.). PIECES MISSING AT THE BACK OF THE HEAD
AND SHOULDERS, ON THE EDGES OF THE ARMOR AND MANTLE IN THE FRONT,
AS WELL AS ON THE EDGES OF FOLDS. CRACKS ON THE NECK AND FACE.
INV. NO. 568

This bust is evidently the same as the "Young Man in Iron Armor, Algardi," mentioned among the busts in the Farsetti collection catalogue. It was added to the crate inventory of the collection as "Martyr in Iron Armor," and Georg Treu called it a "Bust Portrait of a Young Man in Armor," describing it as a "good Italian work of the seventeenth century" and a copy after Algardi. At the Hermitage, Nina Kosareva indicated that the bust was a study for a portrait of Lelio Frangipane (personal communication). Jennifer Montagu, although she pleads inadequate familiarity with the original, says that "there is no basis for considering it a later imitation" and ranks the bust among the works of Algardi. Andrea Bacchi accepted the attribution as well.

Completed by Algardi in 1638, the marble bust of Lelio stands together with portraits of his father, Muzio, and his brother, Roberto, on their tomb at the Frangipane chapel at the church of San Marcello al Corso. Lelio Frangipane, killed at war in 1605 at the age of twenty-six, is portrayed as a young warrior, almost devoid of individual traits, perhaps because no portrait representations of him had survived. The design of the folds and the placement of the plates of armor on the Hermitage terracotta differ somewhat from those features on the marble bust. But both the style and quality of the Hermitage bust are still very close to those of the terracotta models for the bust of Muzio Frangipane (Bologna, Pinacoteca Nazionale). Restoration and cleaning of the bust undertaken in 1991 have revealed the very high quality of its execution.

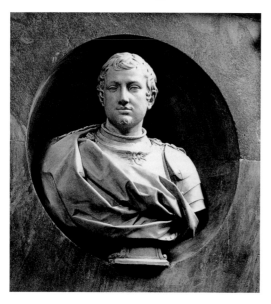

Algardi. *Bust of Lelio Frangipane.*
Marble. Rome, San Marcello al Corso
[photo: Montagu 1958a, vol. 2, plate 153].

Another bust at the Hermitage, also from the Farsetti collection, was considered a work of Algardi and is most likely a different version of the model for the portrait of Lelio Frangipane (Venice 1991, p. 39, no. 4).

BIBLIOGRAPHY: *Museo della casa*, p. 19; Petrov 1864, p. 595; Treu 1871, p. 36, no. 581; Montagu 1985a, vol. 2, p. 426, no. 147 B.1; Leningrad 1989, p. 10, no. 3; Venice 1991, p. 38, no. 3; Bacchi 1996, p. 771.

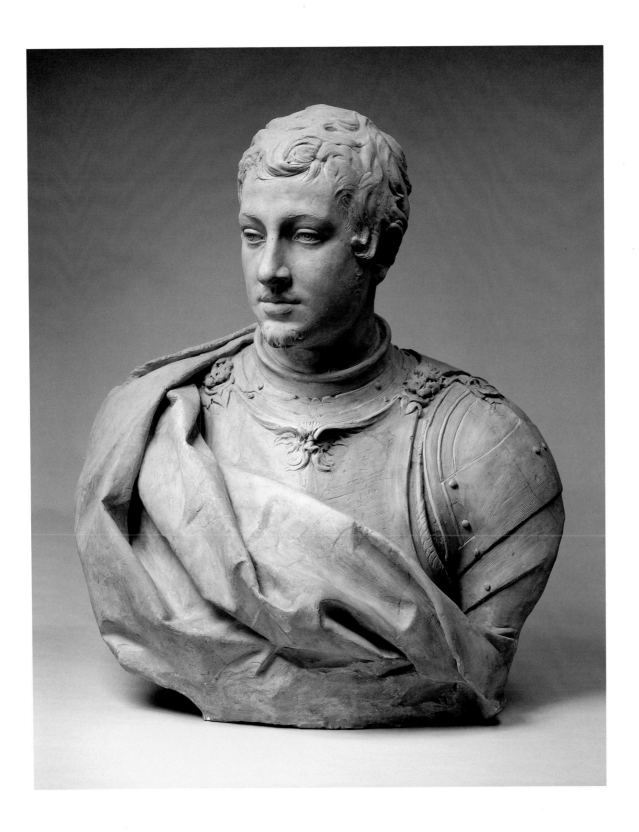

Portrait of Gaspare Mola

HEIGHT 64 CM (25¼ IN.). EDGES OF FOLDS OF MANTLE
DAMAGED. INDEX FINGER HAS BEEN RESTORED,
TIP OF THUMB BROKEN OFF.
INV. NO. 572

In the Farsetti collection catalogue, this bust was listed as a work by Algardi with the title *Old Man*. This is probably the piece Georg Treu called a "Copy from a Portrait of Prince Pamphili, work of Algardi." In a number of Hermitage publications, the bust is called "Portrait of Prince Pamphili, work of Algardi." When Jennifer Montagu analyzed this bust, she saw it as unquestionably a work of Algardi and correctly pointed out the terracotta's similarity to the artist's marble busts of Antonio Cerri (Manchester, City Art Gallery), Giovanni Garzia Mellini (Rome, church of Santa Maria del Popolo), and Laudivio Zacchia (Berlin, Staatliche Museen). Montagu suggested dating the Hermitage terracotta to the end of the 1630s, and identified the subject as the Milanese jeweler and medallion maker Gaspare Mola (c. 1580–1640) due to the resemblance of the man in this bust to the painted portrait of Gaspare Mola by an unknown artist (Rome, Accademia di San Luca). Montagu even suggested that the bust by Algardi could have served as a prototype for the painting. In an inventory of his estate, compiled after Mola's death, mention is made of a "Bust of the Deceased Gaspare Mola, of Fired Clay," perhaps the same sculpture that is now in the Hermitage. According to the entirely convincing arguments of Montagu, this portrait could have been made as a preliminary study for the tomb of Mola, never executed in marble. Andrea Bacchi also mentioned the Hermitage bust as being a work of Algardi.

BIBLIOGRAPHY: *Museo della casa*, p. 19; Petrov 1864, p. 593; Treu 1871, p. 37, no. 585; Zaretskaia and Kosareva 1970, no. 42; Leningrad 1972, p. 116, no. 483; Zaretskaia and Kosareva 1975, no. 42; Montagu 1985a, vol. 2, p. 439, no. 168; Leningrad 1989, p. 11, no. 5; Venice 1991, p. 41, no. 5; Bacchi 1996, p. 771.

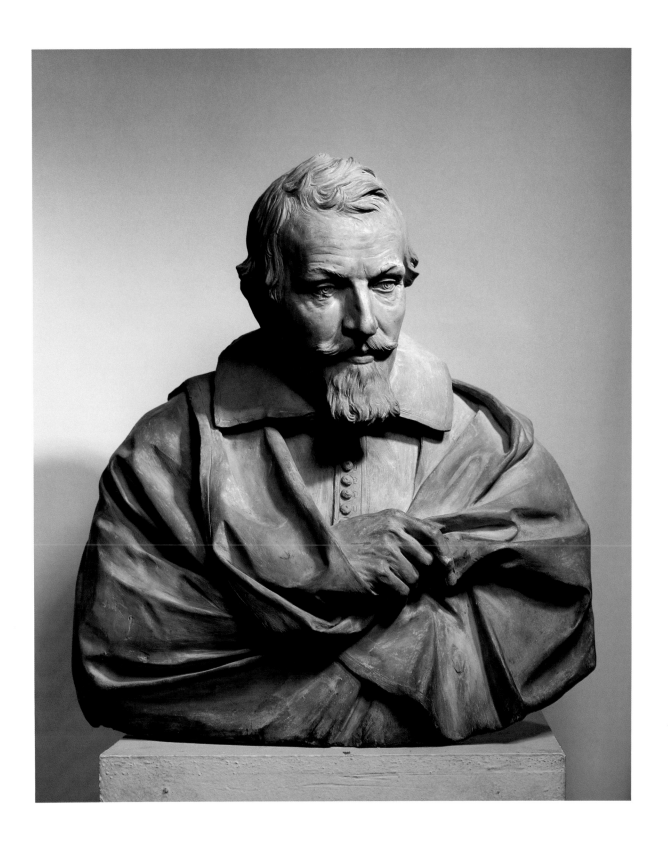

The Apostle Paul

HEIGHT 44 CM (17⅜ IN.). HAIR ABOVE FOREHEAD DAMAGED.
OLD REDDISH PIGMENT IS PARTIALLY PRESERVED
ON THE SURFACE OF THE TERRACOTTA .
INV. NO. 580

In the Farsetti collection, this bust was evidently known as "Saint Paul, Algardi." Georg Treu considered it to be a copy after Algardi, but it was entered into the Hermitage inventory under Algardi's name. Sergei Androsov published the bust with the same attribution as part of a large group of works portraying the apostles Peter and Paul brought together by Jennifer Montagu. Apparently, the Hermitage terracotta served as a model for a large marble bust of the apostle Paul, created by Algardi for Cardinal Giacomo Franzoni, now in a private collection. However, Montagu doubted Algardi's authorship of the piece, noting the "rather dry surface," and was inclined to consider the Hermitage terracotta a copy rather than an original Algardi model. Although she may have good reasons for this opinion, she emphasizes that she knows the bust only from a photograph. Restoration undertaken in 1987 and 1988, however, revealed the excellent quality of the work's execution and a surprising freedom and plasticity in the treatment of the robes. The quality of the Hermitage bust exceeds that of the marble version. Indeed, the 1686 inventory of the studio of Ercole Ferrata, who inherited many of Algardi's models, listed two heads of Saint Paul by "Langardi" (Golzio 1935, p. 67), supporting the theory that Algardi was the author of this piece.

The dates of the marble busts of Peter and Paul have not been precisely established through documentation. Montagu feels that work on the busts may have continued for a fairly long period of time, between 1646 and 1649.

BIBLIOGRAPHY: *Museo della casa*, p. 20; Petrov 1864, p. 593; Treu 1871, p. 38, no. 598; Androsov 1983, p. 82; Montagu 1983, p. 29; Montagu 1985a, vol. 2, p. 378, no. 71 L.B.I.D.1; Leningrad 1989, p. 13, no. 10; Venice 1991, p. 44, no. 8.

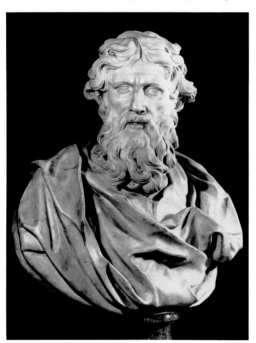

Algardi. *Bust of Saint Paul.*
Marble. Private collection [photo: Montagu
1958a, vol. 2, plate 201].

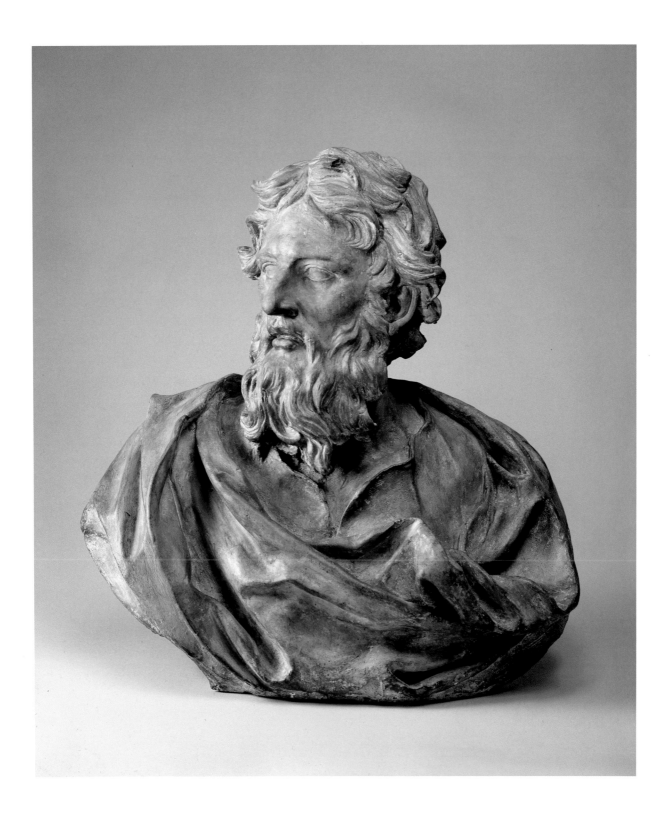

Titan

HEIGHT 38 CM (15 IN.). RESTORED LEFT HAND.

INV. NO. 656

This statuette was identified in the Farsetti collection catalogue as "Kneeling Hercules, Carrying a Sack, Algardi." Algardi's name was omitted, however, in Petrov's Russian translation of the inventory of the collection. Georg Treu referred to the terracotta as "Man, Supporting a Stone," with no attribution. Only on its entry into the Hermitage was the name of Algardi returned to the statuette.

Olga Raggio (personal communication, New York) first suggested in 1974 that the statuette was a model for a figure of Titan supporting a firedog with a representation of Jupiter. About 1649 or 1650, Algardi received a commission from the Spanish king Philip IV for the manufacture of two firedogs with figures of Jupiter and Juno. They were completed in the early 1650s, and until 1959 were part of the decorations for a fountain in the king's garden at Aranjuez. There are many replicas of them, two of which are in the palace museum in Pavlovsk.

Sergei Androsov published the Hermitage statuette as Algardi's original model for one of the figures decorating the firedog. Jennifer Montagu, although

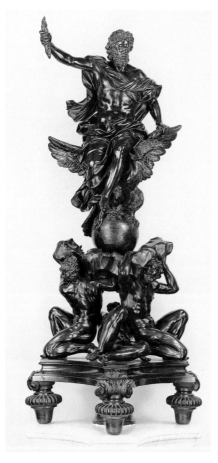

with some reservations, agrees with this attribution. It is worth mentioning that in 1686 the firedog of a "Langardi" work and separate "studies" and "figures" from a firedog were in the studio of Ercole Ferrata (Golzio 1935, pp. 69, 70, 73).

BIBLIOGRAPHY: *Museo della casa*, p. 22; Petrov 1864, p. 601; Treu 1871, p. 52, no. 472; Androsov 1983, p. 81; Montagu 1985a, vol. 2, p. 411, no. 129 B.2; Leningrad 1989, p. 13, no. 8; Venice 1991, p. 43, no. 7.

Algardi. *Firedog of Jupiter*. Bronze.
London, Wallace Collection.

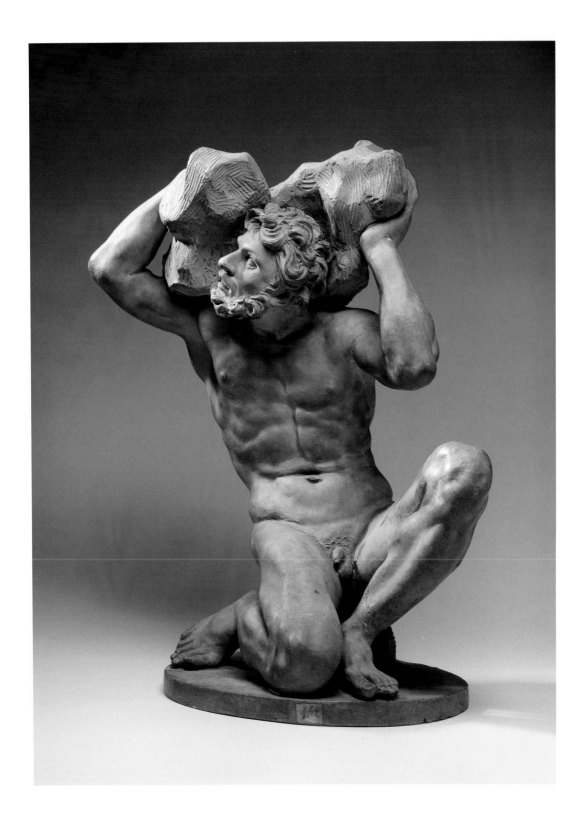

GIAN LORENZO BERNINI

Naples 1598–1680 Rome

10

Torso of Neptune

HEIGHT 37 CM (14⅝ IN.). HEAD, BOTH ARMS FROM
THE SHOULDER, RIGHT LEG FROM THE KNEE, AND THE LEFT FROM
MID-HIP ARE MISSING. THE EDGES OF FOLDS ARE DAMAGED.
INV. NO. 679

This statuette is evidently the one mentioned in the Farsetti collection catalogue as "Neptune, by Bernini." This identification was forgotten in the nineteenth century, and it is possible that this is the statuette called *Running Youth* by Georg Treu (see also cat. no. 5). The terracotta was entered in the Hermitage inventory as a fragment of a running figure by an Italian sculptor of the seventeenth century.

The high quality of execution and masterfully expressed sense of movement alone would have justified the attribution to Bernini, but the characteristically naturalistic scrolling of the folds of the mantle help identify it specifically as a study for the monumental marble group *Neptune with Triton* (London, Victoria and Albert Museum). Bernini evidently created this work on commission from Cardinal Alessandro Peretti in 1620, and by 1786 the marble decorated the garden of the Villa Montalto. Sir Joshua Reynolds acquired the group when he was in Italy in 1786 and took it to England. After the artist's death, it was sold to Lord Yarborough, from whose heirs the Victoria and Albert Museum acquired the work in 1950.

In the terracotta torso, there is none of the freshness and lightness we see in mature and later-period Bernini studies. The form is complete and precise, and the anatomy is splendidly modeled. These peculiarities can be explained, on the one hand, by Bernini's youth and, on the other, by the fact that this is not a *bozzetto*, but a more or less developed model on a small scale.

It is interesting to note that in the Farsetti collection there was also a full-size plaster copy of the *Neptune with Triton* group, which still exists in the Museum of the Academy of Fine Arts in St. Petersburg. The Russian inventory lists it in the section "Large plaster statues."

BIBLIOGRAPHY: *Museo della casa*, p. 21; Petrov 1864, p. 605; Treu 1871, p. 52, no. 747 or 748; p. 43, no. 644; Venice 1991, p. 52, no. 13; Kosareva 1993, p. 82.

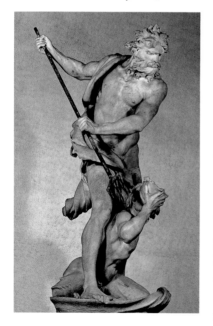

Bernini. *Neptune with Triton*. Marble. London, Victoria and Albert Museum [photo: © The Board of Trustees of the Victoria and Albert Museum].

Torso of Pluto

HEIGHT 38 CM (15 IN.). HEAD, LEGS, RIGHT ARM, AND LEFT HAND
ARE MISSING. THE TORSO, IN TWO PIECES, IS GLUED TOGETHER.
THE CUT AND SMOOTHED SURFACE ON THE CHEST OF THE
TORSO INDICATES THAT ANOTHER FIGURE, PERHAPS
FIRED SEPARATELY, HAD BEEN JOINED AT THIS PLACE.
INV. NO. 678

In the Farsetti collection catalogue, there were two fired-clay works by Bernini on the subject of the abduction of Proserpina: "Pluto Abducting Proserpina, with Triton at His Feet, Bernini" and "Pluto Abducting Proserpina, with the Dog Cerberus, Bernini." In the inventory compiled when the sculptures were shipped to Russia, they were already listed without attribution. Georg Treu mentioned only one such group, also without an artist's name, apparently the same one now at the Hermitage (inv. no. 653). A male character portrayed below apparently embodies hell, but was taken for a Triton by the cataloguers of the Farsetti collection. The quality of execution of the group is not very high, and one may assume that it is a copy of one of Bernini's intermediate models. This gives us reason to conclude that the study torso of Pluto was already in fragmentary condition in the mid-nineteenth century and thus was not mentioned by Treu. Rather, it was entered in the Hermitage inventory as a fragment of a running figure, the work of an Italian sculptor of the seventeenth century.

Bernini executed the marble group *Abduction of Proserpina* from 1621 to 1622 on commission from Cardinal Scipione Borghese, who soon thereafter presented it to Cardinal Ludovico Ludovisi, the nephew of Pope Gregory XV. It was returned to the Villa Borghese in the beginning of the twentieth century.

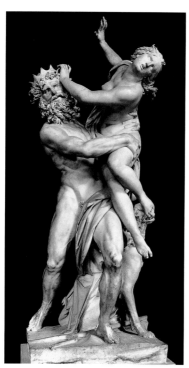

Bernini. *The Abduction of Proserpina.* Marble. Rome, Galleria Borghese.

A comparison of the fragment in the Hermitage with the marble group at the Galleria Borghese not only reveals their similarity but also explains the damage to the chest of the torso. In the surface's preparation, there is none of the spontaneous emotion and liveliness of the casts of Bernini's mature *bozzetti*, but the quality of execution is very high and consistent with the study for the torso of Neptune (cat. no. 10).

It is worth mentioning that the way in which the torso of Pluto was executed differs somewhat from that of Bernini's other studies and models, which, as a rule, are solid or have an insignificant cavity at the back or bottom to facilitate firing. The torso of Pluto is hollow with an opening in the legs, and is thus relatively light. The sculptor's method of developing his ideas explains these peculiarities: while working on the statue, Bernini often made several studies or models, one after another, and would then make a cast from them and reproduce them in clay. After having made the necessary changes and corrections, he would fire them. The torso of Pluto evidently was made in such a fashion, and thus belonged to one of the series of models made in Bernini's studio.

Besides the ones in the Hermitage, there is only one other known model
for the group *Abduction of Proserpina*, a head of Proserpina in terracotta. It moved
from the Palazzo Bernini in Rome, and is now preserved in the Cleveland
Museum of Art (see Wardropper, fig. 11).

BIBLIOGRAPHY: *Museo della casa*, pp. 22, 23; Petrov 1864, pp. 602, 604; Treu 1871, p. 52, no. 739;
Venice 1991, p. 55, no. 14; Kosareva 1993, p. 84.

David

HEIGHT 46 CM (18⅛ IN.). HEAD, ARMS FROM ABOVE THE
ELBOW, LEFT LEG ABOVE THE KNEE, AND THE TIPS OF TWO TOES
ON THE RIGHT FOOT ARE MISSING. RESTORATION SEAMS ON THE
RIGHT HIP AND LEFT ARM. MUCH SURFACE DAMAGE.
INV. NO. 662

In the Farsetti collection catalogue, this statuette was listed as "David Shooting a Sling, Bernini." In Georg Treu's catalogue, the statuette lost its title and the name of the artist, and was renamed *Running Youth*. It was entered into the Hermitage inventory under the same name, as an Italian work of the seventeenth century. This statuette is obviously a preliminary model for the marble *David*, which Bernini worked on from 1623 to 1624, a commission from Cardinal Scipione Borghese (now in Rome, Galleria Borghese). Many details differ between the terracotta fragment and the finished marble, such as the pedestal, harp, and lower part of the armor. The quality of this terracotta's execution is high enough to attest to Bernini's authorship. The fragment has been meticulously made, the surface of the body is smooth, and the details attentively crafted. The statuette clearly should be dated to 1623.

BIBLIOGRAPHY: *Museo della casa*, p. 22; Petrov 1864, p. 601; Treu 1871, p. 521, no. 747 or 748; Leningrad 1989, p. 15, no. 14; Venice 1991, p. 56, no. 15.

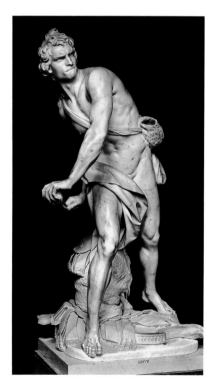

Bernini. *David*. Marble.
Rome, Galleria Borghese.

The Ecstasy of Saint Teresa

HEIGHT 47 CM (18½ IN.). HEAD, UPPER PART OF LEFT WING, RIGHT ARM,
PART OF PALM AND FINGERS OF THE LEFT HAND OF THE ANGEL MISSING;
TERESA'S RIGHT FOOT, MIDDLE FINGER OF THE RIGHT HAND, AND LITTLE FINGER
OF THE LEFT HAND MISSING. RESTORATION ON THE RIGHT WING OF THE ANGEL.
DAMAGE AND OLD CRACKS (FROM FIRING?) ON THE SURFACE.
INV. NO. 619

This group was listed in the Farsetti collection catalogue as "Saint Teresa in the Clouds with an Angel, Bernini." In Treu's catalogue of the Academy of Fine Arts, it was identified as a copy after Bernini's group. In fact, this is a study by Bernini for the monumental marble group *The Ecstasy of Saint Teresa*, executed from 1644 to 1647 on commission from Cardinal Federico Cornaro for the altar of the Cornaro family chapel in the church of Santa Maria della Vittoria in Rome. The group was listed in the Hermitage inventory as a work of Bernini, and was published by Zhannetta Matzulevich and in a series of Hermitage publications with the same attribution. Bernini's authorship of the work, however, has been a topic of dispute among authors internationally. Maurizio and Marcello Fagiolo dell'Arco and Rudolf Kuhn, compilers of the catalogue of Bernini's drawings, and Andrea Bacchi have all expressed doubts about the attribution. Hans Kauffmann and Irving Lavin rejected Bernini as the author of the piece. Rudolf Wittkower, who was unacquainted with the original, abstained from a final judgment.

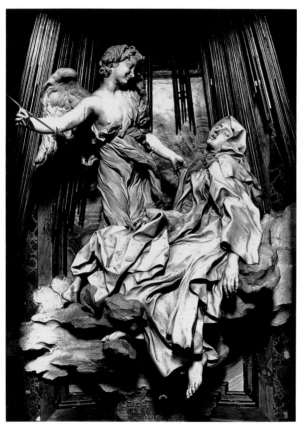

Bernini. *The Ecstasy of Saint Teresa*.
Marble. Rome, Santa Maria della Vittoria,
Cornaro Chapel.

To a large extent, the skeptical attitudes of the scholars can be explained by the poor reproductions of the group. When viewed firsthand, Bernini's authorship of the Hermitage *bozzetto* raises no doubts, owing to the lively modeling, which is particularly expressive in the painterly, flowing garments of the angel, and in the dynamic folds of the nun's clothing, hands, and suffering face.

Though the preparatory works for *The Ecstasy of Saint Teresa* are not well known, there is a drawing in the Museum der bildenden Künste in Leipzig, published by Heinrich Brauer and Rudolf Wittkower (Brauer and Wittkower 1931).

BIBLIOGRAPHY: *Museo della casa*, p. 24; Petrov 1864, p. 604; Treu 1871, p. 50, no. 703; Zaretskaia and Kosareva 1960, no. 22; Matzulevich 1963, p. 69; Wittkower 1966, p. 216; Fagiolo dell'Arco 1967, no. 130; Kuhn 1967, p. 5; Kauffmann 1969, p. 227; Kauffmann 1970, p. 152; Zaretskaia and Kosareva 1970, nos. 38–39; Zaretskaia and Kosareva 1975, nos. 38–39; Androsov, Kosareva, and Saverkina 1978, no. 37; Lavin 1980b, p. 202; Princeton 1981, p. 89; Leningrad 1984, pp. 40, 323, no. 370; Leningrad 1989, p. 16, no. 15; Venice 1991, p. 59, no. 16; Bacchi 1996, p. 781.

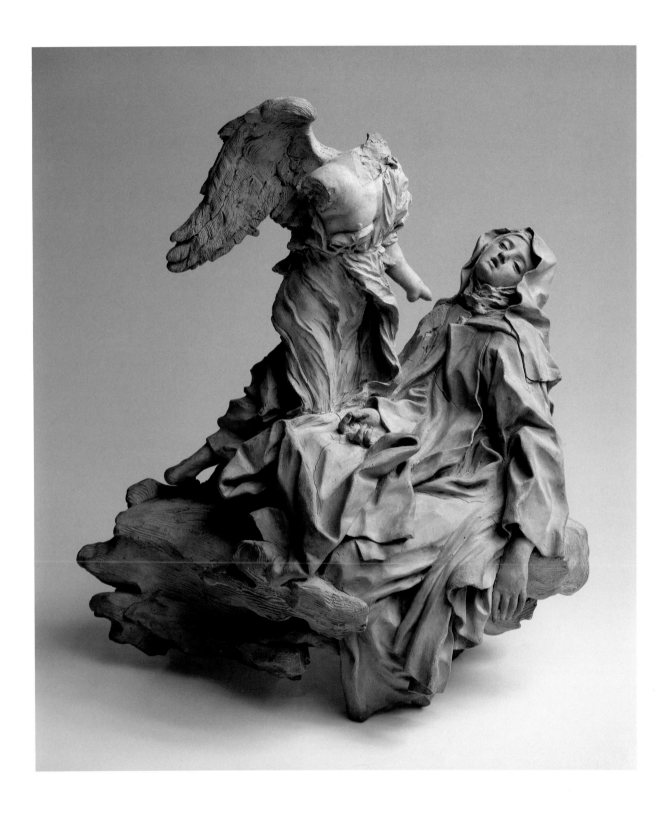

Tritons Holding Dolphins

HEIGHT 46 CM (18⅛ IN.). THE GROUP IS MODELED
SKETCHILY, AND MANY DETAILS ARE NOT COMPLETELY CLEAR.
RESTORATION SEAMS, CRACKS.
INV. NO. 602

In the catalogue of the Farsetti collection, the present group is evidently the one entered under the name "Model of the Fountain on the Piazza Navona by Bernini." However, Georg Treu called it "Fountain Group consisting of Tritons and dolphins; damaged study of terracotta. According to the catalogue of the Farsetti collection, by Algardi." It is true that a "Group of two Tritons by Algardi" is also listed in the catalogue of the Farsetti collection, but in support of our hypothesis that Bernini is the author, we note that we were unable to find in Treu's inventory a model for the fountain on the Piazza Navona (or a copy of it).

This group was nevertheless entered in the Hermitage inventory as a work by Algardi, and no efforts to study the work were undertaken for many years. The lively, extraordinarily energetic modeling of the bodies of the Tritons has nothing in common with Algardi's rather rigid manner of sculpting, and is characteristic instead of Bernini's style. A group similar in composition, in even more damaged condition, is preserved in the Staatliche Museen in Berlin. In that group, the upper portions of the dolphins and the head and raised hand of one of the Tritons have been lost. The design of the two groups and the manner of their execution have much in common: similar fashioning of the muscular, unclothed bodies, and especially of the fish tails that terminate the bodies of the Tritons.

Scholars consider the Berlin composition to be one of the studies for the fountain that Bernini made for the Piazza Navona in Rome, which later was named the Fontana del Moro. A drawing by Bernini preserved in the Royal Library at Windsor showing Tritons supporting dolphins is related to this same version of the fountain and is also extremely similar to the Hermitage group. Bernini himself, in the draft for the contract, gave the following description of the composition: "Marble for a group consisting of two Tritons and four fish will cost approximately 290 *scudi*" (D'Onofrio 1957, p. 72). However, in May 1653, Pope Innocent X, who commissioned the work that was begun at the end of 1651, approved a different version of the fountain, one with a statue of a standing Moor with a dolphin in his arms. It was in this form that the fountain was completed and exists to the present time.

Scholars have accepted the Berlin group as an unquestionable work of Bernini, and it is dated between May 1652 and May 1653 (Schlegel 1978, p. 10, no. 4). The Hermitage group is of no worse quality than the one in Berlin and should be accepted as a work of Bernini as well. By all indications, it was completed at the same general time (if slightly later) as the terracotta in Berlin. This assumption can be confirmed by two observations. First, the Berlin group is closer to the Windsor drawing than is the St. Petersburg group. Second, in the St. Petersburg terracotta, one of the Tritons has long, wavy strands of hair, as if combed. The

hair of the Moor in the final version and in the terracotta *bozzetto* by Bernini
(Rome, Museo di Palazzo Venezia) is treated in exactly the same manner. This
allows us to suggest that the Hermitage group is Bernini's reworking of the
project, a later version than that in Berlin.

BIBLIOGRAPHY: *Museo della casa*, pp. 21, 22; Petrov 1864, pp. 600, 603; Treu 1871, p. 42, no. 641; Androsov 1989, p. 69; Leningrad 1989, p. 16, no. 16; Androsov 1990, p. 9; Venice 1991, p. 60, no. 17.

Saint Ambrose

HEIGHT 46 CM (18⅛ IN.). RIGHT HAND MISSING.
BEARD AND EDGES OF FOLDS OF CLOTHING DAMAGED.
INV. NO. 624

The Farsetti collection catalogue listed this statuette as one of "the three doctors in episcopal dress, with books in their hands, in the cathedral of Saint Peter in Rome." Georg Treu considered all three terracottas to be copies after Bernini. The statuette is entered into the inventory of the Hermitage as a work of Bernini and has been reproduced with that attribution in other publications.

Work on Saint Peter's took approximately ten years, from 1657 to 1666. Bernini and his assistants worked on a number of sculptures and installations for the basilica. The bronze statue of Saint Ambrose, which stands to the left of Saint Peter on the pulpit, below the *Cathedra Petri*, was cast by early 1663. The first sketches for the *Cathedra Petri* evidently date from around 1657. Although Bernini's assistants Ercole Ferrata, Antonio Raggi, and Lazzaro Morelli were entrusted with the full-size models of the Church Fathers, the high quality of the Hermitage terracotta points to Bernini's own authorship. The extraordinarily deep and sharp folds of the draperies on the statuette are characteristic of Bernini's personal style.

Another, seriously damaged study for the same statue is preserved in a private collection in Rome. The quality of its execution is fairly high, but without acquaintance with the original it is impossible to make a definitive judgment as to whether it is a genuine study by Bernini or a studio replica (Mariani 1974, p. 96).

BIBLIOGRAPHY: *Museo della casa*, p. 20; Petrov 1864, p. 600; Treu 1871, p. 50, no. 708, 710, or 711; Zaretskaia and Kosareva 1970, no. 40; Zaretskaia and Kosareva 1975, no. 40; Leningrad 1989, p. 18, no. 19; Venice 1991, p. 62, no. 18.

Bernini. Detail of *Cathedra Petri*.
Vatican, Saint Peter's.

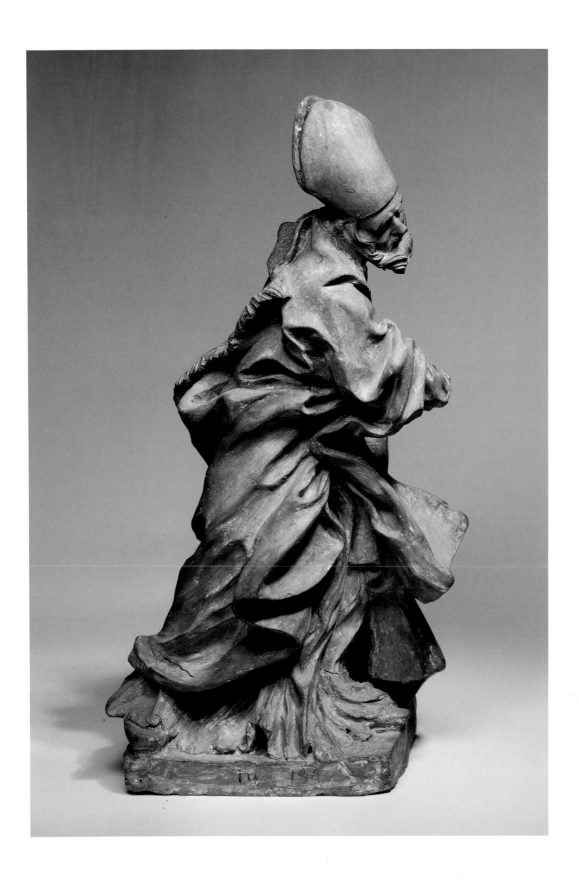

Constantine the Great

HEIGHT 45 CM (17¾ IN.). THE HORSEMAN'S HEAD, RIGHT HAND,
AND RIGHT FOOT; THE FRONT LEGS, A PORTION OF THE HIND LEGS,
AN EAR, AND THE TAIL OF THE HORSE; AND A CORNER OF THE
BASE UNDER THE FRONT LEGS OF THE HORSE ARE MISSING.
INV. NO. 673

This study is not mentioned in the first catalogue of the Farsetti collection, although there is a listing of "Louis XIV, King of France, on Horseback, Bernini." It is entirely possible that this is the statuette in question. The error in determining the subject may have been due to the similarity in composition, both in the figures of the two horsemen, and particularly in the similarity of the horses. The inventory compiled when the Farsetti collection was shipped to Russia correctly listed the statuette as "Constantine on a Horse, Work of Bernini," although it is not mentioned in Georg Treu's index. In the Hermitage inventory, it is mentioned as "Constantine the Great, Work of Bernini," and was published with the same attribution by Zhannetta Matzulevich. The exceedingly high quality of execution of the statuette leaves no doubt as to its authorship, and Bernini is acknowledged by all scholars, including Wittkower, Fagiolo dell'Arco, Rossacher, Herding, Kauffmann, Bacchi, and the authors of the exhibition catalogue of Bernini's drawings.

In 1654 Pope Innocent X commissioned from Bernini a colossal equestrian statue of the ancient Roman emperor Constantine the Great (274–337). It was meant to be a pendant to a monument of Countess Matilda of Tuscany (1046–1115) in the interior of Saint Peter's cathedral. Work on the statue proceeded for several years until it was interrupted. In 1662, when Bernini resumed work on it, it was no longer intended to be placed in the interior, but on the Scala Regia, in the portico of the cathedral. The statue of Constantine the Great was completed in 1668, although it was erected only in January 1669 and unveiled on November 1, 1670. As Rudolf Wittkower has correctly emphasized, the Hermitage statuette should be seen as relating to this second stage of work, begun in 1662. Hans Kauffmann agrees with this opinion, but Kurt Rossacher proposes the date of 1663 for the Hermitage terracotta, which is also possible. There are several preparatory drawings for the statue, but there is only one other sculptural study, in a private collection in Austria, published by Rossacher.

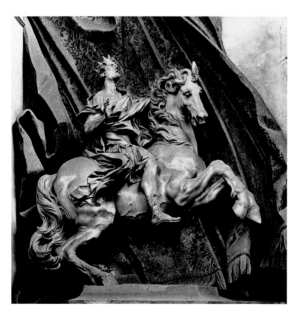

Bernini. *Constantine the Great*. Marble.
Vatican, Saint Peter's, Scala Regia.

BIBLIOGRAPHY: *Museo della casa*, p. 24; Petrov 1864, p. 602; Matzulevich 1963, p. 71; Wittkower 1966, p. 254; Fagiolo dell'Arco 1967, no. 198; Rossacher 1967, p. 9; Kauffmann 1970, p. 283; Herding 1970, p. 122; Princeton 1981, p. 144; Leningrad 1989, p. 17, no. 17; Venice 1991, p. 65, no. 20: Bacchi 1996, p. 783.

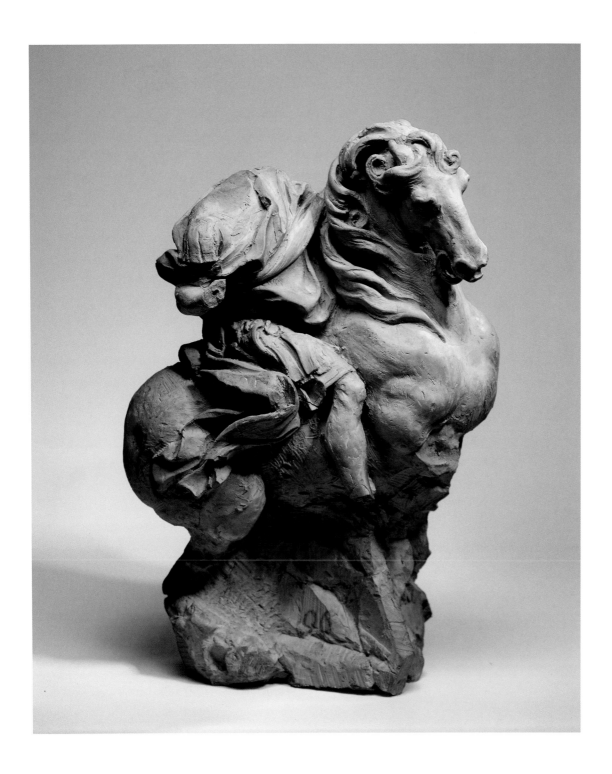

Angel with the Superscription

HEIGHT 33 CM (13 IN.). BOTH HANDS, AS WELL AS THE OBJECT IN THEM,
THE RIGHT WING, AND THE LOWER PART OF THE LEFT WING
ARE MISSING. OLD RESTORATION ON THE NECK. EDGES ARE
DAMAGED AND THE SURFACE IS WORN.
INV. NO. 629

Though the catalogue of the Farsetti collection mentions two models of angels, but with no indication as to who made them, it is obvious that the reference is to this model and catalogue number 18. The catalogue of the Academy of Fine Arts gives a more detailed description: "Angel with Cross, probably a copy of one of Bernini's angels on the so-called Ponte degli Angeli in Rome." Because the gesture of the arms—which are clearly holding something—brought to mind a cross, the statuette came to be listed in the inventory of sculptures of the State Hermitage as "An Angel with a Cross, the work of Bernini." In fact, this is a study for the statue of an angel holding a tablet with the inscription *INRI*, carved in 1669 for the Ponte Sant'Angelo in Rome and now preserved in the church of Sant'Andrea delle Fratte in Rome.

In 1667 Pope Clement IX hired Bernini and sculptors working with him to design and sculpt statues of angels with symbols of Christ's Passion to decorate the Ponte Sant'Angelo in Rome. Bernini made statues of two angels: one with the Crown of Thorns and one with the Superscription. The pope was delighted with them and, so that the originals might be preserved, ordered copies to be made for the bridge. The originals remained in Bernini's studio, and later his heirs presented them to Sant'Andrea delle Fratte.

There is a fairly large number of known preliminary works, including terracotta *bozzetti*, for the angel holding the inscribed tablet. Three *bozzetti* demonstrate the first stages of work and are preserved in the Museo di Palazzo Venezia in Rome; the Kimbell Art Museum in Fort Worth, Texas, formerly in the R. Davis collection; and the Harvard University Art Museums in Cambridge, Massachusetts. More similar to the completed marble statue is another study, also in the collection of Harvard University.

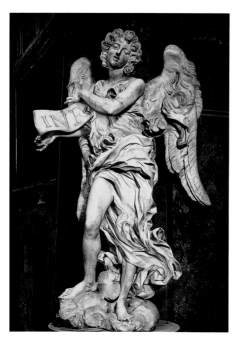

Bernini. *Angel with the Superscription.*
Marble. Rome, Sant'Andrea delle Fratte.

The positions of the figures and the gestures of the arms in the earliest sketches reveal the models' difference in the arrangement and design of the folds and in the gradual increase of dynamism and drama. For the most part, the Hermitage example is consistent with the second *bozzetto* from the Harvard University Art Museums, but apparently preceded it. (The left knee of the angel is exposed in the Hermitage statuette but covered by draperies in the Cambridge version and in the completed statue.) The Hermitage study is not of lesser quality than the other, which is accepted as a work of Bernini. Its execution should

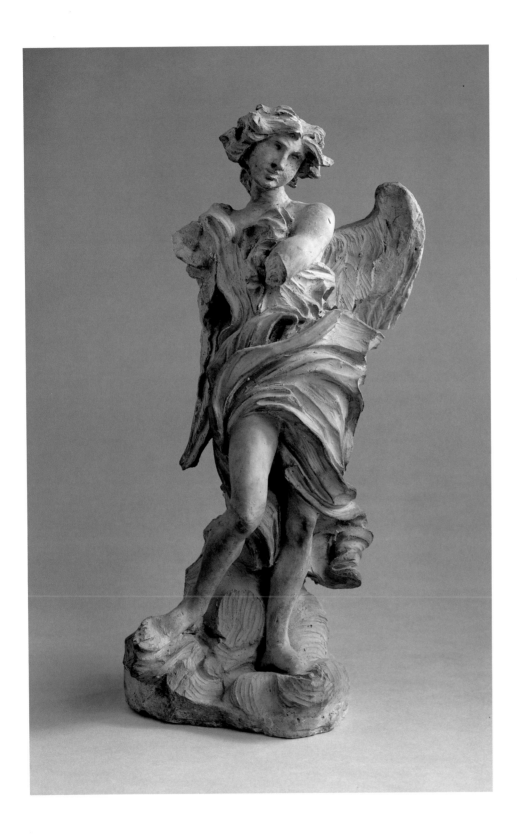

thus be fixed between late 1667 and early 1668. Bernini's authorship of the work is accepted by Andrea Bacchi as well.

BIBLIOGRAPHY: *Museo della casa*, p. 21; Petrov 1864, p. 601; Treu 1871, p. 51, no. 713 or 714; Leningrad 1989, p. 19, no. 20; Venice 1991, p. 66, no. 21; Bacchi 1996, p. 783; Athens 1996, p. 68.

<div align="center">18</div>

Angel with the Superscription

HEIGHT 32 CM (12⅝ IN.). HEAD, TOP OF RIGHT WING, LOWER TIPS OF
WINGS, OBJECT IN HANDS, AND RIGHT ARM TO ELBOW MISSING. CRACKS ON
BASE AND RIGHT LEG. BEHIND THE ANGEL, ON THE RECTANGULAR
PILLAR THAT TAPERS TOWARD THE TOP, IS A VERTICAL LINE MARKED AT
VARYING DISTANCES WITH LINES, WHICH WAS EVIDENTLY USED TO TRANSFER
THE DESIGN OF THE MODEL TO A MODEL OF LARGER DIMENSIONS.
INV. NO. 630

The similarity of this statuette to catalogue number 17 was evident already in the eighteenth century, and the two works are mentioned in the Farsetti collection under one number, as "Two models of angels," with no artist named. Georg Treu also called them "Angel with Cross, probably a copy of one of Bernini's angels on the so-called Ponte degli Angeli in Rome." The statuette was also entered in the Hermitage inventory as "An Angel with a Cross, the work of Bernini."

Irving Lavin published the Hermitage terracotta as a *bozzetto* for the second statue of an angel holding the Superscription, the final version of which was made by Giulio Cartari from 1670 to 1671 under the supervision of Bernini and erected on the Ponte Sant'Angelo. Mark Weil agreed with this attribution, noting that an old biography of Bernini emphasized the master's participation in the creation of the second statue of an angel with the Superscription. Maurizio and Marcello Fagiolo dell'Arco, Rudolf Wittkower, and Andrea Bacchi also accepted this attribution. A comparison of this terracotta with both versions of the angel with the Superscription (Rome, church of Sant'Andrea delle Fratte, and Ponte Sant' Angelo) reveals that it is a reevaluation of the statue in the church and closer to the one on the bridge. Particularly indicative is the scrolling of the mantle behind the angel's right leg, which exists only on the preliminary terracotta and on the Ponte Sant'Angelo statue. The quality of the statuette is similar to that of the other *bozzetto* by Bernini, and thus this piece should be acknowledged as the only Bernini study for the second angel with the Superscription surviving to our times. The marks on the back of the terracotta suggest that it was intended for immediate translation into marble at the indicated scale (see Wardropper, fig. 14). The terracotta should thus be dated between late 1669 and early 1670.

BIBLIOGRAPHY: *Museo della casa*, p. 21; Petrov 1864, p. 601; Treu 1871, p. 51, no. 713 or 714; Lavin 1967, p. 103; Fagiolo dell'Arco 1967, no. 220; Weil 1974, p. 81; Wittkower 1977, p. 199; Leningrad 1989, p. 19, no. 21; Venice 1991, p. 69, no. 22; Bacchi 1996, p. 783.

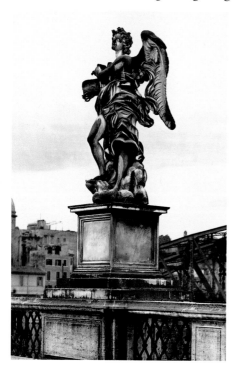

Cartari. *Angel with the Superscription.*
Marble. Rome, Ponte Sant'Angelo.

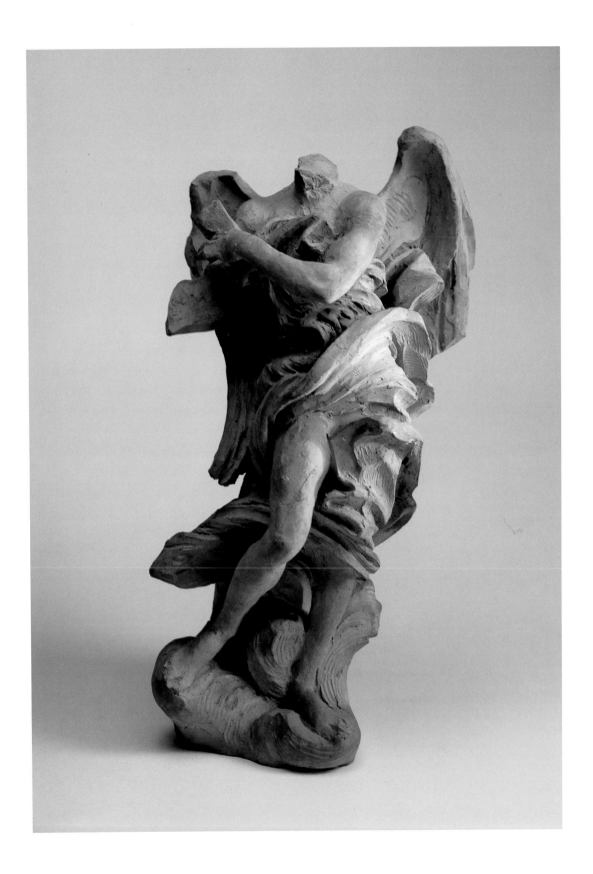

19

Angel with the Crown of Thorns

HEIGHT 43 CM (16⅞ IN.). A PIECE OF THE PEDESTAL, WITH HALF
OF THE LEFT FOOT, THE RIGHT FOOT, LEFT WING, TWO FINGERS
ON THE LEFT, AND ONE FINGER ON THE RIGHT HAND BROKEN OFF.
THE SURFACE IS WORN AND DAMAGED, PARTICULARLY ON THE
EDGES OF CLOTHING, WINGS, AND CROWN.
INV. NO. 628

In the catalogue of the Farsetti collection, in a section of original terracotta models, a statuette is entered as "Angel with the Crown of Thorns, Bernini." Georg Treu correctly suggested the connection between this statuette and Bernini's statue on the Ponte Sant'Angelo, but, in an error he often made, he identified it as a copy after Bernini. It was nonetheless entered in the inventory of the Hermitage as a work by Bernini, with a note as to its possible relation to one of the angels on the Ponte Sant'Angelo. The statuette was considered to be a work of Bernini and a *bozzetto* for the first *Angel with the Crown of Thorns* (Rome, church of Sant'Andrea delle Fratte). If this attribution of the statuette is convincing (Rudolf Wittkower accepted it as well), then an even more accurate interpretation was given by Mark Weil, who said that in reality it was Bernini's model for the second version of the *Angel with the Crown of Thorns*. This statue was executed from 1670 to 1671 by Paolo Naldini, under Bernini's supervision, for the Ponte Sant'Angelo. Jennifer Montagu (Montagu 1985b and 1989) supported Weil's opinion. The principal difference between the first and second statue is the direction in which the drapery falls: in the first, it falls from left to right, swirling at the left leg of the angel; in the second, it falls in the opposite direction. The Hermitage *bozzetto*

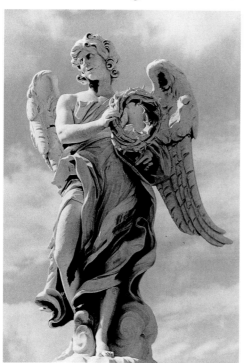

Naldini. *Angel with the Crown of Thorns*.
Marble. Rome, Ponte Sant'Angelo
[photo: Cesare D'Onofrio, *Gian Lorenzo
Bernini e gli angeli di ponte S. Angelo: Storia di un
ponte*, Rome, 1981, p. 108, plate 64].

evidently served as a model for Naldini and has been dated approximately to late 1669 or early 1670.

Other *bozzetti* of the *Angel with the Crown of Thorns* (two at the Harvard University Art Museums, Cambridge, Massachusetts; one at the Musée du Louvre, Paris; and one at the Kimbell Art Museum, Fort Worth, Texas, formerly in the R. Davis collection) evidently relate to the first version of the statue (Sant'Andrea delle Fratte).

BIBLIOGRAPHY: *Museo della casa*, p. 21; Petrov 1864, p. 602; Treu 1871, p. 51, no. 712; Wittkower 1966, p. 251; Weil 1974, p. 79; Androsov, Kosareva, and Saverkina 1978, no. 36; Leningrad 1984, p. 323, no. 369; Montagu 1985b, p. 33; Montagu 1989, p. 144; Leningrad 1989, p. 20, no. 22; Venice 1991, p. 70, no. 23; Bacchi 1996, p. 783.

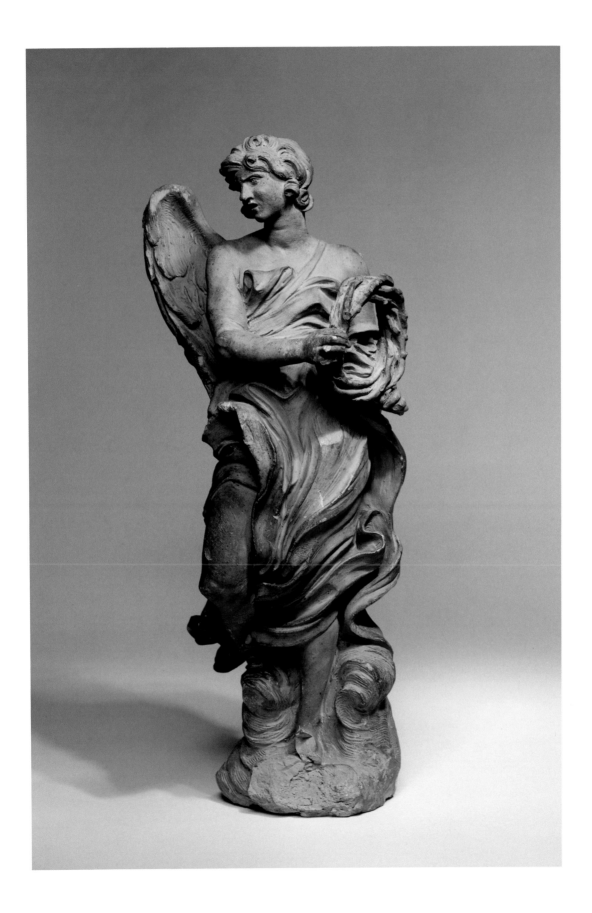

The Blessed Ludovica Albertoni

HEIGHT 24 CM (9½ IN.); LENGTH 48.5 CM (19⅛ IN.).
TWO TASSELS FROM CUSHIONS BROKEN OFF. SMALL CHIPS
ON FOLDS. A NUMBER OF SMALL CRACKS ON CLOTHING.
INV. NO. 614

In the catalogue of the Farsetti collection, this statuette is listed under the incorrect name "Saint Cecilia lying on the ground with hands on breast, by Bernini." In the packing lists for the collection, we find mention of two reclining figures by Bernini, called Saint Cecilia and Saint Praxedes. In his catalogue, Georg Treu mentioned the statuettes, but both by the title *Saint Praxedes*, and he considered them to be copies after Bernini.

In the State Hermitage, the statuette was correctly identified and registered in the inventory as a model for the tomb of the Blessed Ludovica Albertoni (1474–1535?) by Bernini. Nina Kosareva published it in 1974 as a model for the large marble statue portraying this holy woman that is located in the church of San Francesco a Ripa in Rome.

Bernini worked on the statue of the Blessed Ludovica from 1671 to 1674, under the patronage of Cardinal Paluzzo Paluzzi, a member of the Albertoni family, who had obtained the beatification of his ancestor, a devout nun of the Franciscan order. The Hermitage terracotta bears clear traces of the sculptor's tools, the daubing of the clay, and modeling by hand, resulting in an expressive, thrilling surface, which speaks to the fact that this is a model made in the process of work on the statue. It is not a final model, as it differs from the marble version in many details (couch, cushions, the folds of the clothing), although the figure's basic position seems to have been fixed at this point. The terracotta was evidently made shortly after Bernini began work, between 1671 and 1672. The attribution is accepted in publications of the Hermitage. The authors of the catalogue for an exhibition of Bernini's drawings, Michael Mezzatesta and Shelley Perlove, however, stated that the Hermitage statuette may be a copy after Bernini's original.

There are few known preliminary works and studies for *The Blessed Ludovica Albertoni*. A sketch now in the Leipzig Museum der bildenden Künste suggests Bernini's first plan for the sculpture. Two other related terracottas, which may not actually be the work of Bernini, are at the Musée des Beaux-Arts in Dijon, and in a private collection in Rome. Finally, the Victoria and Albert Museum in London recently acquired a terracotta statuette of

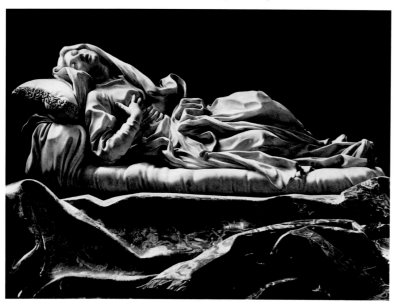

Bernini. *The Blessed Ludovica Albertoni*.
Marble. Rome, San Francesco a Ripa.

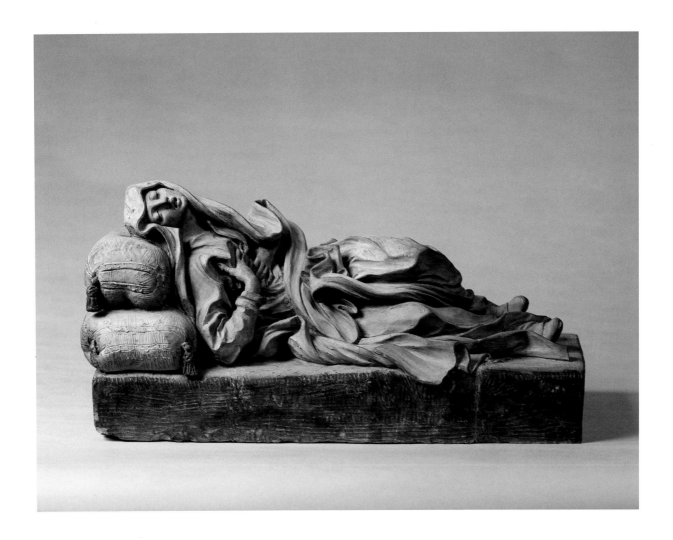

the subject, whose quality of execution is good, but whose condition is unfortunately poor. Its composition is closer to that of the final statue than is the Hermitage figurine.

BIBLIOGRAPHY: *Museo della casa*, p. 23; Petrov 1864, p. 603; Treu 1871, p. 50, no. 695 or 696; Kosareva 1974, p. 481; Androsov, Kosareva, and Saverkina 1978, no. 37; Princeton 1981, p. 306; Fort Worth 1982, no. 10; Perlove 1984, p. 71; Leningrad 1987, p. 151, no. 119; Leningrad 1989, p. 20, no. 23; Venice 1991, p. 72, no. 24.

21
Portrait of Gian Lorenzo Bernini

HEIGHT 46 CM (18⅛ IN.).
MANY DAMAGED PLACES AND RESTORATION SEAMS.
INV. NO. 565

In the catalogue of the Farsetti collection, a "Portrait of Bernini" with no indication of the artist is listed among "Heads of Fired Clay." This identification was not known to Georg Treu, who described the work as "Male portrait, Head of Terracotta; Characteristic work of the end of the seventeenth or beginning of the eighteenth century." Zhannetta Matzulevich first called into question the head from the Farsetti collection in her research at the Hermitage in the 1930s, but she made a full publication only in 1961, when she very convincingly proved that the head was a portrait of Bernini. Matzulevich proposed dating the portrait to the 1670s and related it to a drawing of the artist's tomb (Biblioteca Apostolica Vaticana). From there she concluded that Bernini had prepared his own tomb, for which an authoritative sketch was made. The head was thereafter reproduced in many Hermitage publications as a self-portrait by Bernini. Rudolf Wittkower, however, did not share Matzulevich's opinion, arguing that the drawing for Bernini's tomb was not executed by the master himself. It does appear that the Hermitage portrait is very similar to Arnold van Westerhout's well-known engraving after an original by Giovanni Battista Gaulli; the terracotta was perhaps modeled from that engraving.

Thus, if there is no doubt as to the terracotta's portrayal of Bernini, then Bernini's authorship of the piece seems improbable. To Wittkower's arguments a few more observations can be added. First, in no biographical or documentary source is there any evidence that Bernini had worked on his own monumental tomb. Second, recall that the portrait of Bernini was mentioned in the inventory of the Farsetti collection with no artist's name. Third, although the quality of execution of the head is fairly high, the treatment of the strands of hair seems too dry and rigid for them to have been done by Bernini himself.

We presume that the portrait of Bernini was done by one of his students in the last years of the master's life or immediately after his death. In this context, we point out the similarity of manner between the Hermitage terracotta and the marble busts of Cardinal Fausto Poli and Gaudenzio Poli from their tomb in the Roman church of San Crisogono. To this day, these expressive busts have no convincing attribution. Incidentally, in 1686 Filippo Titi, author of a description of Rome, wrote that Bernini had designed the architecture of the Poli chapel, and that the busts were executed from his drawings (Titi 1686, p. 146). It follows that the busts of both Polis were made in Bernini's studio, perhaps by the same artist who did the so-called self-portrait of Bernini at the Hermitage.

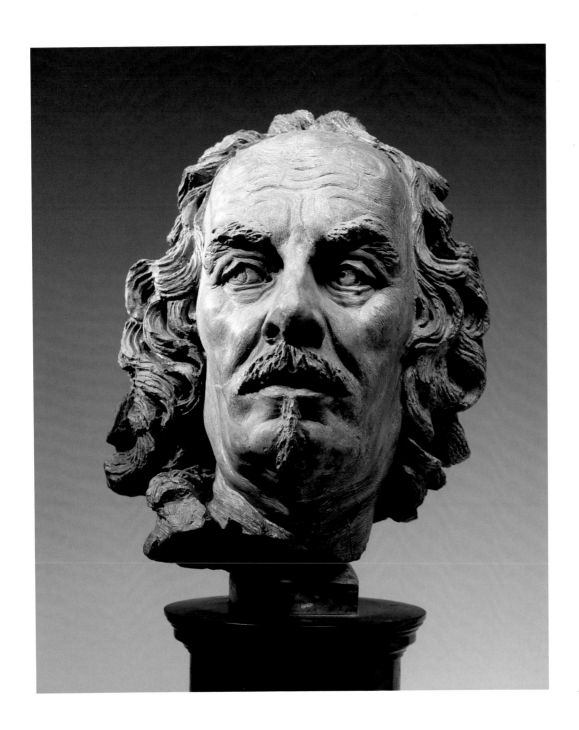

BIBLIOGRAPHY: *Museo della casa*, p. 20; Petrov 1864, p. 593; Treu 1871, p. 36, no. 578; Matzulevich 1945, p. 13; Livshits 1957, p. 52; Zaretskaia and Kosareva 1960, no. 20; Matzulevich 1961, p. 69, no. 1; Wittkower 1966, p. 273; Zaretskaia and Kosareva 1970, no. 41; Leningrad 1972, p. 117, no. 485; Zaretskaia and Kosareva 1975, no. 41; Androsov, Kosareva, and Saverkina 1978, no. 38; Leningrad 1987, p. 152, no. 120; Leningrad 1989, p. 22, no. 25; Venice 1991, p. 74, no. 26.

ERCOLE FERRATA

Pelsotto (Como) 1610–1686 Rome

22

Angel with the Cross

HEIGHT 59 CM (23¼ IN.). THE CROSS AND THE
RIGHT HAND OF THE ANGEL ARE MISSING.
INV. NO. 623

In the Farsetti collection catalogue, this statuette was entered as "Angel with the Cross," with no artist's name. Georg Treu's inventory listed it with the same designation. In the inventory of the Hermitage, it was considered a work of an unknown sculptor of the eighteenth century, and until recently there were no efforts to study it.

The statuette bears an unquestionable resemblance to the statue *Angel with the Cross* that Ercole Ferrata executed for the Ponte Sant'Angelo in Rome. According to the commission, work on the bridge took place between 1667 and 1671 under the supervision of Bernini. Ferrata received a marble block for work on the statue only on November 24, 1668, but on November 22 of the following year the statue was already standing on the bridge. A drawing made by Bernini or by someone in his studio that served Ferrata as a design has been preserved (Rome, Palazzo Rospigliosi). Comparison of this drawing with the Hermitage statuette and the completed statue clearly shows that the terracotta occupies an intermediary position between the sketch and the final version. The turn of the angel's head and the drapery folds on the left hip in the terracotta version are also to be seen, although with some changes, in the marble statue. The character of these changes, as well as the high quality of execution of the Hermitage statuette, gives every reason to consider it a fairly detailed, developed artist's model rather than a copy. An additional argument in favor of such an attribution is the mention in the posthumous inventory of the Ferrata estate, which was compiled on June 11, 1686, of a "small model of an angel of fired clay for the bridge of Mr. Ercole" (Golzio 1935, p. 72). It is possible that the Hermitage statuette is precisely this model. The attribution, first mentioned in the catalogue for the exhibition "Alle origini di Canova" and in two articles written previously but published later, was accepted by Andrea Bacchi as well.

It is evident from the documents that Ferrata began to receive money for work on the *Angel with the Cross* on July 31, 1668, before he received the marble block. One can assume

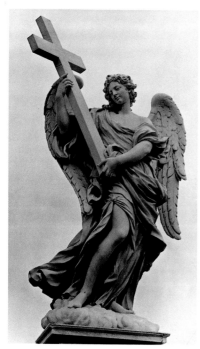

Ferrata. *Angel with the Cross.*
Rome, Ponte Sant'Angelo.

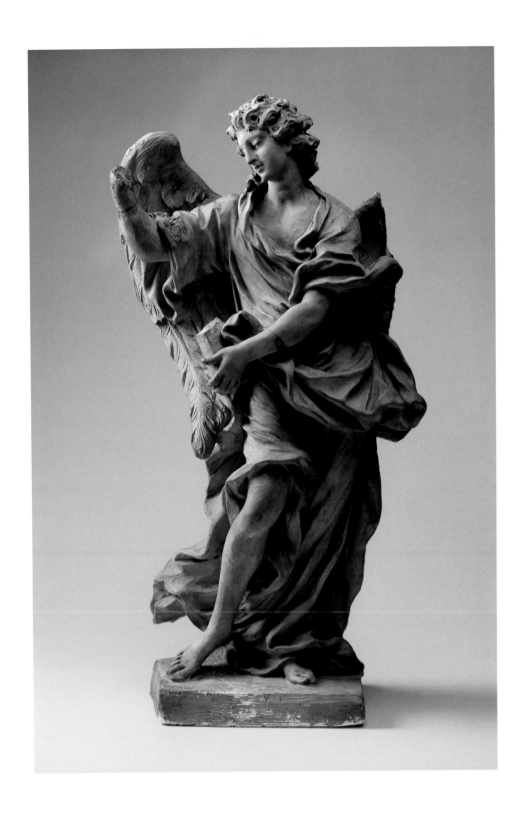

that *bozzetti* and models, including ones from fired clay, may have been done before work on the marble began. In that case, the Hermitage statuette can be dated to the first half of 1668.

BIBLIOGRAPHY: *Museo della casa*, p. 23; Petrov 1864, p. 600; Treu 1871, p. 50, no. 707; Venice 1991, p. 88, no. 37; Androsov 1992, p. 277; Androsov 1993, p. 107; Bacchi 1996, p. 803.

ATTRIBUTED TO FERRATA

23
Wrestling Boys

HEIGHT 24 CM (9½ IN.); LENGTH 24 CM (9½ IN.).
BOTH ARMS AND THE BIG TOE ON THE RIGHT FOOT OF THE KNEELING
BOY, AND THE RIGHT LEG, FINGERS OF THE LEFT HAND, AND THREE
FINGERS OF THE RIGHT HAND OF THE OTHER BOY ARE MISSING.
INV. NO. 586

Thanks to the well-preserved number 17 on the base, this group has been identified as the "two playing boys" by the artist Il Fiammingo (François Duquesnoy) mentioned in the Farsetti collection catalogue. Georg Treu considered them a copy after Duquesnoy.

The group was entered in the Hermitage inventory as a work by Duquesnoy, and it appeared in the catalogues for exhibitions in Leningrad and in Rome and Venice under that name. Arguments in favor of authorship by a Flemish artist hinged on the high quality of execution and the similarity of the faces and figures to those of the angels in the relief *Angels Playing Music* that Duquesnoy made for the Filomarino family chapel altar (Naples, church of Santi Apostoli).

Recently Ursula Schlegel advanced the hypothesis that the author of the Hermitage group was Ercole Ferrata. She offered as evidence the similarity of the boys' faces with the faces of the angels in Ferrata's reliefs. In her opinion, examples by Duquesnoy may have inspired Ferrata when he was designing the present group. Filippo Baldinucci (1847, p. 388) mentioned a group of works depicting a struggle between two putti by Ferrata, which remained in the sculptor's studio after his death. Although Schlegel offered no unquestionable proof of Ferrata's authorship, her hypothesis seems deserving of attention.

BIBLIOGRAPHY: *Museo della casa*, p. 25; Petrov 1864, p. 594; Treu 1871, p. 40, no. 622; Leningrad 1989, p. 26, no. 34; Venice 1991, p. 87, no. 36; Schlegel 1994, p. 283; Bacchi 1996, p. 804.

88

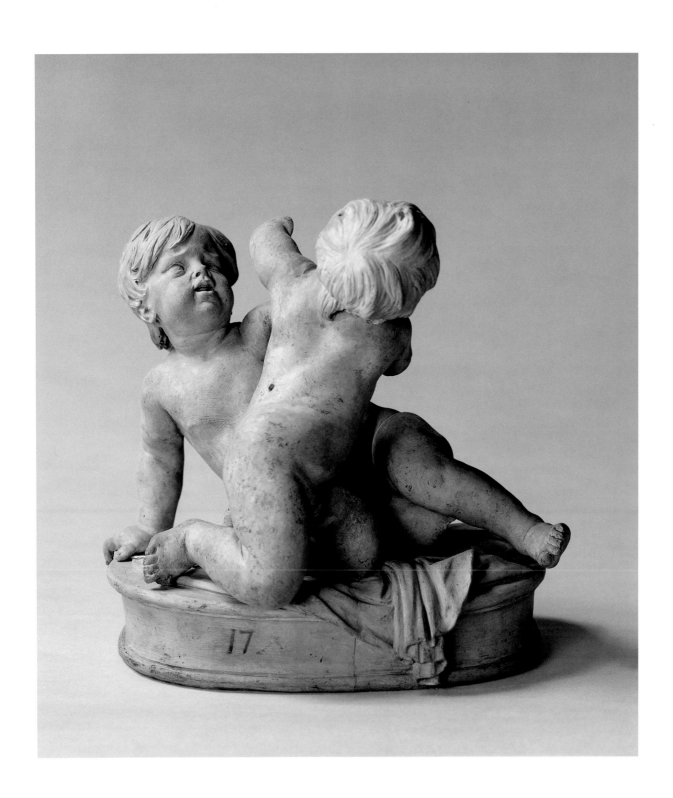

PAOLO NALDINI

Rome 1614–1691 Rome

24

Portrait of Annibale Carracci

HEIGHT 71 CM (28 IN.). EDGES OF FOLDS OF MANTLE AND
COLLAR BROKEN OFF. MULTIPLE RESTORATION SEAMS.
INV. NO. 569

In the catalogue of the Farsetti collection, this bust was listed as "Portrait of Annibale Carracci," with no artist named. Georg Treu dated the portrait to the end of the sixteenth century, within the painter's lifetime, but it was entered in the Hermitage inventory as an Italian work of the seventeenth century.

In the Protomoteca Capitolina at the Palazzo Senatorio in Rome, there is a corresponding marble bust of the painter Annibale Carracci (1560–1609), which came from his tomb in the Pantheon. This bust and its pendant, a portrait of Raphael, are, according to a tradition that goes back to the seventeenth century, the work of Paolo Naldini (Martinelli and Pietrangeli 1955, pp. 7, 29, 64, 80). According to Lione Pascoli, the busts were executed on commission from the painter Carlo Maratti (Pascoli 1730, vol. 2, p. 464). Maratti may have been involved not only in the commission but also in the execution of the busts, based on the evidence of an engraving by Pietro Aquila after a 1674 drawing by Maratti; the engraving depicts Carracci and Naldini in a pose similar to that of the bust. One may assume that Naldini worked on the busts of Carracci and Raphael for a long time and that they were completed and installed in the Pantheon only around 1674. Thus the date of the Hermitage bust may have been as early as 1660.

It is interesting to note the following entry in the inventory of Maratti's estate compiled after his death on April 28, 1712: "two *scabeloni*, carved, blackened, and gilded, with gilded terracotta busts; these are portraits: one of Annibale Carracci and the other of Raphael d'Urbino, models of those which Sig. Cav. Maratti ordered made for the Rotunda" (Bershad 1985, p. 76).

Comparison of the Hermitage terracotta with the bust from the Pantheon confirms the attribution of the terracotta to Naldini. It is softer and more finely executed and differs from the bust in Rome in certain details (the drawing of the folds was altered, one of the buttons is not fastened, etc.). Thus we have every reason to consider the Hermitage bust to be not a copy but a terracotta model made by Naldini during the process of working on the marble version. In such a case, it is

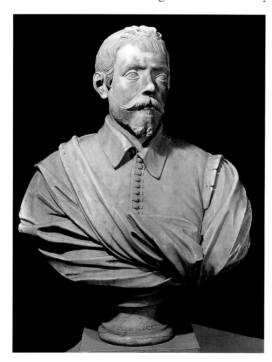

Naldini. *Bust of Annibale Carracci*. Marble.
Rome, Protomoteca Capitolina.

90

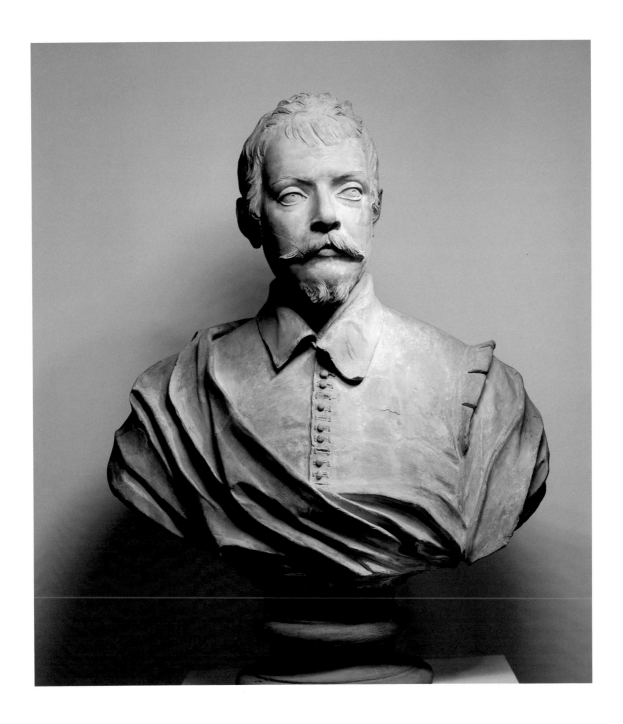

entirely justified to identify the Hermitage bust with the one described in 1712 as belonging to Carlo Maratti, particularly considering the characteristic sign of the gilding. The *Portrait of Annibale Carracci* from the Farsetti collection was unquestionably subjected to restorations and cleanings, but it seems to us that spots in the depths of the folds are traces of old gilding.

* *This entry is, to a great extent, based on materials kindly provided by Dr. Jennifer Montagu.*

BIBLIOGRAPHY: *Museo della casa*, p. 19; Petrov 1864, p. 593; Treu 1871, p. 36, no. 582; Leningrad 1989, p. 35, no. 52; Venice 1991, p. 114, no. 56; Bacchi 1996, p. 830.

DOMENICO GUIDI

Torano (Carrara) 1628–1701 Rome

25

Charity

HEIGHT 46 CM (18⅛ IN.); WIDTH 38 CM (15 IN.). THE HEAD OF THE BOY
SUPPORTING THE SHIELD, THE TOES OF THE RIGHT FOOT OF THE
WOMAN, AND PART OF THE BASE ARE BROKEN OFF. THE HEAD
OF THE WOMAN, THE LEFT LEG OF THE BOY IN HER ARMS, AND THE TOES
ON THE RIGHT FOOT OF THE RECLINING BOY HAVE BEEN RESTORED.
INV. NO. 658

The number 91 on the front of this group corresponds to its number in the Farsetti catalogue; in that list, this group was attributed to Francesco Moderati (c. 1680–1723), an evident mistake. Georg Treu listed it with no artist's name and in the Hermitage it was included in the inventory as a work by an Italian sculptor of the seventeenth century.

In fact, this piece is a preliminary model for a figure of Charity on the tomb of Orazio Falconieri and Ottavia Sacchetti in the Roman church of San Giovanni dei Fiorentini. The sculptor Domenico Guidi signed the contract for the execution of this statue on December 29, 1665, and in doing so committed himself, among other things, to making a small model and cutting a figure of Charity out of marble. In March 1669, *Charity* was erected at the place designated for it (Salerno, Spezzaferro, and Tafuri 1973, p. 251). Although there is no doubt about the general similarity of the Hermitage *bozzetto* to the marble group, there are also several differences between them. In the final version, the pose of the infant sleeping in the lower part of the sculpture has been altered, and there is more drapery on the figure of the putto holding a medallion. Also, instead of rays of light on the medallion, there are portraits of the deceased Ottavia Sacchetti in full-face and Orazio Falconieri in profile. All of these changes indisputably bear witness to the fact that the artist himself made the Hermitage terracotta. One can also assume that this is the very same model mentioned in the contract of 1665. What is more, a model, "one *Charity*," is also mentioned in the posthumous inventory of Guidi's estate, compiled in 1701, also possibly the same model as that in the Hermitage (Bershad 1971, p. 129). According to documentary evidence, this terracotta should be dated 1666.

BIBLIOGRAPHY: *Museo della casa,* p. 20; Petrov 1864, p. 600; Treu 1871, p. 52, no. 744 or 745; Leningrad 1989, p. 26, no. 33; Venice 1991, p. 95, no. 41; Androsov 1992, p. 274; Bacchi 1996, p. 811.

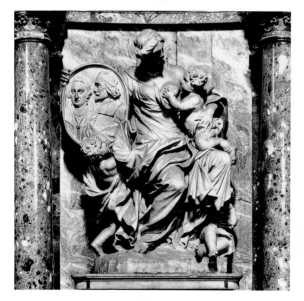

Guidi. *Charity* (detail of Monument to Orazio
Falconieri and Ottavia Sacchetti). Marble.
Rome, San Giovanni dei Fiorentini.

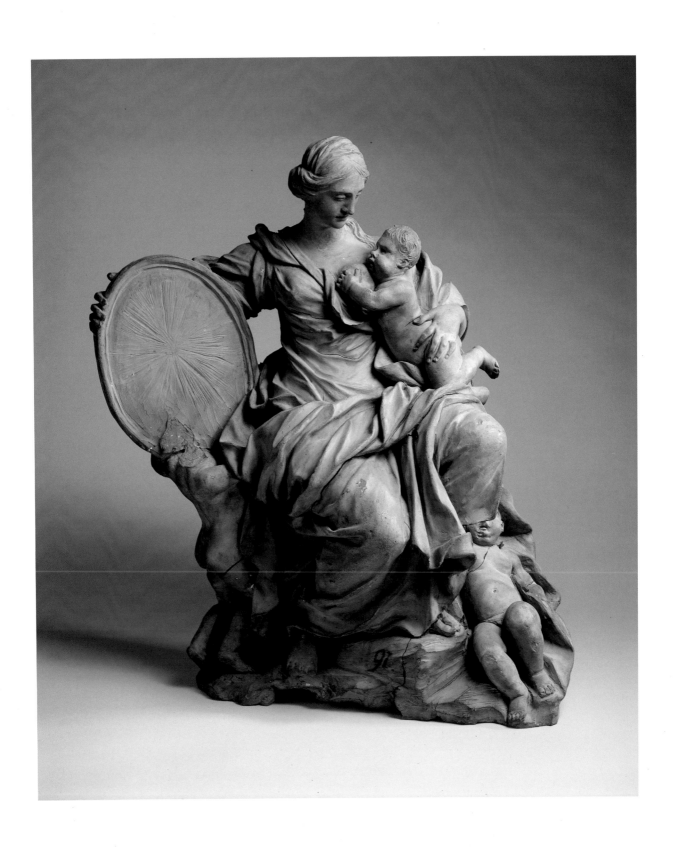

93

FILIPPO PARODI

Genoa 1630–1702 Genoa

26

Putto with a Skull

HEIGHT 29 CM (11⅜ IN.). SOLE OF THE LEFT FOOT
BROKEN OFF. SMALL CHIPS AND RESTORATION SEAMS.
INV. NO. 595

In the catalogue of the Farsetti collection, this statuette was listed without the name of an artist. Georg Treu considered it to be a work of the seventeenth or eighteenth century. In the 1920s, Zhannetta Matzulevich ascribed it to Giuseppe Bernardi Torretto (personal communication), apparently following scholarship on a similar statuette at the Museo Civico in Asolo that attributed the work to Torretto. It was published in 1975 as the work of an Italian master of the seventeenth century.

More recently, it has become possible to establish the terracotta as a model for a figure of a putto lying at the feet of Saint Francis of Assisi in the Cappella del Tesoro of the basilica of Sant'Antonio in Padua. The decoration of the chapel was one of the major works of the Genoese sculptor Filippo Parodi. A drawing of the chapel was presented by Parodi to a trustee on March 8, 1689, and on April 18, a contract was signed with the sculptor in which all the elements of decoration and statues were listed, including a *Saint Francis with a Crucifix in His Arms and with a Skull*. First to be executed, apparently, was a statue of Saint Anthony, which was erected in the cathedral on April 23, 1691. At the same time, Parodi began work on the statue of Saint Francis, for which he received payment beginning in April 1691, and on November 19 of the same year the completed statue was moved to the cathedral (Alvarez 1984, pp. 200–202).

The Hermitage statuette differs in a number of details from the final version, particularly in the eyes of the boy, which are here half-closed, and the lower part of his stomach, which has no decorative leaves on it. The high quality of execution of the terracotta confirms that this is a model made by the artist himself rather than a later copy. Judging by surviving documents, it should be dated to late 1690 or early 1691.

The statuette from the Asolo museum seems to be a work of lower quality than the Hermitage terracotta. It is likely that Bernardi Torretto only copied Parodi's composition.

BIBLIOGRAPHY: *Museo della casa*, p. 25; Petrov 1864, p. 593; Treu 1871, p. 42, no. 633; Zaretskaia and Kosareva 1975, no. 49; Leningrad 1989, p. 36, no. 53; Venice 1991, p. 116, no. 57.

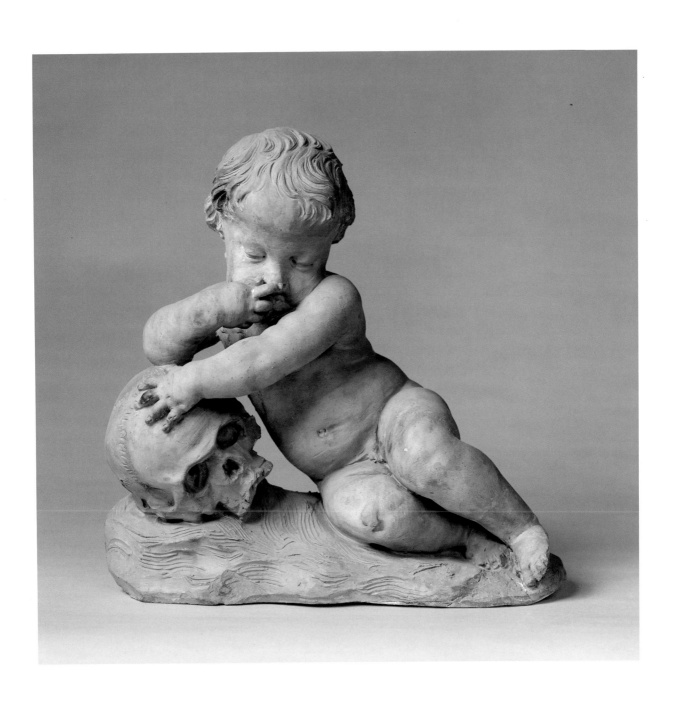

ANTONIO GIORGETTI

Rome 1635–1669 Rome

27

Head of an Angel

HEIGHT 35 CM (13¾ IN.). EDGES OF THE
BUST AND ENDS OF LOCKS OF HAIR DAMAGED.
INV. NO. 576

In the Farsetti collection, this work was listed among "Heads of Fired Clay" as "Angel by Bernini." Georg Treu called it a copy after Bernini. *Head of an Angel* was listed in the Hermitage inventory as being a work by Bernini. Phoebe Dent Weil suggested it might be a rare Bernini model of large dimensions. In fact, the angel's face is similar to the types of faces of the angels in the statues on the Ponte Sant'Angelo. For this reason the head was displayed in the Hermitage as a work from Bernini's studio.

Andrew Ciechanowiecki first noted the similarity between the Hermitage *Head of an Angel* and the face of the *Angel with the Sponge* created for the Ponte Sant'Angelo by Antonio Giorgetti (conversation with the author, London, 1988). The similarity is so striking that it is reasonable to assume that the Hermitage terracotta should be considered a *modello* after which Giorgetti fashioned the marble head. A close model, though one not brought to such a high degree of completion, belonged to the Heim Gallery in London. Described in the catalogue of the summer exhibition of 1983 as a work by a Roman sculptor of the third quarter of the seventeenth century (London 1983b, no. 26), it was later also described as a work by Antonio Giorgetti. This attribution for the Hermitage version was accepted in the catalogue for "Alle origini di Canova" (Venice 1991) and by Andrea Bacchi. Insofar as Giorgetti worked on the *Angel with the Sponge* in 1668 and 1669, and it was placed on the bridge on September 19, 1669, the Hermitage model should be dated 1668.

BIBLIOGRAPHY: *Museo della casa*, p. 20; Petrov 1864, p. 593; Treu 1871, p. 73, no. 589; Dent Weil 1978, p. 133 no. 128; Leningrad 1989, p. 22, no. 26; Venice 1991, p. 92, no. 39.

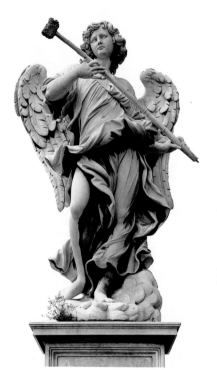

Giorgetti. *Angel with the Sponge.*
Rome, Ponte Sant'Angelo.

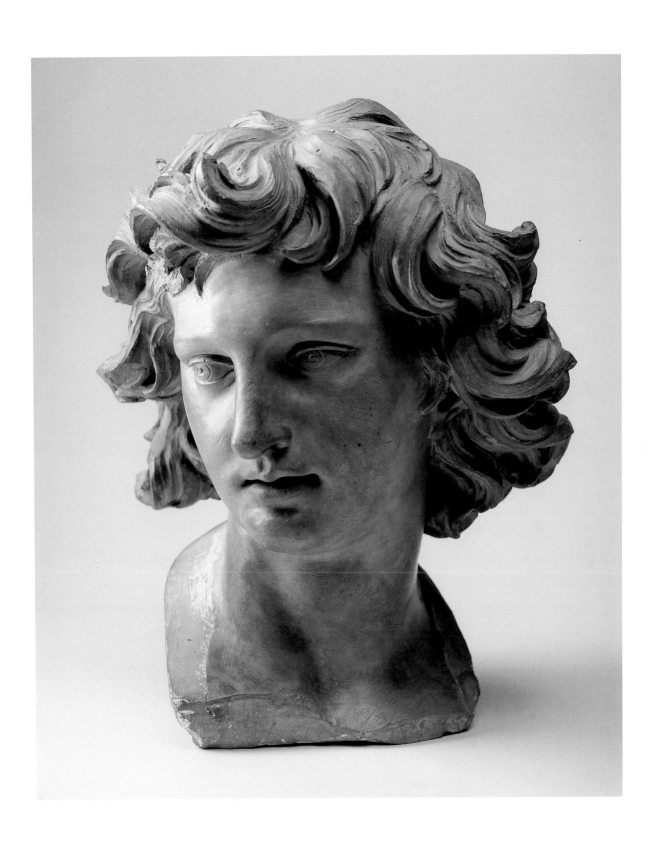

28

Lion

HEIGHT 24 CM (9½ IN.); LENGTH 40 CM (15¾ IN.).
GOOD CONDITION.
INV. NO. 640

This statuette appears in the inventory of the Farsetti collection as a work by Melchiorre Maltese, a name given to Caffà because he was born in the village of Vittoriosa on the island of Malta. Georg Treu considered the work a copy after Maltese. Liubov Latt published the statuette as unquestionably the work of Caffà, a *bozzetto* for the marble relief *The Martyrdom of Saint Eustace* (Rome, church of Sant'Agnese in Agone) that was executed in the studio of Ferrata and Giovanni Francesco Rossi. The attribution was accepted by both Rudolf Preimesberger and Elena Di Gioia, although rejected by Bruno Contardi. It is worth noting that the position of the lion in the Hermitage statuette corresponds fully neither with the position of the lions on the marble relief nor with the small terracotta *modello* (Rome, Museo di Palazzo Venezia). Nonetheless, Latt's suggestion that Caffà had to make studies of lions "in full roundness" when he was beginning work for the relief seems entirely convincing. The particularities of the anatomy of the lion's body are identical to those in the *modello*, and the very high quality of execution of the Hermitage terracotta confirms Caffà's authorship. Finally, it is plausible that the attribution of the statuette to Caffà in the inventory of the Farsetti collection dates from seventeenth-century evidence.

According to published documents, the *modello* from the Museo di Palazzo Venezia dates from 1659 to 1660, and, according to the contract signed in December 1660, Caffà was to make a large *modello* as well, on which he worked in 1661. One can assume that the Hermitage terracotta belongs to that same stage of work and was executed in late 1660 and early 1661.

BIBLIOGRAPHY: *Museo della casa*, p. 22; Petrov 1864, p. 603; Treu 1871, p. 51, no. 724; Latt 1964, p. 72; Preimesberger 1973, p. 231; Di Gioia 1986, p. 194; Rome 1989, p. 33; Leningrad 1989, p. 47, no. 35; Venice 1991, p. 80, no. 31.

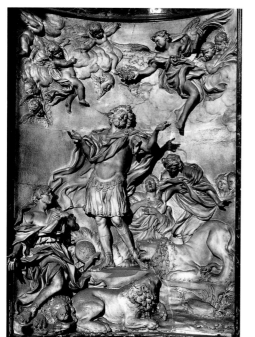

Ferrata. *The Martyrdom of Saint Eustace*.
Marble. Rome, Sant'Agnese in Agone.

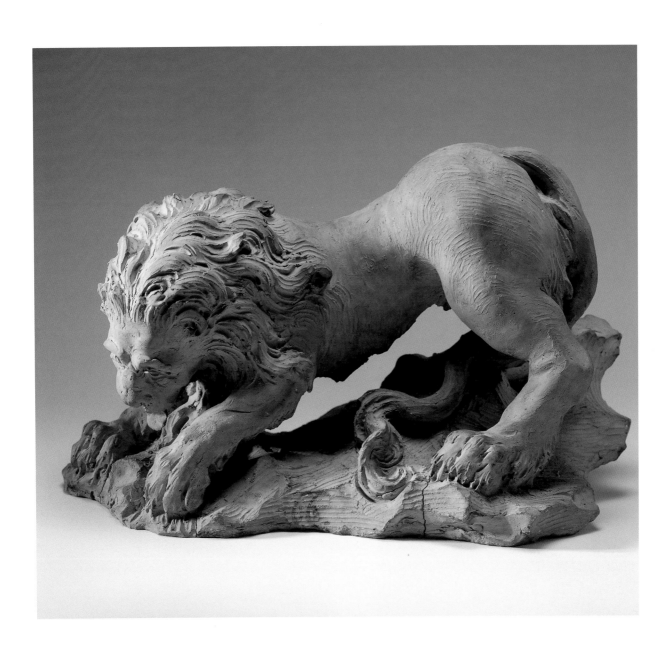

The Apostle Andrew

HEIGHT 44 CM (17 ⅜ IN.). GOOD CONDITION.
INV. 650

This statuette was included in the catalogue of the Farsetti collection, along with another, similar model of a slightly smaller size, under the name "Saint Andrew the Apostle, by Melchiorre Maltese." Georg Treu mentioned both terracottas as copies after an original by Maltese. Liubov Latt published this statuette as a work by Caffà, and she showed that the Hermitage figurine served as a sketch for the travertine statue of the apostle Andrew in a niche on the facade of the Roman church of Sant'Andrea della Valle, a work considered to be by Ercole Ferrata. Latt also expressed the opinion that the *bozzetto* by Caffà was used for the statue as well. Daniela Jemma accepted that attribution, which confirms that Ferrata habitually used the models and *bozzetti* of his co-workers. Rudolf Preimesberger, Ursula Schlegel (Schlegel 1978 and 1994), Jennifer Montagu, the authors of the commentaries to Lione Pascoli's *Lives*, and Andrea Bacchi all agree with the authorship of Caffà. Insofar as the attribution of the statuette to Caffà was entered into the inventory of the Farsetti collection in the eighteenth century and rests on an old tradition, it seems reasonably convincing.

Work on *The Apostle Andrew* for the facade of the church of Sant'Andrea della Valle was apparently carried out in 1664 and 1665. For that reason the Hermitage terracotta may be dated to around 1664.

A second statue of the apostle Andrew of smaller size is also preserved at the Hermitage. It is possible that both derived from an initial model, in turn, as Latt indicated. Schlegel (1994) published yet another model for the same statue, from a private collection, which she ascribes to Ferrata.

BIBLIOGRAPHY: *Museo della casa*, p. 22; Petrov 1864, p. 601; Treu 1871, p. 52, no. 733 or 734; Latt 1964, p. 76; Preimesberger 1973, p. 231; Jemma 1976, p. 84; Schlegel 1978, p. 52; Montagu 1989, p. 208; Leningrad 1989, p. 47, no. 36; Venice 1991, p. 82, no. 32; Pascoli 1992, p. 336; Schlegel 1994, p. 281; Bacchi 1996, p. 792.

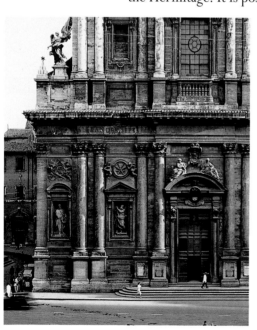

Rome, detail of facade of Sant'Andrea della Valle.

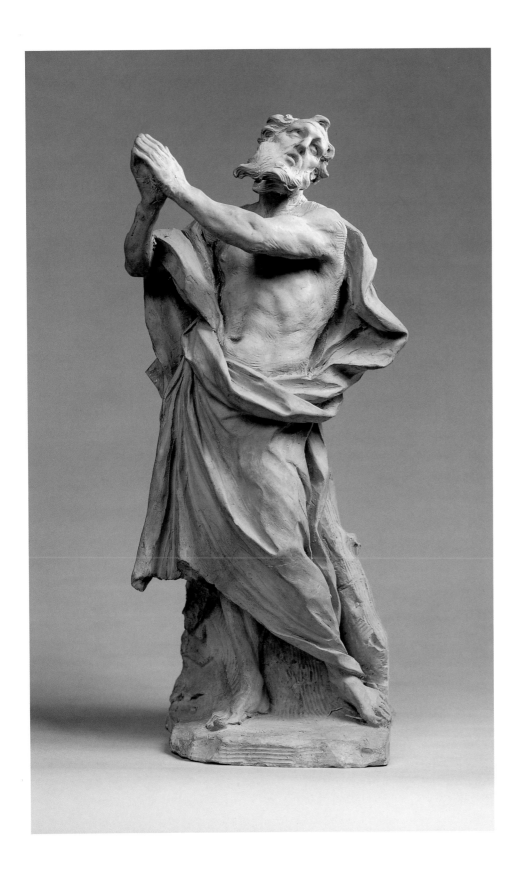

GIUSEPPE MAZZUOLI

Volterra 1644–1725 Rome

30

Charity Treading on Avarice

HEIGHT 42 CM (16½ IN.). HEADS OF THE CHILDREN
IN THE ARMS OF THE WOMAN AND AT HER RIGHT LEG ARE MISSING.
THE LATTER'S LEFT LEG BELOW THE KNEE IS ALSO MISSING.
INV. NO. 618

In the catalogue of the Farsetti collection, this statuette is listed as "Charity with Wrath at Her Feet, by Bernini." Georg Treu considered it a copy after Bernini. Although the attribution to Bernini was accepted at the Hermitage, the elongated proportions of the figure apparently raised some doubts. In fact, a slightly smaller bronze version of this same composition at the Staatliche Museen in Berlin was considered a work of an "Italian-Dutch artist of the seventeenth century," and Ursula Schlegel subsequently attributed it to Giuseppe Mazzuoli, dating it to the 1670s or early 1680s. Schlegel saw in the Berlin bronze similarities to the marble figure of Charity that Mazzuoli made between 1673 and 1675 under the supervision of Bernini for the tomb of Pope Alexander VII (Rome, Saint Peter's). In addition, Schlegel mentioned the terracotta statuette *Charity* (London, Victoria and Albert Museum), which she also attributed to Mazzuoli (Schlegel 1967, p. 388). A second version of the bronze, depicting Charity treading on Avarice and also attributed to Mazzuoli, was formerly stored at the Victoria and Albert Museum and subsequently sold at Christie's in London on April 21, 1982. A third version of the group is at the Museo Poldi-Pezzoli in Milan. The absolute correspondence of the composition of the three bronzes with that of the Hermitage terracotta justifies the suggestion that Mazzuoli is the author of the latter as well.

The only questionable aspect is the date of the bronze statuettes and the associated Hermitage terracotta. The elongated proportions and extraordinarily free rendering of the drapery folds on the St. Petersburg statuette demonstrate more similarity to Mazzuoli's works from the beginning of the eighteenth century than to works earlier in his career. The exquisite figure of Charity, in particular, is reminiscent of the figure of the servant in the terracotta group *The Death of Cleopatra* (Siena, Pinacoteca), dated around 1713. Schlegel correctly called attention to the similarity of the servant's pose to that of Charity on the tomb of Pope Alexander VII, and this convincingly establishes the interest that Mazzuoli had in Bernini, even in his old age. At the same time, this implies that the Berlin bronze need not necessarily be dated in the 1670s to 1680s range. Rather, it is much more convincing to change the dates to between 1710 and 1715.

BIBLIOGRAPHY: *Museo della casa*, p. 20; Petrov 1864, p. 601; Treu 1871, p. 50, no. 702; Leningrad 1989, p. 32, no. 446; Venice 1991, p. 106, no. 49.

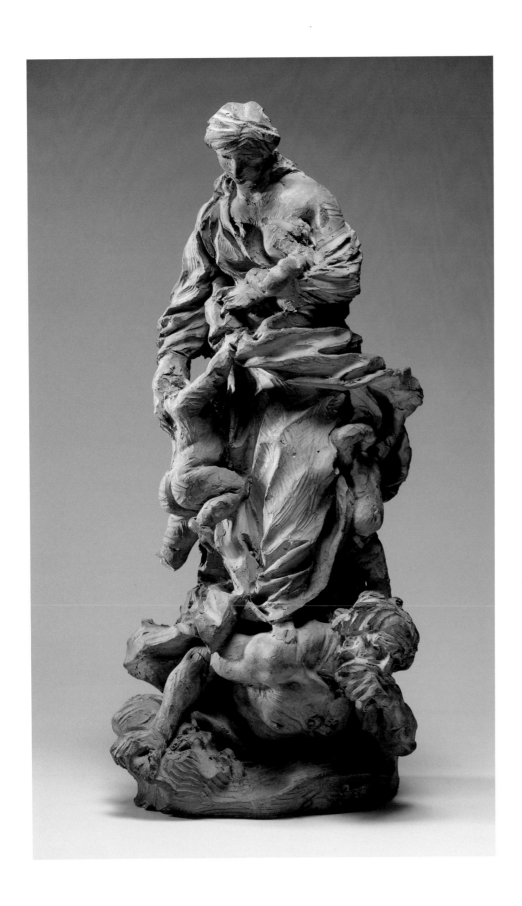

PIERRE ETIENNE MONNOT

Orchamps-Vennes 1657–1733 Rome

31
Cybele

HEIGHT 58 CM (22⅞ IN.).

TIP OF RIGHT FOOT AND TWO LEAVES BROKEN OFF.

TRACES OF RESTORATION.

INV. NO. 645

In the museum of the Academy of Fine Arts, this statuette was listed as "Goddess of the City (?)" with no identification of the artist. It was entered with the same description into the Hermitage inventory as the work of an Italian sculptor of the seventeenth century. In fact, the crown, made of city walls with towers, and the cornucopia are features of Terra (the personification of the earth). In the seventeenth century, Terra was often identified with the goddess Cybele. (For example, two firedogs executed in Algardi's studio for the Spanish king Philip IV, currently in the park at Aranjuez, depict Neptune as the sea and Cybele, wearing a similar crown, as the earth.) Indeed, the inventory and lists of the Farsetti collection mention a "Cybele by M. Mono." Evidently this "M. Mono" is Pierre Etienne Monnot. Comparison of *Cybele* with works by Monnot, such as the reliefs *Adoration of the Magi* and *Flight into Egypt* (both Rome, church of Santa Maria della Vittoria), reveals a definite similarity of types of women's faces and rich rendering of draperies. Judging by the resemblance to the reliefs, dated 1695 to 1699, the Hermitage statuette should be dated to the end of the seventeenth century.

As is well known, one of Monnot's major works was a group of marble statues and reliefs for the Marmorbad (Marble Pool) in Kassel. The sculptor worked on these statues (commissioned by Landgraf Karl von Hesse-Kassel) from the early 1690s to 1720. Although none of the statues from the Marmorbad corresponds exactly to the Hermitage terracotta, its theme and symbols are fully in the spirit of that complex of works. Therefore, the Hermitage statuette is considered a model for an unrealized or lost decorative statue.

BIBLIOGRAPHY: *Museo della casa*, p. 23; Petrov 1864, p. 600; Treu 1871, p. 52, no. 729; Leningrad 1989, p. 35, no. 51; Venice 1991, p. 112, no. 54.

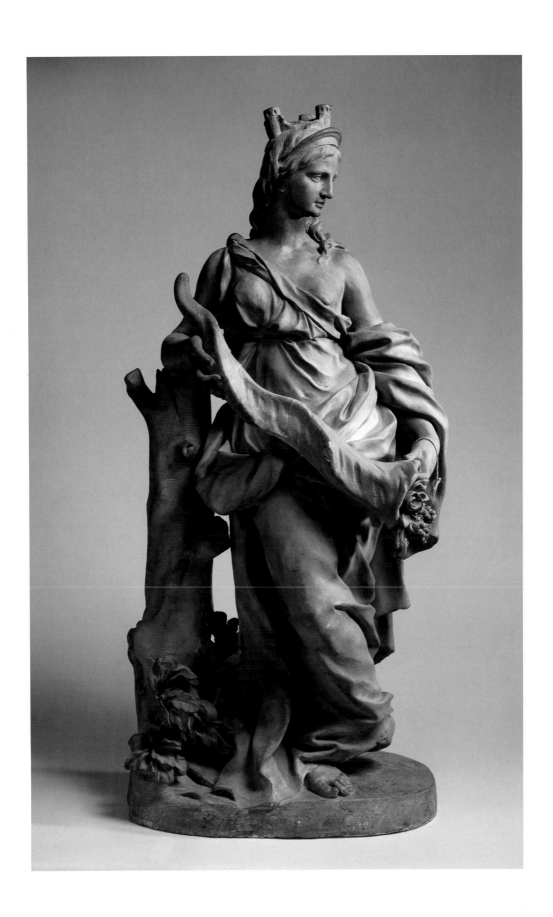

CAMILLO RUSCONI
Milan 1654/58–1728 Rome

32
Allegory of Winter

HEIGHT 27 CM (10 ⅝ IN.). HEAD OF BIRD IS MISSING.

INV. NO. 599

This statuette is described in the catalogue of the Farsetti collection as "Seated Puttino Personifying Winter, by Algardi." The name of the sculptor was not indicated in the packing lists compiled when the collection was sent to Russia. Georg Treu considered the terracotta to be a work of the seventeenth or eighteenth century. It was entered in the Hermitage inventory as the work of an Italian sculptor of the eighteenth century, and it was with this attribution that it was published in 1970, under the title *Allegory of Air.*

It was also in 1970, however, at the Heim Gallery in London, that a similar statue of larger dimensions (approximately 50 cm [19 ¾ in.] high) was exhibited and ascribed to Camillo Rusconi. Andrew Ciechanowiecki, who compiled the catalogue for the exhibition, indicated that the London terracotta was a model for one of the marble statues in a series depicting the Four Seasons, mentioned by eighteenth-century authors. Lione Pascoli explained further that the work was commissioned by Marchese Niccolò Maria Pallavicini, and on the death of the marchese, the marbles were sold in England (Pascoli 1730, vol. 1, p. 261. See also the evidence of Filippo della Valle, in Bottari and Ticozzi 1822–25, vol. 2,

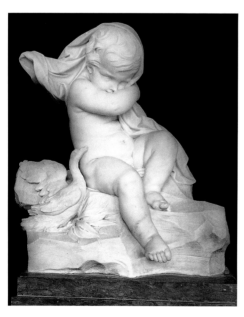

Rusconi. *Putto Personifying Winter.* Marble. London, Royal Collection in Windsor Castle. [photo: © Her Majesty Queen Elizabeth II].

p. 314). Francesco Baldinucci's detailed description of this series gives a basis for their identification (see Baldinucci 1975, p. 90). Based on the evidence of these sources, Ciechanowiecki proposed dating the Rusconi series before 1711 and noted that marble statues of putti depicting the Seasons are now in the royal collection in Windsor. He mentioned the Hermitage terracotta as well, but said mistakenly that at the Hermitage it is attributed to Duquesnoy. In addition, Ciechanowiecki considered a third terracotta version of this figure, preserved at the Museo di Palazzo Venezia in Rome, to be a much later copy than the London and St. Petersburg versions. The Heim Gallery statuette was acquired by the New York collector Arthur M. Sackler. Charles Avery, the author of the catalogue of that collection, repeated Ciechanowiecki's information.

The comparison proposed by the English researcher certainly seems convincing. The quality of execution of the

106

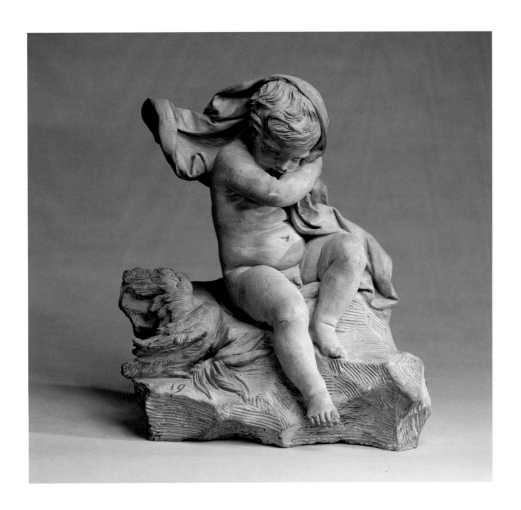

Hermitage terracotta is fairly high, and, judging by photographs, it is even superior in quality to the New York statuette. This supports the authorship of Rusconi for the version that came from the Farsetti collection. It is evidently a fairly detailed small model, whereas the New York version is a model of the size of the realized marble statuette. The attribution of the Hermitage statuette to Rusconi has been accepted by Maria Giulia Barberini, Stella Rudolph, and Andrea Bacchi.

It follows that, as Barberini has stated, the statuette *Winter* from the Museo di Palazzo Venezia, which came from the collection of Bartolomeo Cavaceppi, is an artist's *bozzetto* by Rusconi. The date Avery proposed for the series *The Seasons*, about 1700 to 1710, seems to Rudolph to be too late, and she suggests dating the series about 1692 to 1695.

BIBLIOGRAPHY: *Museo della casa*, p. 25; Petrov 1864, p. 593; Treu 1871, p. 42, no. 637; Zaretskaia and Kosareva 1970, no. 49; London 1970, p. 27; Washington 1981, p. 82; Leningrad 1989, p. 38, no. 56; Rome 1991, p. 66; Venice 1991, p. 118, no. 58; Rudolph 1995, p. 198; Bacchi 1996, p. 843.

Peter the Great on Horseback

HEIGHT 44 CM (17⅜ IN.); LENGTH 41 CM (16⅛ IN.). MAN'S HEAD,
ARMS, RIGHT LEG TO THE KNEE, AND LEFT FOOT, AS WELL AS THE FRONT
HOOVES OF THE HORSE, ARE LOST. THE ONLY PIECES REMAINING OF THE
FIGURE OF THE CONQUERED ENEMY ARE A PART OF THE LEFT LEG
AND A HAND RESTING ON THE CHEST OF THE HORSE.
INV. NO. 677

This statuette is listed in the catalogue of the Farsetti collection as "Tsar Peter on a Horse with a Figure Below, by Rusconi." This description was later forgotten; Georg Treu did not mention it, and the terracotta was entered in the Hermitage inventory as a work depicting a horseman by an unknown sculptor of the seventeenth century.

In 1985 Sergei Androsov proposed the identification of the present statuette with that mentioned in the Farsetti documents. He also suggested a historical reconstruction of the unrealized project for which this terracotta is a sketch. In early 1720, a certain Alessandro Salaroli in Rome sent to Nicola Michetti in St. Petersburg "two models, wax and clay, which depict the triumph of His I[mperial] M[ajesty]." Androsov proposed that the sender was the Florentine architect Alessandro Saller, who in 1721 wanted to work for the Russian court. Despite the disappearance of the two models sent to Russia, the statuette in the Farsetti collection, yet another replica of the lost composition, bears witness to one of the very first projects for an equestrian monument to Peter I.

This hypothesis was later somewhat refined. Alessandro Salaroli was a monk who was closely connected with Rusconi and supervised his work on the tomb of Pope Gregory XIII. He was also most likely the Alessandro Salaroli who sent the wax and clay models to Russia. These circumstances confirm the Farsetti inventory data regarding Rusconi's authorship. On the other hand, the correspondence of Russian agents in Italy gives us reason to assume that the project for an equestrian monument to Peter I could have been that of architect Nicola Michetti. From 1718 to 1723, he was in the Russian service, and by virtue of his connections in Rome he could have commissioned the monument from the most prominent contemporary sculptor, Camillo Rusconi. Yurii Kologrivov, sent to Italy to purchase sculpture, criticized that project as unsuccessful. Kologrivov complained in particular that Peter would not trample his enemies, as the terracotta shows the figure doing. He called the artist "this pauper sculptor Bernardino," which leads us to suppose that Bernardino Cametti was also involved in work on the project. By all indications, the model brought from Rome was not approved by Peter the Great and was subsequently destroyed. For further work on the equestrian monument, the Florentine sculptor Bartolomeo Carlo Rastrelli (1675–1744) was invited to St. Petersburg, and it was from his model that the monument was cast in 1747.

Robert Enggass's stylistic analysis of the statuette gives every reason to confirm the attribution of the statuette to Rusconi, as it was listed in the Farsetti collection catalogue (Androsov and Enggass 1994). Nevertheless, Andrea Bacchi doubted Rusconi's authorship and considers a possible attribution of the terracotta to Cametti worthy of attention.

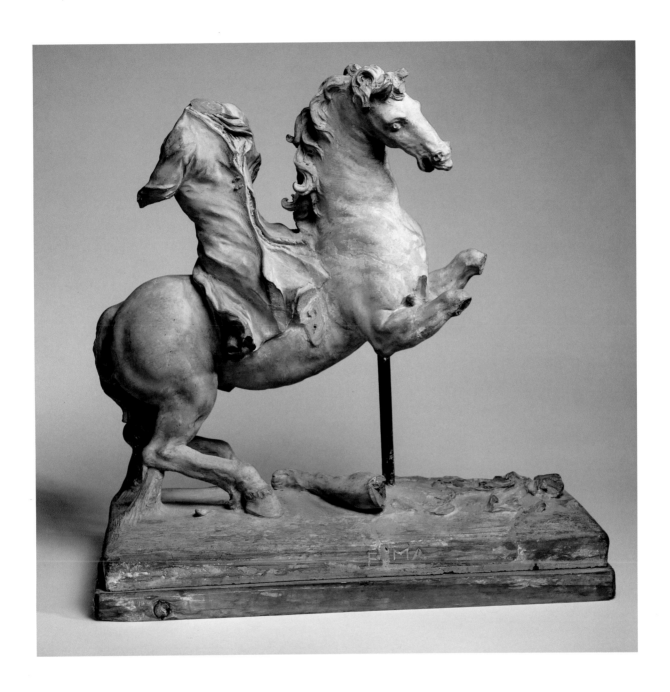

BIBLIOGRAPHY: *Museo della casa*, p. 23; Petrov 1864, p. 602; Androsov 1985, p. 88; Leningrad 1989, p. 40, no. 59; Venice 1991, p. 120, no. 59; Androsov and Enggass 1994; Bacchi 1996, p. 843.

PIERRE LEGROS (?)

Paris 1666–1719 Rome

34

Saint Francis Xavier

HEIGHT 58 CM (22⅞ IN.). EDGES OF MANTLE BROKEN OFF.

BOTH HANDS MISSING. TRACES OF RESTORATION.

INV. NO. 632

The only statuette listed in the Farsetti collection that may correspond to this terracotta is identified as "Saint Cajetan, preaching, by Carlo Monaldi." Georg Treu saw this as a copy after Monaldi. In the Hermitage inventory, the statuette is also attributed to Monaldi. However, a comparison of it with the marble statue *Saint Cajetan*, made by Carlo Monaldi in 1730 for Saint Peter's basilica in Rome, reveals that they have nothing in common.

Our opinion is that the Hermitage terracotta is more closely related to a marble statue, *Saint Francis Xavier*, completed in 1702 by Pierre Legros for the church of Sant'Apollinare in Rome. The pose of the two figures is almost identical, in reverse, and the clothing of the two, including the cascades of folds on the sleeves, is depicted similarly. One can also speak of a significant similarity of the faces framed by a small beard. All this leads to the suggestion that the Hermitage statuette is one of the studies for the statue *Saint Francis Xavier* that Legros made between October 1701 (when the contract for the statue was signed) and June 7, 1702 (when the sculptor received the first payment for his work). Legros's authorship has also been accepted by François Souchal. Another statue of smaller dimensions, also considered to be a study by Legros for the same statue, is preserved at the Museo di Roma (Di Gioia 1986, p. 208).

BIBLIOGRAPHY: *Museo della casa*, p. 23; Petrov 1864, p. 600; Treu 1871, p. 51, no. 716; Leningrad 1989, p. 29, no. 40; Venice 1991, p. 98, no. 43; Souchal 1993, p. 145; Bissell 1997, p. 64, fig. 31.

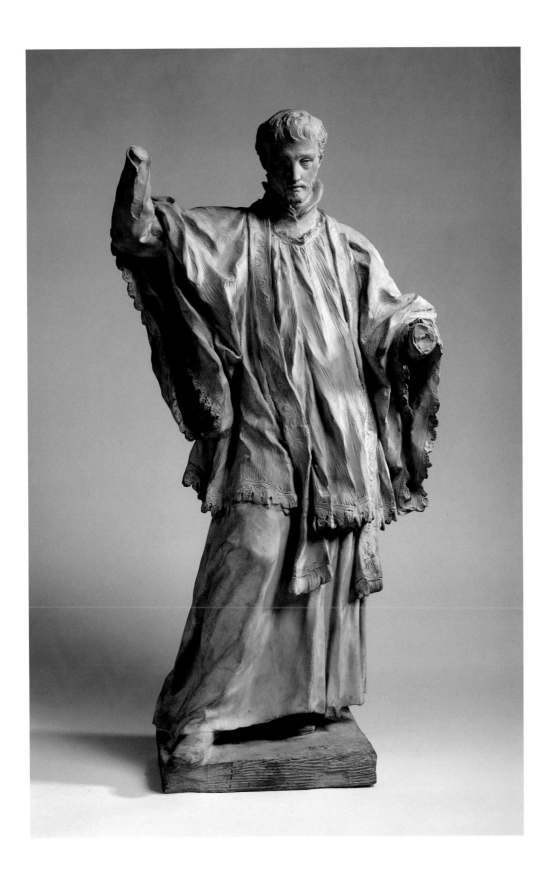

35

The Apostle James the Less

HEIGHT 55 CM (21⅝ IN.). HEAD, LEFT ARM, FOLDS OF MANTLE IN FRONT,
AND THE LEFT FRONT CORNER OF THE BASE ARE MISSING.
INV. NO. 676

The statuette is listed in the Hermitage inventory as a depiction of Saint John by an Italian sculptor of the seventeenth century. In fact, it is a study for a statue of the apostle James the Less made by Angelo de' Rossi for the basilica of San Giovanni in Laterano in Rome. De' Rossi apparently began work on this statue in 1705, and by the end of the year had prepared a large model. Work on the marble block took place from 1709 to 1711. The Hermitage statuette differs in some details from the marble statue, such as the rendering of the folds on the breast. Its execution is characterized by the freshness and lightness of an authentic sketch. It is apparent that sculptors hoping to receive a commission would present a model of approximately three *palmi* in size (about 67 cm, or 26⅜ in.). The Hermitage statuette is approximately this size. Finally, the attribution of the terracotta to de' Rossi is supported by the inventory of the Farsetti collection, which mentions a "Saint James the Great with Book in Hands by Angelo Rossi."

Regardless of discrepancies in the description, it is clear that the present statuette is the one in question.

In spite of the extensive damage, the high quality of execution of the Hermitage terracotta is convincing evidence that this is an artist's model for a statue rather than a later copy. Angelo de' Rossi's authorship has been accepted by Andrea Bacchi as well.

The suggested date for the Hermitage statuette is between 1704 and 1705.

BIBLIOGRAPHY: *Museo della casa*, p. 24; Petrov 1864, p. 600; Leningrad 1989, p. 37, no. 55; Venice 1991, p. 113, no. 55; Bacchi 1996, p. 840.

De' Rossi. *The Apostle James the Less*. Marble.
Rome, San Giovanni in Laterano.

Notes

THE FARSETTI COLLECTION IN ITALY AND RUSSIA

1. Vasari 1878, vol. 1, pp. 152–55. See also Lavin 1967.

2. Sandrart 1925, p. 286.

3. Biographical data on Filippo Farsetti and other members of the Farsetti family were taken from Vedovato 1994.

4. Leningrad 1989, p. 25, no. 32.

5. Memmo 1973, p. 60.

6. *Museo della casa*, pp. 35–38.

7. Vedovato 1994, p. 126.

8. Laste 1764.

9. Giuseppe Pavanello, in Venice 1978, p. 17, no. 9; p. 58, nos. 73, 74.

10. Antonio Canova, letter dated March 30, 1780, in Canova 1959, p. 112.

11. Je me suis addressé à Rome à un de nos Cavaliers qu'il s'y trouve actuellement, pensionne bien entendue dans le genre de Peinture et Sculpture, c'est le même qu'il avait obtenu la permission du Benoit XIV de tirer les copies de toutes les plus rares statues de Rome, et il en a porté ici les modèles pour instituer une académie de sculpture à les fraix (RGADA, area 17, file 276, sheet 31).

12. Vedovato 1994, p. 138.

13. Levi 1900, pp. 249–52.

14. *Museo della casa*.

15. Documents concerning the acquisition of the Farsetti collection are published in Russian in Androsov 1985, p. 84; see also Androsov 1983.

16. Korolev and Kuchumova 1987, p. 24.

17. Nepi-Scirè 1991, p. 24.

18. RGIA, area 789, list 1, part 1, file 1580.

19. Petrov 1864, p. 593.

20. Vio 1967, p. 10.

21. Androsov 1985, p. 85.

22. RGIA, area 789, list 1, part 1, file 2721.

23. Treu 1871.

24. Leningrad 1989.

25. Venice 1991.

26. Lavin 1978, p. 398.

SURVEYING THE HISTORY OF COLLECTING
ITALIAN SCULPTURAL MODELS

I wish to thank the staff of the Philadelphia Museum of Art Library and my departmental assistant, Erik Goldner, for their constant help with various aspects of research. I am grateful, too, for the comments of my colleague Ian Wardropper who read an advanced draft of this essay.

1. Valuable information about collecting terracottas and other sculptural models has emerged mostly since 1970; however, comments on collecting have generally appeared in studies devoted to investigating the function of preparatory sculptural models. I know of no substantial survey that focuses on the collecting of these models. Most of the important published references with comments about collecting are mentioned in their appropriate places below and were essential sources, I admit with gratitude, for this essay. A brief general survey in which comments about collecting appear is Avery 1996.

2. See Radke 1992. A useful English translation of Benedetto's inventory appears in Gilbert 1980, pp. 42–47. Dr. Andrew Butterfield kindly discussed aspects of Verrocchio's and Benedetto's models with me.

3. Rossi 1975, pls. 30–35.

4. Pope-Hennessy 1970a, pp. 186–95.

5. Rome 1994, p. 129, no. 65, fig. 116; and Athens 1996, pp. 48–49, no. 5.

6. Corti 1976, and Avery 1987, p. 237.

7. See Radke 1992.

8. For Verrocchio's models, see Radcliffe 1992, pp. 118–19.

9. Radke 1992, p. 218.

10. Avery 1987, p. 276, no. 192, and p. 277, no. 198.

11. Ibid.

12. Pope-Hennessy 1996, p. 443; and Ragionieri 1987, p. 64.

13. Boucher 1991, vol. 1, pp. 10–11; vol. 2, p. 316, no. 5. This monograph, a comprehensive treatment of the sculptor and his working methods, includes numerous references to Sansovino's preparatory models, both existing ones and others known from documents.

14. Pope-Hennessy 1970b, p. 16.

15. Avery 1987, p. 63.

16. Boucher 1991, vol. 1, p. 147; vol. 2, p. 318, no. 7.

17. See especially Watson 1978, pp. 33–41.

18. Pope-Hennessy 1985, p. 225.

19. Borghini 1584; Pope-Hennessy 1970b, p. 9; and Avery 1987, pp. 237–38.

20. Sweeny 1972, p. 18, no. 656, repr. p. 242; and Avery 1987, pp. 237–38.

21. Pope-Hennessy 1970b, p. 9; and Avery 1987, p. 237.

22. Vasari is quoted in Avery 1984, p. 171; also reprinted in Avery 1988, vol. 2, p. 25.

23. Corti 1976, pp. 630–34.

24. On *Kunst-* and *Wunderkammer*, see Hanover 1991.

25. Avery 1987; for pieces associated with Vecchietti, see nos. 163, 193, 197; and for those preserved by the Medici family, see nos. 186, 189, 192, 198.

26. Raggio 1983, p. 379 n. 51.

27. Montagu 1985a.

28. Golzio 1935.

29. For the Wallace Collection's bronze examples of the firedogs, see Montagu 1985a, vol. 2, nos. 129.c.2 and 130.c.3. They and other versions are discussed on pp. 409–13.

30. In addition to her 1985 monograph on Algardi, see also Montagu 1983.

31. The bibliography in which Bernini terracottas are discussed is large. The basic works, with comments of interest for the issue of collecting Bernini's terracottas, are Hibbard 1965; Wittkower 1966; Lavin 1967; Weil 1974; Lavin 1978; Lavin 1980a; Princeton 1981; Vatican City 1981; and Fort Worth 1982. An important reference, unavailable to me for this essay, is Lavin 1955.

32. Mezzatesta 1982, n. 23, citing Bernini, *Vita del Cavalier Gio. Lorenzo Bernino* (1713), pp. 161–62.

33. Washington 1981, p. 21; Avery 1996, p. 770.

34. See Borsi, Acidini Luchinat, and Quinterio 1981. The relevant pages of the 1706 inventory are reproduced on pp. 104–20.

35. Ibid., pp. 107, 120.

36. See especially, Weil 1974; Lavin 1978, p. 404; and Vatican City 1981, pp. 152–54, nos. 132–33.

37. For a bronze bust of Urban VIII after a terracotta model by Bernini, see New York 1982, p. 84, no. 26, ill.

38. For a papier-mâché relief of Suor Maria Raggi attributed to Bernini that belongs to the Museo Nazionale del Palazzo di Venezia, see Rome 1991, p. 37.

39. Hawley 1971.

40. See Raggio 1983.

41. By long tradition terracotta models were sometimes gilded for the benefit of patrons who commissioned sculptural projects (see Draper 1994). Beyond their decorative function, such additional layers protected the surface of the terracotta. Of course, the surface of statuettes could be given a coating at any time by later owners. Some of Flavio Chigi's terracottas in the Vatican were first gilded and later painted with a thick black coating. Multiple layers on terracottas are found fairly frequently on pieces that have not been cleaned in this century. It is also interesting to note that there are few references to gilded terracottas in the inventories of the models owned by the sculptors Ercole Ferrata and the Mazzuoli family.

42. Haskell 1971, p. 191.

43. Brinckmann 1924–25, vol. 2, pls. 17, 18.

44. Lavin 1975, p. 7, document 49, p. 465. For the model of the elephant and obelisk, see Wittkower 1966, pp. 247–48, no. 71.

45. Golzio 1935.

46. Duplessis 1959, p. 160, no. 1386.

47. Montagu 1985a, vol. 2, p. 361, 61.L.B. 4; and Montagu 1989, pp. 16, 200 n. 79.

48. Montagu 1989, pp. 16, 200 n. 80.

49. Ibid., p. 14.

50. Fusco 1988.

51. Butzek 1988.

52. Souchal 1973/74, especially p. 189; for Natoire, see Anne Poulet in Paris 1992, p. 127.

53. Howard 1982, p. 231. Also of interest for Cavaceppi is London 1983a.

54. See Gasparri and Ghiandoni 1993/94; and Rome 1994.

55. Cavaceppi's inventory of his terracotta collection is transcribed in Gasparri and Ghiandoni 1993/94, document 2, pp. 223–26. The inventory is reproduced and many pieces are identified with useful comments in Barberini 1994.

56. Howard 1982, p. 13.

57. Haskell 1971, pp. 362–63. Other information about Farsetti's collecting of casts after antiquities is to be found in Haskell and Penny 1981.

58. The 1788 catalogue of the Farsetti Museum is reproduced in facsimile in Venice 1991, pp. 140–53.

59. Rome 1994, p. 116.

60. Baker 1986.

61. Golzio 1933; and Fusco 1978, p. 227.

62. Pinto 1986, pp. 98–127.

63. Bacchi 1996, pl. 632.

64. Klaus Lankheit in Detroit 1974, pp. 120–25, nos. 81a–d, 82a–d.

65. Arisi 1986, pp. 465–67, nos. 471, 475.

66. Kenworthy-Browne 1979b.

67. Honour 1959.

68. Pope-Hennessy 1970b, p. 9; and Avery 1987, pp. 239–41.

69. See Kenworthy-Browne 1979a; and Kenworthy-Browne, in Ingamells 1997, pp. 709–11.

70. Avery 1987, pp. 237–39; and Ingamells 1997, pp. 608–09.

71. For Cosway's sculptural models, see Avery 1987, pp. 239–41; and especially, Edinburgh 1995, pp. 73–82.

72. Edinburgh 1995, p. 78; and Thornton and Dorey 1992, p. 126.

73. Pope-Hennessy 1970b, pp. 7–8.

74. Gasparri 1994, p. 60.

75. Rome 1991, pp. 14–18.

76. Ibid.

77. Venice 1991.

THE ROLE OF TERRACOTTA MODELS IN
ITALIAN BAROQUE SCULPTURAL PRACTICE

1. Useful studies on models in Italian sculpture include Lavin 1967; Montagu 1986; Dent Weil 1978, pp. 113–14; and Rome 1991. The major compilation of models of the Baroque period is Brinckmann 1924–25. Wittkower 1977 is a useful introduction to models in sculptural practice.

2. Golzio 1935.

3. Vasari 1878; Cellini 1901, p. 780.

4. Avery 1987, pp. 63–70.

5. *Bireno and Olimpia*, The Art Institute of Chicago, 1993.348. See London 1978, p. 121, no. 73; Florence 1986, p. 459, no. 4.37; and Berlin 1995, no. 24.

6. Fréart de Chantelou 1985, p. 24.

7. Androsov 1991, p. 296.

8. Venice 1991, pp. 134, 135, nos. 66, 67.

9. See Montagu 1985a, vol. 1, pp. 138–46.

10. Ibid., vol. 2, no. 48.B.1.

11. Ibid., vol. 2, no. 129.B.2.

12. Posse 1905.

13. Passeri 1934, p. 207.

14. Montagu 1983.

15. Montagu 1985a, vol. 2, nos. 8.L.B.1, 129.L.B.1, and 129.L.B.2.

16. Sandrart 1925, p. 286.

17. Fréart de Chantelou 1985, p. 24; see Wittkower 1951, p. 8.

18. Baldinucci 1966, p. 78. See Preimesberger and Mezzatesta 1996, p. 837.

19. Dent Weil 1978, fol. 56 and pp. 129–32.

20. Lavin 1978, pp. 400–01.

21. See Wittkower 1966, pp. 196–97, no. 28.

22. Baldinucci 1966, p. 78.

23. Princeton 1981, pp. 57–60, no. 1.

24. Wittkower 1966, pp. 4–5.

25. For the head of Proserpina, see Hawley 1971. See also Fort Worth 1982, no. 1.

26. See the explanation in the present cat. no. 11. It should be noted, too, that Renaissance authorities recommended attaching solid limbs to a hollowed torso and head for terracotta models, as is seen in Giambologna's *Florence Triumphing over Pisa*, fig. 4. Raffaello Borghini (Borghini 1584, pp. 115f.) also mentioned that the body and head of clay models should be made hollow.

27. See Walton 1982.

28. This is the suggestion of Olga Raggio, in New York 1982, p. 90, no. 32.

29. For the relationship of Bernini to his workshop, see Montagu 1985b; and Tratz 1988. For a comprehensive overview of workshop relations in Rome, see Montagu 1989.

30. See Weil 1974.

31. Montagu 1985b, p. 33.

32. For the use of scales on drawings and models, see Lavin 1967, pp. 103–04.

33. Bernini workshop, drawing for *Angel with the Cross*, formerly Rospigliosi coll., Rome; see Weil 1974, p. 42, fig. 25.

34. See Weil 1974, p. 42, fig. 26.

35. Dent Weil 1978, p. 132.

36. Fusco 1988. A pair of painted and gilded terracottas of Venus and Cupid and Narcissus and Echo (68 cm [26¾ in.] and 72 cm [28⅜ in.]), respectively, now on the art market, appear to be presentation models for the Marmorbad, although most of these models can be traced to the artist's studio at his death.

37. For an overview of this commission, see Broeder 1967.

38. Schlegel 1969.

Works Cited

Alvarez 1984
 Alvarez, Giulio Bresciani. "Il tardo barocco: L'opera di Filippo
 Parodi e di Giovanni Bonazza." In *Le sculture del Santo di Padova*,
 Giovanni Lorenzoni, ed., pp. 193–217. Venice, 1984.

Androsov 1981
 Androsov, Sergei O. "Of One Tradition in Italian Renaissance
 Art." In *Iskusstvo i religiya: sbornik nauchnykh trudov* (Art and
 religion: a collection of scholarly works), pp. 86–94. Leningrad,
 1981.

Androsov 1983
 Androsov, Sergei O. "Some Works of Algardi from the Farsetti
 Collection in the Hermitage." *Burlington Magazine* 125, 959 (Feb.
 1983), pp. 77–83.

Androsov 1985
 Androsov, Sergei O. "O kollektsionirovanii ital'yanskoy skul'ptury
 v Rossii v XVII veke" (On the collecting of Italian sculptures in
 Russia in the eighteenth century). *Trudy Gosudarstvennogo
 Ermitazha* (Studies of the State Hermitage) 25 (1985), pp. 84–91.

Androsov 1989
 Androsov, Sergei O. "Neizvestnoye proizvedeniye Dzhan Lorentso
 Bernini" (The unknown works of Gian Lorenzo Bernini). *Iskusstvo*
 12 (Dec. 1989), pp. 68–79.

Androsov 1990
 Androsov, Sergei O. "Neizvestnoye proizvedeniye Dzhan Lorentso
 Bernini" (The unknown works of Gian Lorenzo Bernini).
 Soobshcheniya Gosudarstvennogo Ermitazha (Newsletter of the
 State Hermitage) 54 (1990), pp. 9–10.

Androsov 1991
 Androsov, Sergei O. "Works by Stefano Maderno, Bernini,
 and Rusconi from the Farsetti Collection in the Ca' d'Oro and
 the Hermitage." *Burlington Magazine* 133, 1058 (May 1991),
 pp. 292–97.

Androsov 1992
 Androsov, Sergei O. "Proizvedeniya Ercole Ferraty i Domenico
 Gvidi v Ermitazhe" (Works of Ercole Ferrata and Domenico
 Guidi in the Hermitage). In *Pamyatniki kul'tury: Novye otkrytiya,
 Ezhegodnik 1990* (Monuments of culture: new discoveries, yearly
 1990). Moscow, 1992.

Androsov 1993
 Androsov, Sergei O. "Novye atributsii ital'ianskikh terrakot
 XVII–XVIII vv. V" (New attributions for Italian terracottas of the
 seventeenth and eighteenth centuries). In *Stranitsy istorii zapadno-
 evropeyskoy skul'ptury. Sbornik nauchnykh statey. Pamyati Zh. A.
 Matsulevich (1890–1973)* (Pages of history of western European
 sculpture: collection of scholarly articles in memory of Zh. A.
 Matzulevich [1890–1973]), pp. 106–21. St. Petersburg, 1993.

Androsov et al. 1988
 Androsov, Sergei O., Nina Kosareva, Michael Liebmann, and
 Charmian Mezentseva. *Western European Sculptures from Soviet
 Museums: Fifteenth and Sixteenth Centuries*. Yelena Bessmertnaya
 and Alexander Zhuravliov, trans. Leningrad, 1988.

Androsov and Enggass 1994
 Androsov, Sergei O., and Robert Enggass. "Peter the Great on
 Horseback: A Terracotta by Rusconi." *Burlington Magazine* 136,
 1101 (Dec. 1994), pp. 816–21.

Androsov, Kosareva, and Saverkina 1978
 Androsov, Sergei O., Nina K. Kosareva, and Irina Saverkina.
 The Hermitage: Sculpture. Tokyo, 1978.

Arisi 1986
 Arisi, Ferdinando. *Gian Paolo Panini e i fasti della Roma del '700.*
 Rome, 1986.

Athens 1996
 *Masterpieces of Renaissance and Baroque Sculpture from the Palazzo
 Venezia, Rome.* Exh. cat. by Shelley E. Zuraw et al. Athens,
 Georgia Museum of Art, University of Georgia, 1996.

Avery 1984
 Avery, Charles. "'La Cera sempre aspetta': Wax Sketch-Models for
 Sculpture." *Apollo*, n.s., 119, 265 (March 1984), pp. 166–76.

Avery 1987
 Avery, Charles. *Giambologna: The Complete Sculpture*. Oxford and
 Mt. Kisco, N.Y., 1987.

Avery 1988
 Avery, Charles. *Studies in European Sculpture*. 2 vols. London,
 1988.

Avery 1996
 Avery, Charles. "Modello, II: Sculpted." In *The Dictionary of Art*,
 Jane Turner, ed., vol. 21, pp. 767–71. New York, 1996.

Bacchi 1996
 Bacchi, Andrea. *Scultura del '600 a Roma*. Milan, 1996.

Baker 1986
 Baker, Malcolm. "Roubiliac's Models and 18th-Century English
 Sculptors' Working Practices." In *Entwurf und Ausführung in der
 europäischen Barockplastik*, exh. cat., pp. 59–83. Munich,
 Bayerisches Nationalmuseum, 1986.

Baldinucci 1847
 Baldinucci, Filippo. *Notizie dei professori del disegno da Cimabue in
 qua.... *Vol. 5. Florence, 1847.

Baldinucci 1966
 Baldinucci, Filippo. *The Life of Bernini*. S. Samek Ludovici, ed.
 (1948). Catherine Enggass, trans. University Park, Pa., 1966.

Baldinucci 1975
 Baldinucci, Francesco Saverio. *Vite di artisti dei secoli XVII–XVIII*
 (1682). Anna Matteoli, ed. Rome, 1975.

Barberini 1994
 Barberini, Maria Giulia. "I bozzetti ed i modelli dei secoli
 XVI–XVIII della collezione di Bartolomeo Cavaceppi." In
 Rome 1994 (see below), pp. 115–37.

Berlin 1995
 Von allen Seiten schön: Bronzen der Renaissance und des Barock. Exh.
 cat. Berlin, Altes Museum, 1995.

Bershad 1971
 Bershad, David L. *Domenico Guidi, a Seventeenth-Century Roman
 Sculptor*. Ann Arbor, Mich., and London, 1971.

Bershad 1985
 Bershad, David L. "The Newly Discovered Testament and
 Inventories of Carlo Maratti and His Wife Francesca." *Antologia di
 belle arti* 25–26 (1985), pp. 65–84.

Bissell 1997
 Bissell, Gerhard. *Pierre Le Gros, 1666–1719*. Reading,
 England, 1997.

Borghini 1584
 Borghini, Raffaello. *Il Riposo*. Florence, 1584.

Borsi, Acidini Luchinat, and Quinterio 1981
 Borsi, Franco, Cristina Acidini Luchinat, and Francesco
 Quinterio. *Gian Lorenzo Bernini: Il testamento, la casa, la raccolta
 dei beni*. Florence, 1981.

Bottari and Ticozzi 1822–25
 Bottari, Giovanni Gaetano, and Stefano Ticozzi. *Raccolta di lettere
 sulla pittura, scultura, ed architettura*. 8 vols. Milan, 1822–25.

Boucher 1991

Boucher, Bruce. *The Sculpture of Jacopo Sansovino*. 2 vols. New Haven, Conn., 1991.

Brauer and Wittkower 1931

Brauer, Heinrich, and Rudolf Wittkower. *Die Zeichnungen des Gianlorenzo Bernini*. Berlin, 1931.

Brinckmann 1924–25

Brinckmann, A. E. *Barock-Bozzetti, Italienische Bildhauer*. 4 vols. Frankfurt, 1924–25.

Broeder 1967

Broeder, Frederick Den. "The Lateran Apostles: The Major Sculpture Commission in Eighteenth-Century Rome." *Apollo* 85 (1967), pp. 360–65.

Butzek 1988

Butzek, Monika. "Die Modellsammlung der Mazzuoli in Siena." *Pantheon* 46 (1988), pp. 75–102.

Canova 1959

Canova, Antonio. *I quaderni di viaggio (1779–1780)*. Elena Bassi, ed. Venice and Rome, 1959.

Cellini 1901

Cellini, Benvenuto. *Trattato della scultura*. In *La Vita di Benvenuto Cellini*. A. J. Rusconi and A. Valeri, eds. Rome, 1901.

Corti 1976

Corti, Gino. "Two Early Seventeenth-Century Inventories Involving Giambologna." *Burlington Magazine* 118, 882 (Sept. 1976), pp. 629–34.

Dent Weil 1978

Dent Weil, Phoebe. "*Bozzetto-Modello*: Form and Function." In *Orfeo Bosselli: Osservazioni della scoltura antica*, Phoebe Dent Weil, ed., pp. 113–34. Florence, 1978.

Detroit 1974

The Twilight of the Medici: Late Baroque Art in Florence, 1670–1743. Exh. cat. The Detroit Institute of Arts and Florence, Palazzo Pitti, 1974.

Draper 1994

Draper, James David. "Some Mazzuoli Angels." In *Antologia di belle arti*, n.s., nos. 48–51 (1994), pp. 59–63.

Duplessis 1959

Duplessis, Georges. *Catalogue de l'oeuvre de Abraham Bosse*. Paris, 1959.

Edinburgh 1995

Richard and Maria Cosway: Regency Artists of Taste and Fashion. Exh. cat. by Stephen Lloyd, with Rou Porter and Aileen Ribeiro. Edinburgh, Scottish National Portrait Gallery; and London, National Portrait Gallery, 1995.

Fagiolo dell'Arco 1967

Fagiolo dell'Arco, Maurizio, and Marcello Fagiolo dell'Arco. *Bernini: Una introduzione al gran teatro del barocco*. Rome, 1967.

Florence 1986

Il seicento fiorentino: Arte a Firenze da Ferdinando I a Cosimo III. Exh. cat. Vol. 2. Florence, Palazzo Strozzi, 1986.

Fort Worth 1982

The Art of Gianlorenzo Bernini: Selected Sculpture. Exh. cat. by Michael P. Mezzatesta. Fort Worth, Kimbell Art Museum, 1982.

Fréart de Chantelou 1985

Fréart de Chantelou, Paul. *Diary of the Cavaliere Bernini's Visit to France (1885)*. Anthony Blunt, ed. Margery Corbett, trans. Princeton, N.J., 1985.

Fusco 1978

Fusco, Peter "L.-S. Adam's Adieu to Rome." *Antologia di belle arti* 2, nos. 7–8 (Dec. 1978), pp. 225–32.

Fusco 1988

Fusco, Peter. "Pierre-Etienne Monnot's Inventory after Death." *Antologia di belle arti*, nos. 33–34 (1988), pp. 70–77.

Gasparri 1994

Gasparri, Carlo. "La fine dello studio Cavaceppi e le collezioni Torlonia." In Rome 1994 (see below), pp. 57–64.

Gasparri and Ghiandoni 1993/94

Gasparri, Carlo, and Olivia Ghiandoni. "Lo Studio Cavaceppi e la collezioni Torlonia." *Rivista dell'istituto nazionale d'archeologia e storia dell'arte*, 3rd ser., 16 (1993/94).

Gilbert 1980

Gilbert, Creighton E. *Italian Art, 1400–1500: Sources and Documents*. Englewood Cliffs, N.J., 1980.

Di Gioia 1986

Di Gioia, Elena B. "'Casa e bottega del Cav. Francesco Antonio Fontana': Materiali dallo studio di uno scultore romano della seconda metà del '600." In *Archeologia nel centro storico: apporti antichi e moderni di arte e cultura dal Foro della Pace*, exh. cat., pp. 151–60. Rome, Museo Nazionale di Castel Sant'Angelo, 1986.

Golzio 1933

Golzio, Vincenzo. *Le terrecotte della R. Accademia di S. Luca*. Rome, 1933.

Golzio 1935

Golzio, Vincenzo. "Lo 'studio' di Ercole Ferrata." *Archivi*, 2nd ser., 2 (1935), pp. 64–74.

Hanover 1991

The Age of the Marvelous. Exh. cat. ed. by Joy Kenseth. Hanover, N.H., Hood Museum of Art, Dartmouth College, 1991.

Haskell 1971

Haskell, Francis. *Patrons and Painters: Art and Society in Baroque Italy*. New York, 1971.

Haskell and Penny 1981

Haskell, Francis, and Nicholas Penny. *Taste and the Antique*. New Haven, Conn., 1981.

Hawley 1971

Hawley, Henry. "A Terra-cotta Model for Bernini's Proserpina." *Bulletin of the Cleveland Museum of Art* 58 (April 1971), pp. 107–11.

Herding 1970

Herding, Klaus. *Pierre Puget: Das bildnerische Werk*. Berlin, 1970.

Hess 1931

Hess, Jacob. "Ein Spätwerk des Bildhauers Alessandro Algardi." *Münchner Jahrbuch der bildenden Kunst*, n.F., 8 (1931), pp. 292–303.

Hibbard 1965

Hibbard, Howard. *Bernini*. New York, 1965.

Honour 1959

Honour, Hugh. "Antonio Canova and the Anglo-Romans, Part I: The First Visit to Rome." *The Connoisseur* 143, 578 (June 1959), pp. 241–45.

Howard 1982

Howard, Seymour. *Bartolomeo Cavaceppi: Eighteenth-Century Restorer* (1958). Reprint, New York, 1982.

Ingamells 1997

John Ingamells. *A Dictionary of British and Irish Travellers in Italy, 1701–1800*. New Haven, Conn., 1997.

Jemma 1976
Jemma, Daniela. "Melchior Caffà Melitensis." Degree thesis. Rome, 1976.

Kauffmann 1969
Kauffmann, Hans. "Der Werdegang der Theresagruppe von Giovanni Lorenzo Bernini." In *Essays in the History of Art Presented to Rudolf Wittkower*, Douglas Fraser, ed., pp. 222–29. London, 1969.

Kauffmann 1970
Kauffmann, Hans. *Giovanni Lorenzo Bernini: Die figürliche Komposizionen*. Berlin, 1970.

Kenworthy-Browne 1979a
Kenworthy-Browne, John. "Establishing a Reputation, Joseph Nollekens: The Years in Rome—I." *Country Life* 165, 4274 (June 7, 1979), pp. 1844–48.

Kenworthy-Browne 1979b
Kenworthy-Browne, John. "Genius Recognised, Joseph Nollekens: The Years in Rome—II." *Country Life* 165, 4275 (June 14, 1979), pp. 1930–31.

Korolev and Kuchumova 1987
Korolev, E. V., and A. M. Kuchumova. "Antichnaya skul'ptura Pavlovska v 1918–1922 gg. i problemy muzeynoy spetsializatsii" (Pavlovsk antique sculpture in 1918–1922 and problems of museum specialization). In *Antichnoye iskusstvo v sovetskom muzeevedenii* (Ancient art in Soviet museum science), pp. 20–34. Leningrad, 1987.

Kosareva 1974
Kosareva, Nina. "A Terracotta Study by Gianlorenzo Bernini for the Statue of the Blessed Ludovica Albertoni." *Apollo*, n.s., 100, 154 (Dec. 1974), pp. 480–85.

Kosareva 1993
Kosareva, Nina K. "Dva terrakotovykh fragmenta iz sobraniya Farsetti" (Two terracotta fragments from the Farsetti collection). In *Stranitsy istorii zapadnoevropeyskoy skul'ptury. Sbornik nauchnykh statey: Pamyati Zh. A. Matsulevich (1890–1973)* (Pages of history of western European sculpture: collection of scholarly works in memory of Zh. A. Matsulevich [1890–1973]), pp. 82–91. St. Petersburg, 1993.

Kuhn 1967
Kuhn, Rudolf. "Die Unio mystica der hl. Therese von Avila von Lorenzo Bernini in der Cornarocapelle in Rom." *Alte und Moderne Kunst* 12, 94 (Sept./Oct. 1967), pp. 2–8.

Laste 1764
Laste, Natale dalle. *De musaeo Philippi Farsetti....* Venice, 1764.

Latt 1964
Latt, Liubov Yakovlevna. "Mel'khior Caffà i ego proizvedeniya v Ermitazhe" (Melchiorre Caffà and his works in the Hermitage). *Trudy Gosudarstvennogo Ermitazha* (Studies of the State Hermitage) 8 (1964), pp. 61–83.

Lavin 1955
Lavin, Irving. "The Bozzetti of Gianlorenzo Bernini." Ph.D. dissertation. Harvard University, Cambridge, Mass., 1955.

Lavin 1967
Lavin, Irving. "*Bozzetti* and *Modelli*: Notes on Sculptural Procedure from the Early Renaissance through Bernini." In *Stil und Überlieferung in der Kunst des Abendlandes*, Akten des 21. Internationalen Kongress für Kunstgeschichte in Bonn, 1964, vol. 3, pp. 93–104. Berlin, 1967.

Lavin 1975
Lavin, Marilyn Aronberg. *Seventeenth-Century Barberini Documents and Inventories of Art*. New York, 1975.

Lavin 1978
Lavin, Irving. "Calculated Spontaneity: Bernini and the Terracotta Sketch." *Apollo*, n.s., 107, 195 (May 1978), pp. 398–405.

Lavin 1980a
Lavin, Irving. *Bernini and the Unity of the Visual Arts*. 2 vols. New York, 1980.

Lavin 1980b
Lavin, Irving. *Bernini e l'unità delle arte visive*. Rome, 1980.

Leningrad 1972
Iskusstvo portreta: Katalog vystavki iz sobraniya Ermitazha (The art of the portrait: catalogue of an exhibition from the collections of the Hermitage). Exh. cat. Leningrad, State Hermitage Museum, 1972.

Leningrad 1984
The Hermitage State Museum. *Le Musée de l'Ermitage: L'art de l'Europe occidental*. Leningrad, 1984.

Leningrad 1987
The Hermitage State Museum. *Masterpieces of Western Art from the Hermitage, Leningrad*. Leningrad, 1987.

Leningrad 1989
Ital'ianskaia terrakotta XVII–XVIII vekov: Eskizy i modeli masterov barokko iz sobraniya Ermitazha (Italian terracottas of the seventeenth and eighteenth centuries: studies and models of the baroque masters from the collections of the Hermitage). Exh. cat. by Sergei O. Androsov and Nina K. Kosareva. Leningrad, State Hermitage Museum, 1989.

Levi 1900
Levi, Cesare Augusto. *Le collezioni veneziane d'arte e d'antichità del secolo XIV ai nostri giorni*. Vol. 2. Venice, 1900.

Livshits 1957
Livshits, Nina A. *Bernini*. Moscow, 1957.

London 1970
Paintings and Sculptures of the Baroque. Exh. cat., no. 12, autumn exhibition. London, Heim Gallery, 1970.

London 1978
Giambologna, 1529–1608: Sculptor to the Medici. Exh. cat. by Charles Avery and Anthony Radcliffe. Edinburgh, Royal Scottish Museum; London, Victoria and Albert Museum; and Vienna, Kunsthistorisches Museum, 1978.

London 1983a
Bartolomeo Cavaceppi: Eighteenth-Century Restorations of Ancient Marble Sculpture from English Private Collections. Exh. cat. by Carlos A. Picon. London, 1983.

London 1983b
Portraits and Figures in Paintings and Sculpture, 1570–1870. Exh. cat., no. 36, summer exhibition. London, Heim Gallery, 1983.

London 1988
European Works of Art and Sculpture. Sales cat. London, Sotheby's & Co., Dec. 8–9, 1988.

Mariani 1974
Mariani, Valerio. *Gian Lorenzo Bernini*. Naples, 1974.

Martinelli and Pietrangeli 1955
Martinelli, Valentino, and Carlo Pietrangeli. *La Protomoteca Capitolina*. Rome, 1955.

Matzulevich 1945
Matzulevich, Zhannetta A. "Avtoportret Bernini" (Self-portrait of Bernini). *Soobshcheniya Gosudarstvennogo Ermitazha* (Newsletter of the State Hermitage) 3 (1945), pp. 13–14.

Matzulevich 1961
Matzulevich, Zhannetta A. "Avtoportret Lorenzo Bernini" (Self-portrait of Lorenzo Bernini). *Iskusstvo* I (1961), pp. 69–73.

Matzulevich 1963
Matzulevich, Zhannetta A. "Tre bozzetti di G. L. Bernini all'Ermitage di Leningrado." *Bollettino d'arte*, ser. 4, 48 (1963), pp. 67–74.

Memmo 1973
Memmo, Andrea. *Elementi dell'architettura lodoliana* (1786). Reprint, Milan, 1973.

Mezzatesta 1982
Mezzatesta, Michael. "Introduction." In Fort Worth 1982 (see above), n.p.

Montagu 1983
Montagu, Jennifer. "Alessandro Algardi's *Saint Peter* and *Saint Paul* and the Patronage of the Franzoni Family." *Bulletin of the Detroit Institute of Arts* 61, 1–2 (Summer 1983), pp. 19–29.

Montagu 1985a
Montagu, Jennifer. *Alessandro Algardi.* 2 vols. New Haven, Conn., 1985.

Montagu 1985b
Montagu, Jennifer. "Bernini Sculpture Not by Bernini." In *Gianlorenzo Bernini: New Aspects of His Art and Thought,* Irving Lavin, ed., pp. 25–43. University Park, Pa., and London, 1985.

Montagu 1986
Montagu, Jennifer. "*Disegni, Bozzetti, Legnetti,* and *Modelli* in Roman Seicento Sculpture." In *Entwurf und Ausführung in der europäischen Barockplastik,* exh. cat., pp. 25–43. Munich, Bayerisches Nationalmuseum, 1986.

Montagu 1989
Montagu, Jennifer. *Roman Baroque Sculpture: The Industry of Art.* New Haven, Conn., 1989.

Museo della casa
Museo della casa eccellentissima Farsetti in Venezia (1788). Repro. in Venice 1991 (see below), pp. 140–53.

Nepi-Scirè 1991
Nepi-Scirè, Giovanna. "Le reliquie estreme del Museo Farsetti." In Venice 1991 (see below), pp. 23–29.

New York 1982
The Vatican Collections: The Papacy and Art. Exh. cat. New York, The Metropolitan Museum of Art; The Art Institute of Chicago; and Fine Art Museums of San Francisco, 1982.

D'Onofrio 1957
D'Onofrio, Cesare. *Le Fontane di Roma.* Rome, 1957.

Paris 1992
Clodion, 1738–1814. Exh. cat. by Anne L. Poulet and Guilhem Scherf. Paris, Musée du Louvre, 1992.

Pascoli 1730
Pascoli, Lione. *Vite de' pittori, scultori, ed architetti moderni.* 2 vols. Rome, 1730.

Pascoli 1992
Pascoli, Lione. *Vite de' pittori, scultori, ed architetti moderni* (1730–36). Perugia, 1992.

Passeri 1934
Passeri, Giovanni Battista. *Vite de' pittori, scultori, et architetti dall'anno 1641 sino all'anno 1673.* Jacob Hess, ed. Leipzig and Vienna, 1934.

Perlove 1984
Perlove, Shelley K. "Gianlorenzo Bernini's *Blessed Lodovica Albertoni* and Baroque Devotion." Ph.D. dissertation. Ann Arbor, Mich., 1984.

Petrov 1864
Petrov, Petr Nikolaevich. *Sbornik materialov dlya istorii imperatorskoy S-Peterburgskoy Akademii khudozhestv . . . chast' 1* (Collection of materials for the history of the imperial Saint Petersburg academy of the fine arts . . . Part 1). St. Petersburg, 1864.

Pinto 1986
Pinto, John A. *The Trevi Fountain.* New Haven, Conn., 1986.

Pope-Hennessy 1970a
Pope-Hennessy, John. *The Frick Collection, Sculpture.* Vol. 3. New York, 1970.

Pope-Hennessy 1970b
Pope-Hennessy, John. "The Gherardini Collection of Italian Sculpture." *Victoria and Albert Museum Yearbook,* no. 2 (1970), pp. 7–26.

Pope-Hennessy 1985
Pope-Hennessy, John. *Cellini.* New York, 1985.

Pope-Hennessy 1996
Pope-Hennessy, John. *Italian High Renaissance and Baroque Sculpture.* 4th ed. London, 1996.

Posse 1905
Posse, Hans. "Alessandro Algardi," *Jahrbuch der Königlich preussischen Kunstsammlungen,* xxvi, 1905, pp. 169–201.

Preimesberger 1973
Preimesberger, Rudolph. "Cafà." In *Dizionario biografico degli italiani,* vol. 16, pp. 230–35. Rome, 1973.

Preimesberger and Mezzatesta 1996
Preimesberger, Rudolph, and Michael P. Mezzatesta. "Gianlorenzo Bernini, II: Working Methods and Technique." *The Dictionary of Art,* Jane Turner, ed., vol. 3, pp. 837–38. New York, 1996.

Princeton 1981
Drawings by Gianlorenzo Bernini from the Museum der Bildenden Künste, Leipzig, German Democratic Republic. Exh. cat. by Irving Lavin et al. Princeton, N.J., Art Museum, Princeton University, 1981.

Radke 1992
Radke, Gary M. "Benedetto da Maiano and the Use of Full-Scale Preparatory Models in the Quattrocento." In *Verrocchio and Late Quattrocento Italian Sculpture,* Steven Bule et al., eds., pp. 217–24. Florence, 1992.

Radcliffe 1992
Radcliffe, Anthony. "New Light on Verrocchio's Beheading of the Baptist." In *Verrocchio and Late Quattrocento Italian Sculpture,* Steven Bule et al., eds., pp. 117–23. Florence, 1992.

Raggio 1983
Raggio, Olga. "Bernini and the Collection of Cardinal Flavio Chigi." *Apollo,* n.s., 117, 255 (May 1983), pp. 368–79.

Ragionieri 1987
Ragionieri, Giovanna. *Casa Buonarroti.* Florence, 1987.

RGADA
Rossiiskii Gosudarstvennyi arkhiv drevnikh aktov (Russian State Archive of Ancient Documents), St. Petersburg.

RGIA
Rossiiskii Gosudarstvennyi istoricheskii arkhiv (Russian State Historical Archive), St. Petersburg.

Rome 1989
Due terracotte romane del seicento. Exh. cat. by Bruno Contardi. Rome, Museo Nazionale di Castel Sant'Angelo, 1989.

Rome 1991
Sculture in terracotta del barocco romano: Bozzetti e modelli del Museo Nazionale del Palazzo di Venezia. Exh. cat. by Maria Giulia Barberini. Rome, Museo Nazionale del Palazzo di Venezia, 1991.

Rome 1994
Bartolomeo Cavaceppi, scultore romano (1717–1799). Exh. cat. by Maria Giulia Barberini, Carlo Gasparri, et al. Rome, Museo Nazionale del Palazzo di Venezia, 1994.

Rossacher 1967
Rossacher, Kurt. "Berninis Reiterstatue des Konstantin an der Scala Regia: Neues zur Werkgeschichte." *Alte and Moderne Kunste* 12, 90 (Jan./Feb. 1967), pp. 2–11.

Rossi 1975
Rossi, Paola. *I disegni di Jacopo Tintoretto.* Florence, 1975.

Rudolph 1995
Rudolph, Stella. *Niccolò Maria Pallavicini: L'ascesa al tempio della virtù attraverso il mecenatismo.* Rome, 1995.

Salerno, Spezzaferro, and Tafuri 1973
Salerno, Luigi, Luigi Spezzaferro, and Manfredo Tafuri. *Via Giulia: Una utopia urbanistica del 500.* Rome, 1973.

Sandrart 1925
von Sandrart, Joachim. *Academie der Bau- Bild- und Mahlerey-Künste von 1675.* A. R. Peltzer, ed. Munich, 1925.

Schlegel 1967
Schlegel, Ursula. "Some Statuettes of Giuseppe Mazzuoli." *Burlington Magazine* 109, 772 (July 1967), pp. 388–95.

Schlegel 1969
Schlegel, Ursula. "Alcuni disegni di Camillo Rusconi, Carlo Maratta e Angelo de' Rossi." *Antichità viva* 8, 4 (1969), pp. 28–41.

Schlegel 1978
Schlegel, Ursula. *Die italienischen Bildwerke des 17. und 18. Jahrhunderts in Stein, Holz, Ton, Wachs und Bronze mit Ausnahme der Plaketten und Medaillen.* Berlin, 1978.

Schlegel 1994
Schlegel, Ursula. "Arbeiten in Terracotta von Alessandro Algardi und Ercole Ferrata." In *Studi di storia dell'arte in onore di Mina Gregori*, pp. 279–84. Milan, 1994.

Schottmüller 1933
Schottmüller, Frida. *Die italienischen und spanischen Bildwerke der Renaissance und des Barock.* Vol. 1 of *Die Bildwerke in Stein, Holz, Ton und Wachs.* 2nd ed. Berlin and Leipzig, 1933.

Souchal 1973/74
Souchal, François. "L'inventaire après décès du sculpteur Lambert-Sigisbert Adam." *Bulletin de la société de l'histoire de l'art français* (1973/74), pp. 181–91.

Souchal 1993
Souchal, François. *French Sculptors of the Seventeenth and Eighteenth Centuries: The Reign of Louis XIV.* Suppl. vol. Augusta Audubert, trans. London and Boston, 1993.

Sweeny 1972
Sweeny, Barbara. *John G. Johnson Collection: Catalogue of Flemish and Dutch Paintings.* Philadelphia, 1972.

Thornton and Dorey 1992
Thornton, Peter, and Helen Dorey. *Sir John Soane: The Architect as Collector, 1753–1837.* New York, 1992.

Titi 1686
Titi, Filippo. *Ammaestramento utile e curioso di pittura, scoltura et architettura, nelle chiese di Roma* Rome, 1686.

Tratz 1988
Tratz, Helga. "Werkstatt und Arbertsweise Berninis." *Römisches Jahrbuch für Kunstgeschichte* 23–24 (1988), pp. 395–472.

Treu 1871
Treu, Georg. *Ukazatel' skul'pturnogo muzeya imperatorskoy akademii khudozhestv: Skul'ptura XIV–XVIII stoletii* (Index of the sculpture museum of the imperial academy of the fine arts: sculpture of the fourteenth through eighteenth centuries). St. Petersburg, 1871.

Vasari 1878
Vasari, Giorgio. *Le vite de'più eccelenti pittori, scultori ed architettori.* 5 vols. Gaetano Milanesi, ed. Florence, 1878.

Vatican City 1981
Bernini in Vaticano. Exh. cat. Vatican City, Palazzo Vaticano, 1981.

Vedovato 1994
Vedovato, L. *Villa Farsetti nella storia.* Venice, 1994.

Venice 1978
Venezia nell'età di Canova, 1780–1830. Exh. cat. Venice, Museo Correr, 1978.

Venice 1991
Alle origini di Canova: Le terrecotte della collezione Farsetti. Exh. cat. by Sergei O. Androsov, Nina K. Kosareva, and Giovanna Nepi-Scirè. Rome, Fondazione Memmo, Palazzo Ruspoli, and Venice, Galleria Giorgio Franchetti alla Ca' d'Oro, 1992. Venice, 1991.

Vio 1967
Vio, Ettore. *La Villa Farsetti a Sala.* Padua, 1967.

Walton 1982
Walton, Guy. "Bernini's Equestrian Louis XIV." *Art Bulletin* 64, 2 (June 1982), pp. 319–20.

Washington 1981
Fingerprints of the Artist: European Terra-Cotta Sculpture from the Arthur M. Sackler Collections. Exh. cat. by Charles Avery et al. Washington, D.C., National Gallery of Art; New York, The Metropolitan Museum of Art; Cambridge, Mass., Fogg Art Museum, 1981.

Watson 1978
Watson, Katherine. "Giambologna and His Workshop: The Later Years." In London 1978 (see above), pp. 33–41.

Weil 1974
Weil, Mark S. *The History and Decoration of the Ponte S. Angelo.* University Park, Pa., 1974.

Wittkower 1951
Wittkower, Rudolf. *Bernini's Bust of Louis XIV.* Oxford, 1951.

Wittkower 1966
Wittkower, Rudolf. *Gian Lorenzo Bernini: The Sculptor of the Roman Baroque.* 2nd ed. London, 1966.

Wittkower 1977
Wittkower, Rudolf. *Sculpture: Processes and Principles.* London, 1977.

Zaretskaia and Kosareva 1960
Zaretskaia, Zinaida Vladimirovna, and Nina K. Kosareva. *Gosudarstvennyj Ermitazh: Zapadnoevropeyskaya skul'ptura XV–XX vekov* (The State Hermitage: western European sculpture of the fifteenth through twentieth centuries). Moscow, 1960.

Zaretskaia and Kosareva 1970
Zaretskaia, Zinaida Vladimirovna, and Nina K. Kosareva. *Zapadnoevropeyskaya skul'ptura v Ermitazhe* (Western European sculpture in the Hermitage). Leningrad, 1970.

Zaretskaia and Kosareva 1975
Zaretskaia, Zinaida Vladimirovna, and Nina K. Kosareva. *Zapadnoevropeyskaya skul'ptura v Ermitazhe. 2-e izdanie* (Western European sculpture in the Hermitage). 2nd ed. Leningrad, 1975.